IMAGES
of America

JEWS OF
SCRANTON

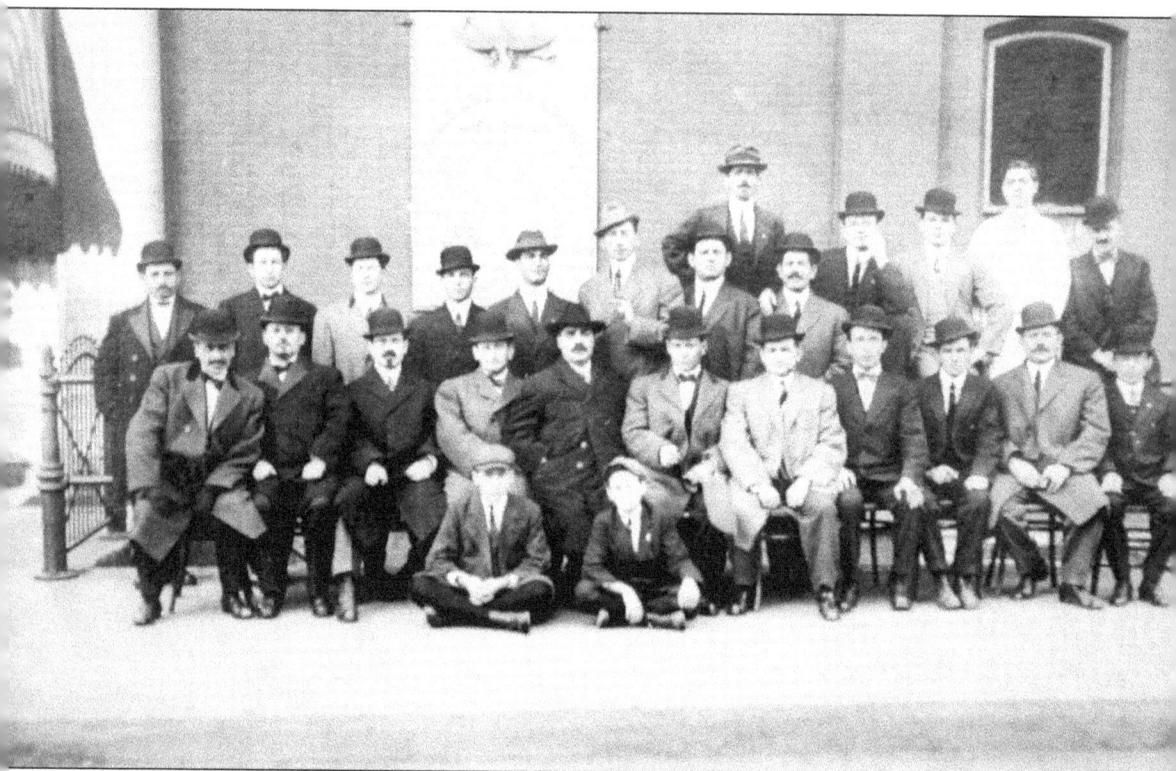

Zionist Group Outside GAR Building. This group gathered in Scranton to welcome Zionist speaker Nahum Sokolow, who visited the city in 1915 and 1922. Sokolow is seated fifth from the left. (Courtesy of Rachel Weisberger.)

IMAGES
of America

JEWS OF SCRANTON

Arnine Cumsky Weiss and Darlene Miller-Lanning

ARCADIA
PUBLISHING

Published by Arcadia Publishing,
Charleston, South Carolina

Library of Congress Catalog Card Number: 2004114103

For all general information, contact Arcadia Publishing:
Telephone 843-853-2070
Fax 843-853-0044
E-mail sales@arcadiapublishing.com
For customer service and orders:
Toll-free 1-888-313-2665

Visit us on the Internet at www.arcadiapublishing.com

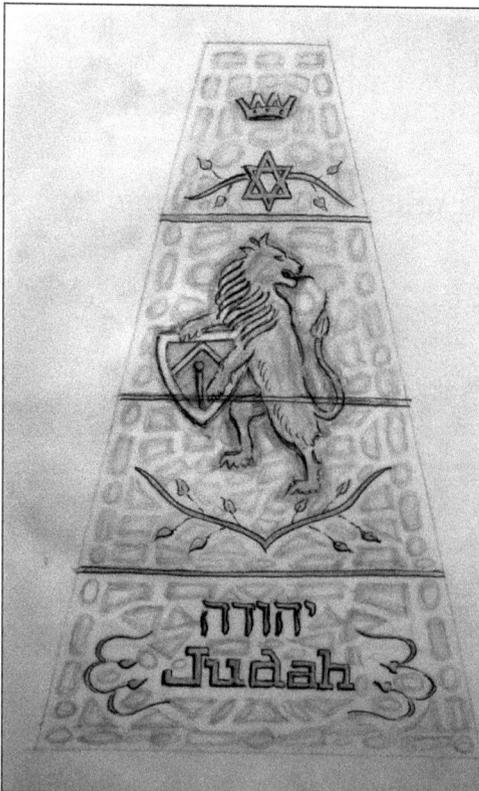

A STUDY FOR A STAINED-GLASS WINDOW.
In 1970, Lester Cohen designed a series of
stained-glass windows depicting the 12 tribes
of Israel for Beth Shalom. (Courtesy of the
Cohen family.)

CONTENTS

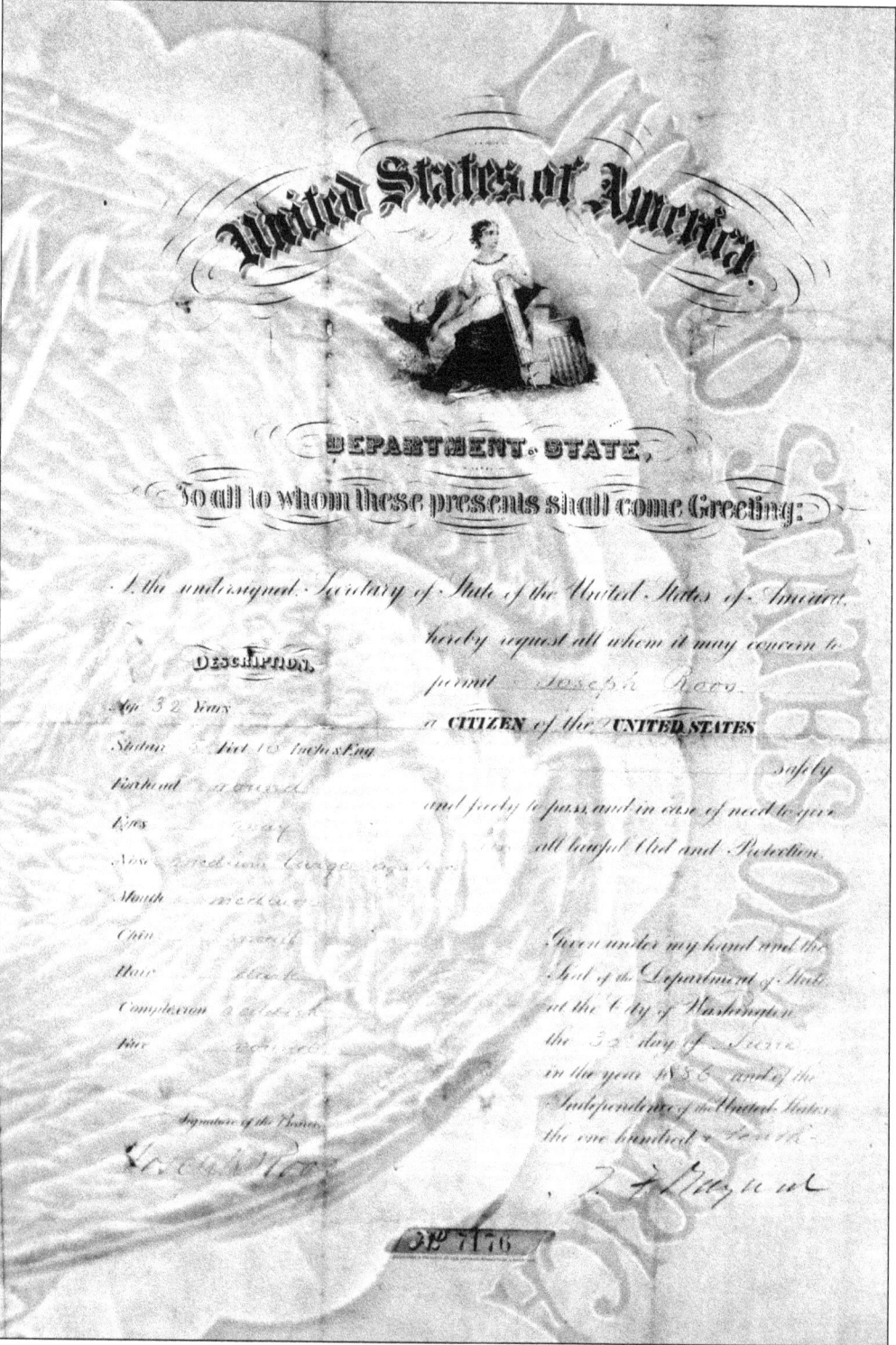

JOSEPH ROOS'S CITIZENSHIP PAPERS. In 1886, Joseph Roos, a 32-year-old butcher from Germany, became a citizen of the United States. (Courtesy of the Roos family.)

INTRODUCTION
A Magical Jewish Kingdom

Perhaps the place where one grows up turns into a magical kingdom later in life. But Scranton, and especially its Jewish community as I knew it in the 1940s and 1950s, may actually deserve the title. In Marjorie Levin's *The Jews of Wilkes-Barre*, writer Harriet Segal remarked that it was "a privilege" to have grown up in Wilkes-Barre. Sportswriter Sandy Padwe, onetime dean of journalism at Columbia University, said that when he locked the door to his father's apartment for the last time, he realized that he had lived his childhood and adolescence in a "magical kingdom." Those comments and the recollections of my own friends and family have reinforced my sense of northeastern Pennsylvania and its Jewish communities as very special places indeed.

There is some real irony, of course, in describing this part of the world as magical, for King Coal's realm has not exactly been trouble free. Before World War I, Scranton was said to be the fastest-growing city in the United States, and in 1919, *National Geographic* claimed the city was "richer" than any city of its size in the country. When Rabbi Max Arzt came to the new Temple Israel in 1924, he believed that the Jewish community and the city had "unlimited potential." But the Great Depression, which began only five years later, ushered in a period of economic decline that has never really ended in Scranton. The industries that were the mainstays of the local economy after the ironworks and steelworks were moved to Buffalo in 1901—coal, textiles, and railroads—collapsed or moved away. Scranton had the dubious honor in the post-Weinberg era (after the demise of the old Scranton Transit Company) of being the largest city without a public transit system in the United States. And it has the equally dubious honor of having the oldest housing stock—that is, proportionately fewer new houses than any other American city. The population of Scranton and Wilkes-Barre peaked c. 1930, and the urban loss has not been matched by suburban gain, as has been the case in many other places. Already by the end of World War II, the Jewish communities of northeastern Pennsylvania were beginning to see the flight of their young people to larger centers with greater economic opportunities.

One of the sad aspects of looking backward for me is realizing what and who are no more. Central High School, from which my father and I graduated, is no longer a high school, and the Linden Street Shul, where my father celebrated his bar mitzvah, is barely a memory. My grandparents' home, with its old stable, splendid purple bathroom, and beamed dining-room ceiling, seemed like something out of a fairy tale to a little boy; the house, located on the corner of Quincy and Mulberry, has been replaced by a University of Scranton dormitory. Gone, too,

is the Boston Fish Car Market, which was started by my grandfather in a railroad car on a Lackawanna Avenue siding and quickly developed into the largest fish market in the area. Most of my relatives—of whom there once were dozens in Scranton, Wilkes-Barre, Pittston, Sunbury, Carbondale, Hazelton, and elsewhere up and down the line—are either no longer living or have moved away, a process of dissolution that began over 75 years ago.

But it is a magical Jewish kingdom nonetheless. The uniqueness and the magic, as I knew it, were expressed in many ways. I want to talk about these in the context of what I believe to have been two of the main forces that created the magic: size and geography. While it may not always be obvious, Scranton and Wilkes-Barre (and especially their Jewish communities) have been blessed by both size and geography.

We will begin with size. In 1945, Rabbi Arthur T. Buch, then the rabbi of Temple Israel, wrote a doctoral dissertation about the Scranton Jewish community. (I remember hearing of the nervousness that he might "tell all," whatever "all" was, and of the efforts to ensure that the dissertation would not be published as a book, which it never was.) In the thesis, Buch comments that the Scranton Jewish community is small enough that everyone counts, but large enough that no one counts too much.

Scranton Jews have had their *machers*, their movers and shakers, to be sure. I remember those of my day. A. B. Cohen, for example, was instrumental in shaping Jewish education in Scranton as a founder of the Montefiore Talmud Torah (later the Central Talmud Torah) in 1894. Some three decades later, he was one of the founders of Temple Israel, and some three decades after that, he led the drive to acquire Scranton's first municipal ambulance. Ike Oppenheim, the proprietor of the Scranton Dry Goods Company, the second-largest store in Scranton, was another. A member of the Madison Avenue Temple, Oppenheim was a generous, dependable dispenser of charity to the whole community, a paternal figure to his employees, someone who would try to find a job in his store for anyone who needed one and who played host in the store to all sorts of charitable groups. A third was Rabbi Henry Guterman, a rabbinical scholar with a reputation far beyond Scranton. He was the city's "chief rabbi" from soon after he arrived from Atlanta in 1909 until his death in 1966. A man of impeccable Orthodoxy, Guterman reached out to those who were not Orthodox, even experimenting with some of the new forms American Jews were trying out, such as the late Friday night service.

All three of these men understood that in a place like Scranton, they needed the community as much as the community needed them. I remember A. B., as he was known, reciting Maftir Yonah every year on Yom Kippur in Temple Israel. He was a natural to community affairs, and I suspect he would have been the same A. B. had he lived in New York. But Oppenheim and Guterman might have been quite different. Had there been more people like him, Oppenheim might have isolated himself and family in his Dalton castle and socialized only with his own social and economic equals, perhaps, even, supporting only the causes of his own group. Here, however, he closed his store on Rosh Hashanah and Yom Kippur—the Globe store always ran sales on those days, to "stick it" to the Jews—and he helped to support the whole Jewish community. Guterman made a point of having good relations with everyone, including Reform and Conservative rabbis. He understood that in Scranton, his significance depended on being able to touch people beyond the confines of Orthodoxy, and he wrote no one off.

A smaller community also meant that individuals had a chance to shine and an opportunity to do things they might not have done if others with greater talent had been around. An outstanding example from my own years was Boy Scout Troop 65 of Temple Israel under the leadership of Scoutmaster Bob Roth. A bachelor, Roth made the Scouts his family. He devoted his time and energy to each boy, pushing us all to achieve well beyond our abilities or inclinations.

The modest size of the city of Scranton also meant that not much was going on. So we welcomed the excitement of a Scout meeting or a Junior Congregation election or a Purim carnival. And on shabbat (shabbes then), the movies raised the prices only at 1:00, so one could easily manage shul and the movies. One could avoid a conflict and see a film—all for 25¢. (Shul was free.)

8

While size, then, was one ingredient of the magic, geography was another. Scranton Jews were just far enough from New York and Philadelphia to have to create their own communal life: social, political, and religious. Before television and computers, there were neither reality shows nor virtual reality. Reality was whatever you made of your life. It was important, too, that Scranton was near enough to the world's largest Jewish community to draw upon the resources of New York when they were needed (or for New York to provide an escape hatch from small-city claustrophobia, which occasionally set in). As a result, the Jewish community in Scranton created a variety of institutions that larger communities envied: vibrant synagogues (of which there were 10 when I was a kid, and Temple Israel in the 1930s and 1940s was one of the leading synagogues of the Conservative movement); a model YM-YWHA and then JCC; youth groups, including Boy and Girl Scouts (Goose Pond Boy Scout Camp had one of only a handful of Scout camp kosher kitchens in the country), Young Judea, KIDs, ULPs, and AZA (later BBYO); one of the first Jewish federations in the United States; the Jewish Home for the Friendless (now the Jewish Home of Northeastern Pennsylvania); and eventually a day school, a yeshiva, a country club, and other institutions usually found only in larger communities.

Geography was a help in another way. Although northeastern Pennsylvania was always accessible via good roads, railroads, and then an airport, it was still a bit off the beaten track. Growing up, we Scrantonians thought of ourselves as "big city" kids, especially compared to those who lived "up the line" or even in Wilkes-Barre. While we were not, I think, hicks (New Yorkers seemed a lot more provincial, convinced as they were that the world ended at the Hudson River), we did live in a world that was a bit slower, more relaxed, more caring, where the lines of ideology and class were less sharply drawn than elsewhere. Scranton was big enough and not so isolated that there were Orthodox, Conservative, and Reform Jews, Zionists and anti-Zionists, communists and Yiddishists. But the city was far enough removed from the fray for ideology to have its sharp edges smoothed. Until recently, moreover, most Scranton Jews had similar origins, and many were related to one another. Family and friendship also moderated differences.

When I was a student at the Jewish Theological Seminary, I spent several Sukkot holidays (sometimes bringing along a student friend) at the Finks' chicken farm near Hamlin. The Finks were one of America's premier Orthodox families, featured on the cover of *Life* when it did a story on Jews in 1955. To entertain a student for the Conservative rabbinate was not an unacceptable thing for them to do in Scranton, but it would likely not have occurred in a larger community then, and it would likely not occur even in Scranton today. In the 75th-anniversary booklet of Temple Israel, I happened to notice that among the candidates for the Junior Congregation board in the late 1940s were kids whose parents belonged to the Madison Avenue Temple and to various Orthodox synagogues. Again, this is a kind of cross-denominational activity that could occur because we were far enough away from the centers of ideological controversy and few enough in numbers for people to count more than principles.

Geography contributed to provinciality and a degree of insularity. I remember how hard it was for the few newcomers who moved to town in the postwar years to integrate into our tight little circle. The flip side of insularity was stability, solidarity, and local pride. As long as economic conditions permitted (until the 1960s, more or less), many of the best and brightest remained within the community. Harry Austryn Wolfson, a *melamed* (teacher) at the Montefiore Talmud Torah, went on to Harvard, where he was named to the first chair of Jewish studies; Pauline Mack, later the national president of Hadassah, left with her businessman husband and their children. Generally, however, the natives tended to stay, and those who came eventually made their way in and remained. Cantor William Horn, for example, served Temple Israel for 60 years, and Rabbi Simon Shoop served for 41 years. Rabbi Guterman served the Orthodox community for 57 years. Ike Oppenheim, the patrician of the community, was born in Aberdeen, Mississippi.

It helped, too, that we were isolated enough in northeastern Pennsylvania for antisemitism to lose some of its sting. I cannot recall much of anything from my own growing up, at school or elsewhere. I even got to speak to the Daughters of the American Revolution once. My

grandparents and parents had other experiences. My mother used to tell that one day when she was teaching at Kingston High School, the ragman passed by and tooted his unmistakable horn. One of the kids in the class leaned over to his neighbor and said in a stage whisper, "I wonder if the sheenie is her father." (On hearing the story, one of the gentile male teachers administered a beating to the student, an acceptable thing to do at the time.) In the 1920s, my Grandfather Brown bought his first home, on Jefferson Avenue, not far from the Jermyn and the Woolworth mansions. One of the neighbors was so upset at the idea of living next to Jews that he offered my grandfather $5,000 over the purchase price if he would move elsewhere. My grandfather was a businessman, so he took the offer and bought a bigger house. In the 1920s and 1930s, the KKK was active here, as elsewhere. And, of course, the big companies—the ICS, the International Salt, the coal companies, the banks—were all closed to Jews, as were the Scranton Club and the Scranton Country Club, until long after World War II. But antisemitism was low-key here. Jews were a part of the fabric of the city from its earliest days. A Jew, Barnett Rosenthal, was Scranton's first and, for a long time, only policeman.

Undoubtedly there were more ingredients to the magic than size and geography. One component surely was that people of talent and energy and dedication to the Jewish community lived here and were willing to give of themselves and to create and maintain the splendid, variegated infrastructure of the community. I mentioned some of the institutions and a few individuals earlier, and perhaps I should just add here the name of Harry Weinberg, who remembered Scranton and its Jewish community so generously in his will. Another ingredient of the magic was the warmth and care and rather good education that the community provided and which nurtured individuals who, wherever life took them, were well equipped for careers and for a creative Jewish life.

For me, and for so many others then, Scranton was a kind of magical kingdom, but it was not Disneyland. It was real enough, with lots of problems, but perhaps all the more magical for having been warm and nurturing despite the problems. The memory of the magic days is preserved in part, at least, by this volume. It is a legacy worth recording for future generations of Scranton Jews and for those of us who now live elsewhere. I, for one, am very grateful to have grown up in King Coal's Magic Kingdom.

<div align="right">

——Michael Brown
Professor Emeritus of Hebrew, Humanities, and History
York University, Toronto

</div>

One

RELIGIOUS LIFE

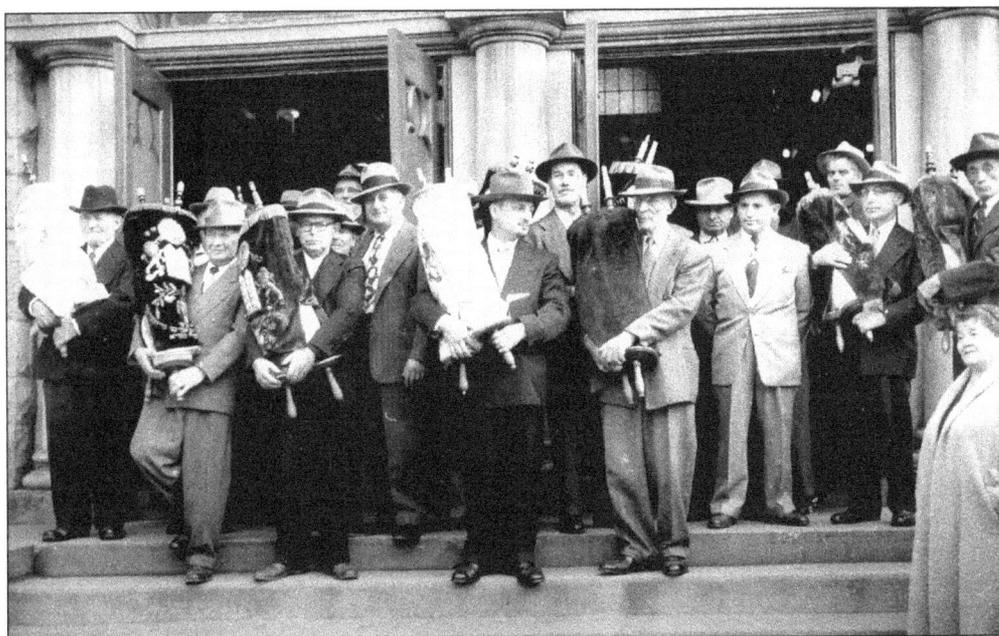

REMOVING THE TORAHS FROM B'NAI ISRAEL AFTER THE FLOOD. In 1955, the Flats section of Scranton was flooded, and the Torahs were removed from B'Nai Israel, which later merged with Ahavas Achim, Anshe Sfard, and Bais Hamedresh Hagadol to form Beth Shalom. This photograph was taken by Fuzzy Popick, a local resident and writer. Popick, who suffered from polio as a child, was known for his great physical strength and his enduring community spirit. For many years, he published *Popickganda*, a national newsletter for Jewish families. (Courtesy of Beth Shalom.)

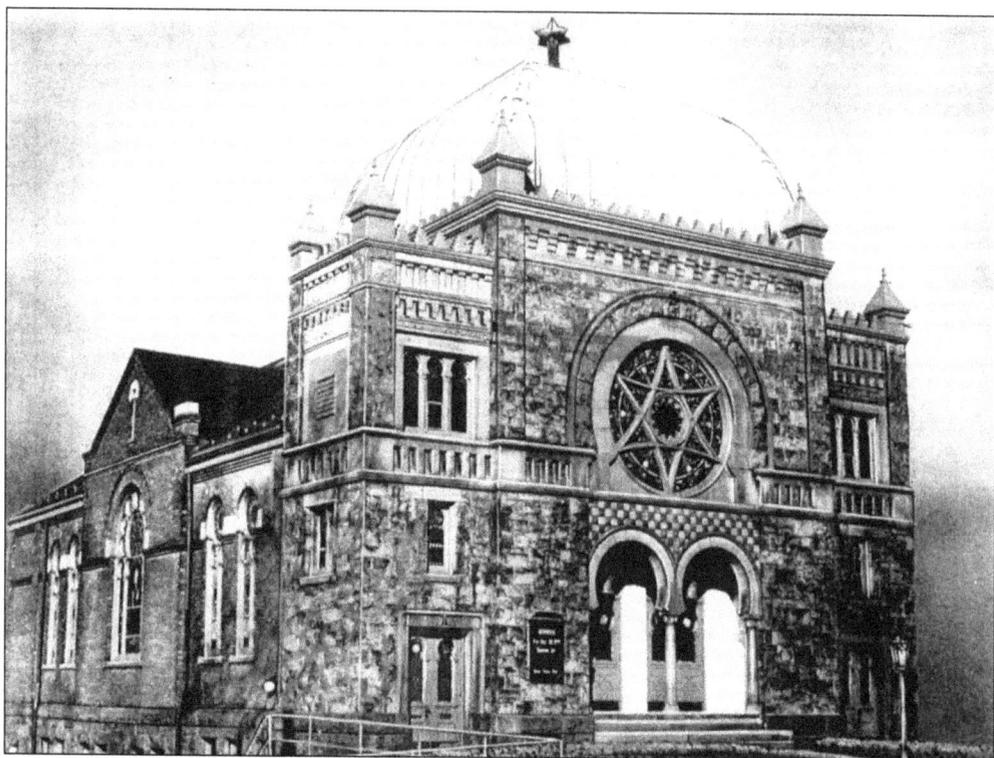

THE MADISON AVENUE TEMPLE OF CONGREGATION ANSHE CHESED. The oldest congregation in Scranton, Anshe Chesed was founded in 1860. Its first permanent home was built and dedicated at the Linden Street Temple in 1867. In 1902, the congregation constructed this new synagogue on Madison Avenue. (Courtesy of Alan Firestone.)

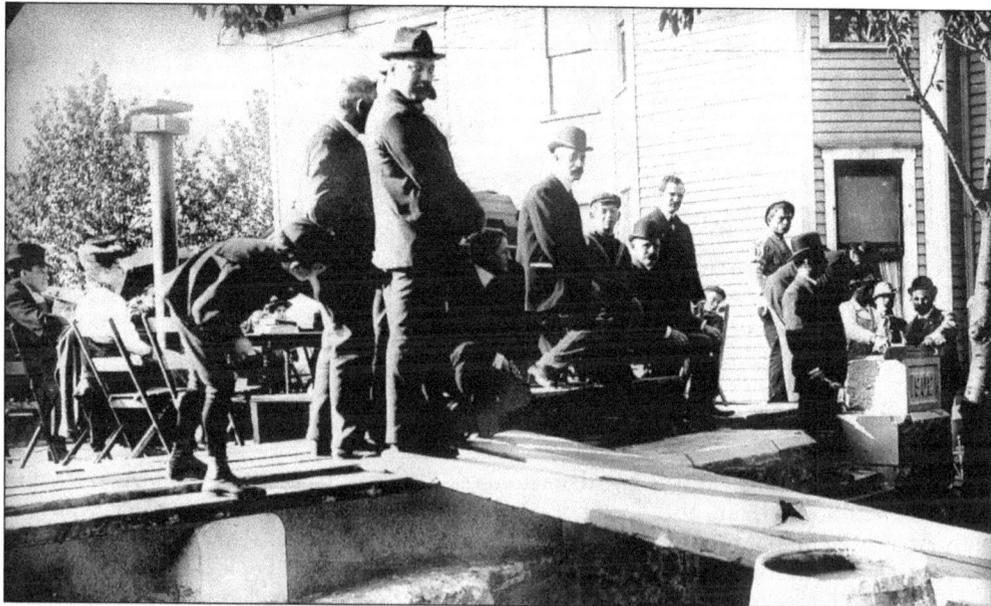

THE DEDICATION OF THE MADISON AVENUE TEMPLE. This photograph documents the laying of the cornerstone for the Madison Avenue Temple in 1902. (Courtesy of Temple Hesed.)

THE PROGRAM FOR THE MADISON AVENUE
TEMPLE DEDICATION. The dedication of
the Madison Avenue Temple was such an
event that the speeches were printed in the
local newspaper the next day. (Courtesy of
Temple Hesed.)

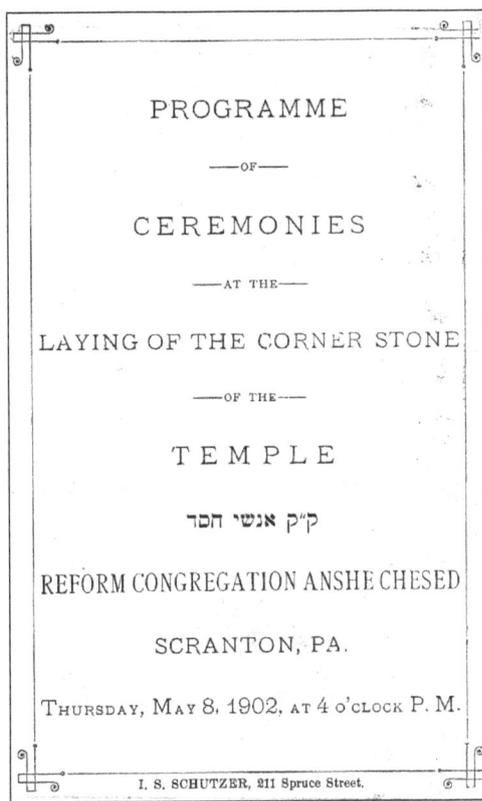

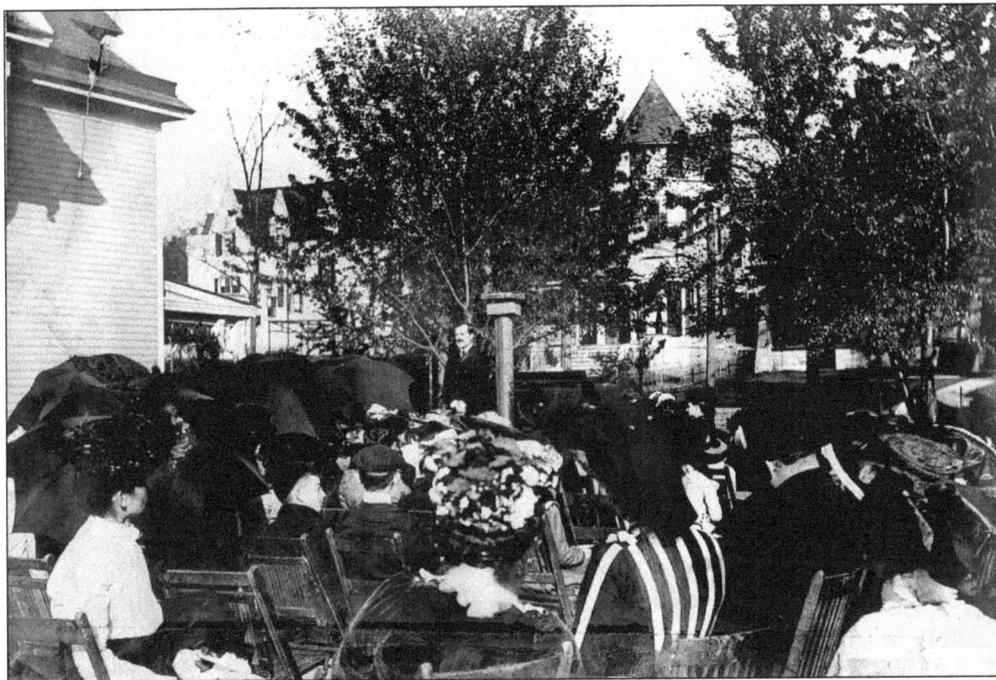

PROGRAMME

—OF—

CEREMONIES

—AT THE—

LAYING OF THE CORNER STONE

—OF THE—

TEMPLE

ק"ק אנשי חסד

REFORM CONGREGATION ANSHE CHESED

SCRANTON, PA.

THURSDAY, MAY 8, 1902, AT 4 O'CLOCK P. M.

I. S. SCHUTZER, 211 Spruce Street.

THE CROWD AT THE DEDICATION. Many prominent community members attended the Madison
Avenue Temple dedication ceremony in 1902. (Courtesy of Temple Hesed.)

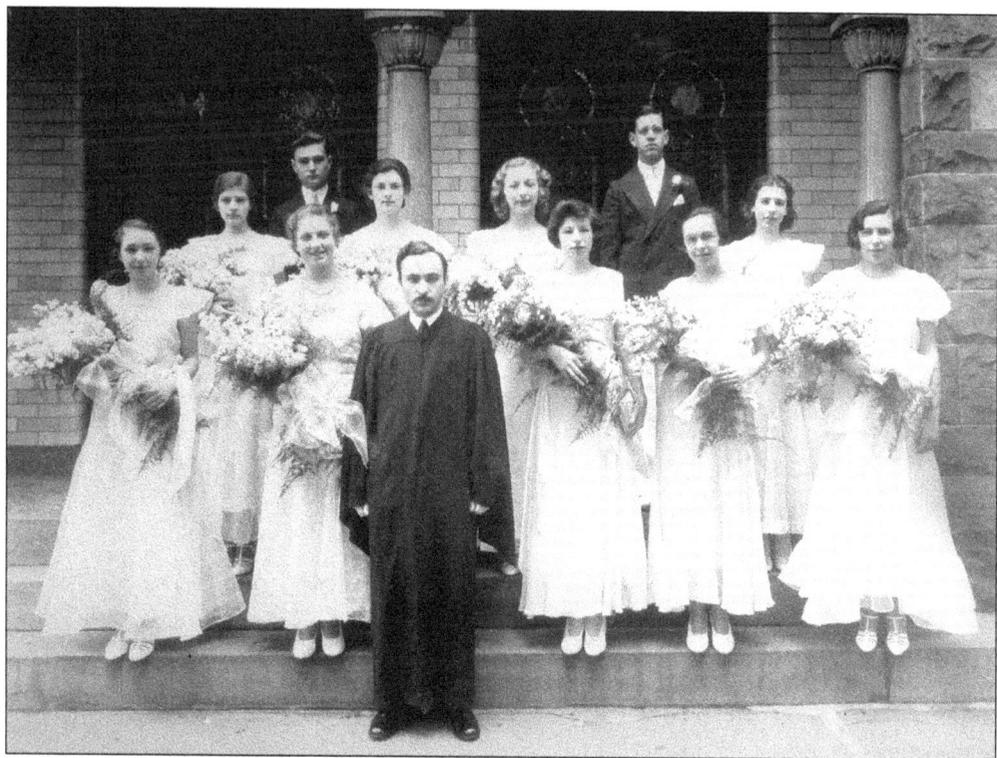

A MADISON AVENUE TEMPLE CONFIRMATION CLASS. This confirmation class is shown in front of the Madison Avenue Temple in 1928. From left to right are the following: (at front) Rabbi Tepfer; (first row) Marion Endfield, Betty Kabatchnick, Florence Rubenstein, Annette Gildar, and Bernice Goldberg; (second row) Esther Cohen, Iris ?, Selma Ball, and Jane Brown; (third row) Jack Newman and Louis Kleeman. (Courtesy of Nancy Weinberger.)

THE MADISON AVENUE SISTERHOOD. This meeting of the Madison Avenue Sisterhood was held during the 1920s at the La Plume home of Constance Oppenheim (front row, far right). (Courtesy of the Oppenheim family.)

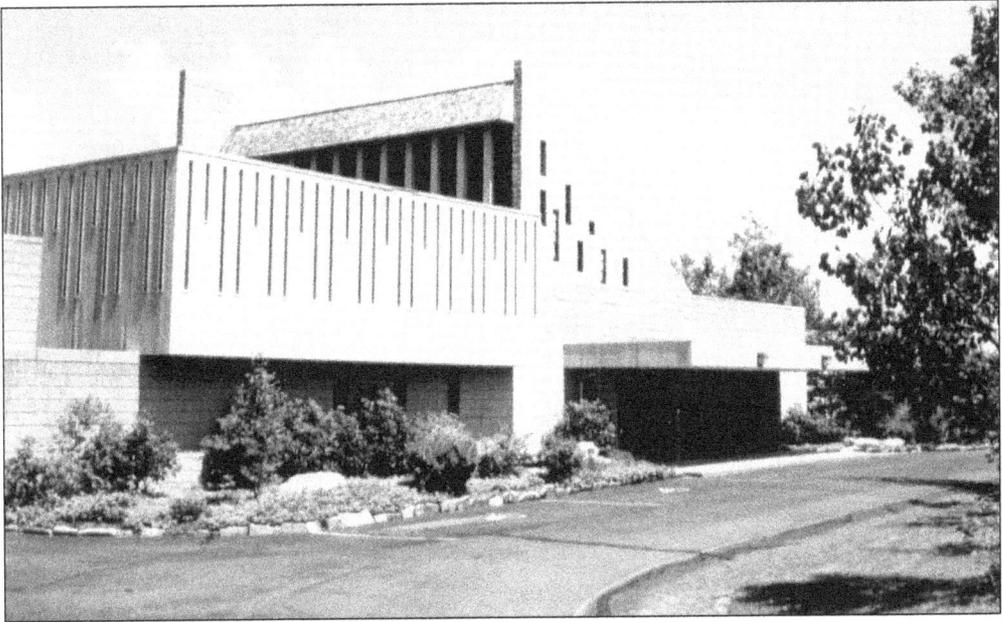

TEMPLE HESED. Located in East Mountain on the outskirts of the city, Temple Hesed became the new home of the Anshe Chesed congregation in 1972. (Courtesy of Alan Firestone.)

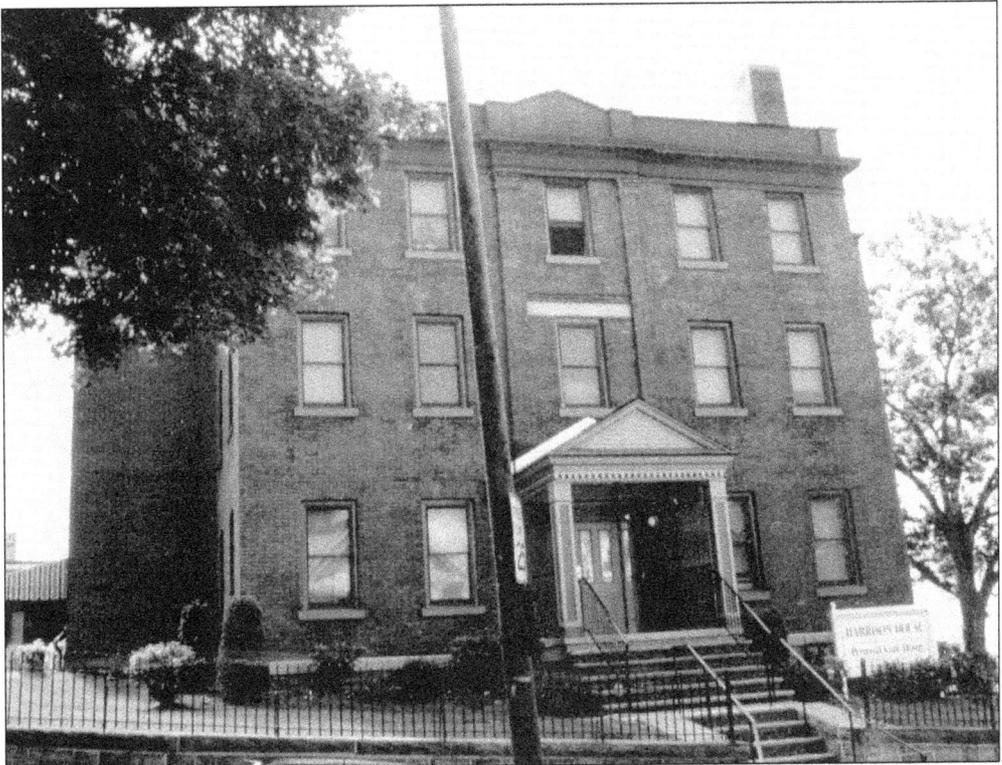

THE JEWISH HOME FOR THE FRIENDLESS. The original Jewish Home, founded in 1915, was located in the Providence section of Scranton and housed both orphans and the elderly. The home later relocated to this structure on Harrison Avenue. (Courtesy of Alan Firestone.)

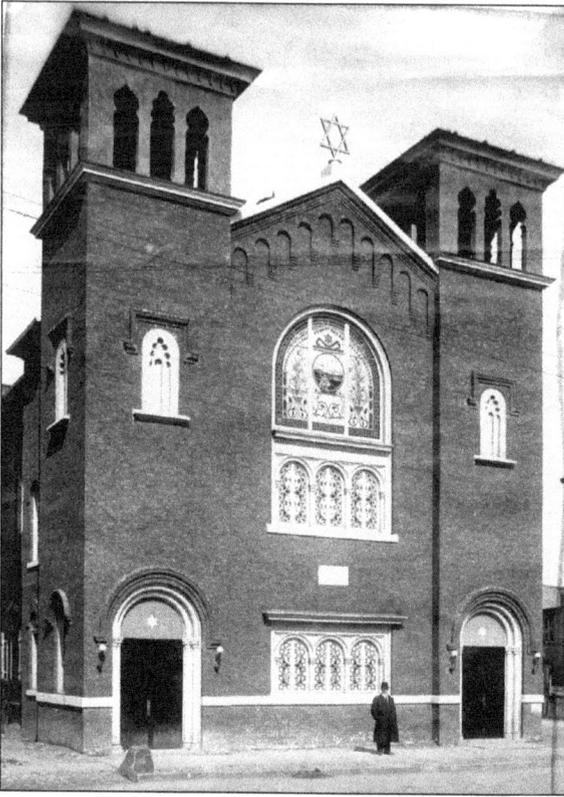

THE LINDEN STREET SHUL. This Orthodox congregation moved into this building when the Reform congregation of Anshe Chesed moved into their new home on Madison Avenue in 1902. The synagogue was renovated and rededicated in 1913. (Courtesy of Alan Firestone.)

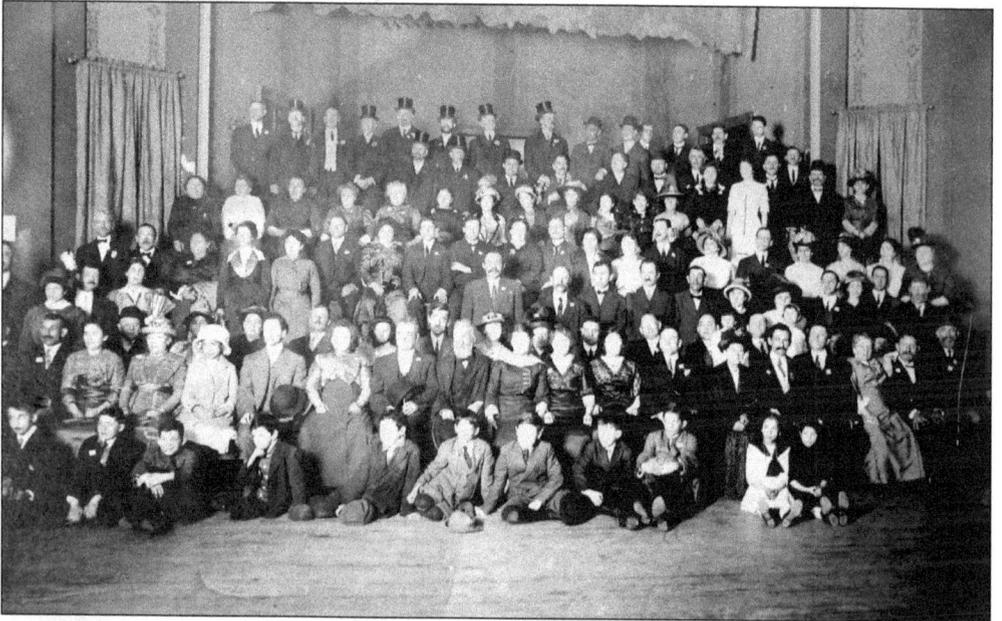

THE REDEDICATION OF THE LINDEN STREET SHUL. Those in attendance at the rededication of the Linden Street Shul in 1913 included Rabbi Wolf Gold, a former Scranton rabbi who moved to Eretz Yisroel and was one of the signers of the Declaration of Independence for the State of Israel. (Courtesy of Sydney Newman.)

16

RABBI LEWIS. Rabbi Lewis served at the Linden Street Shul in 1904. (Courtesy of Faye Spatt.)

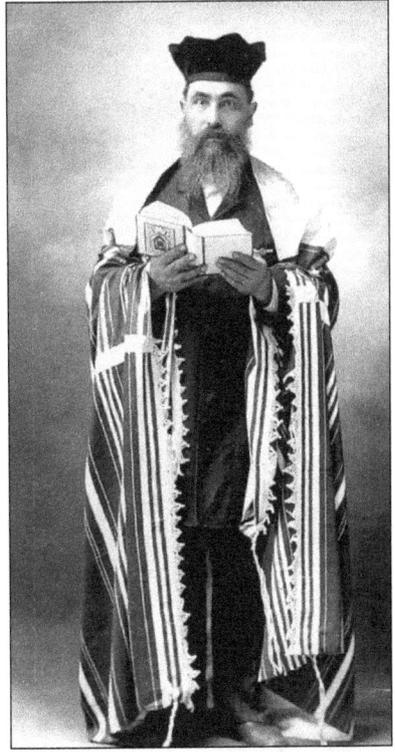

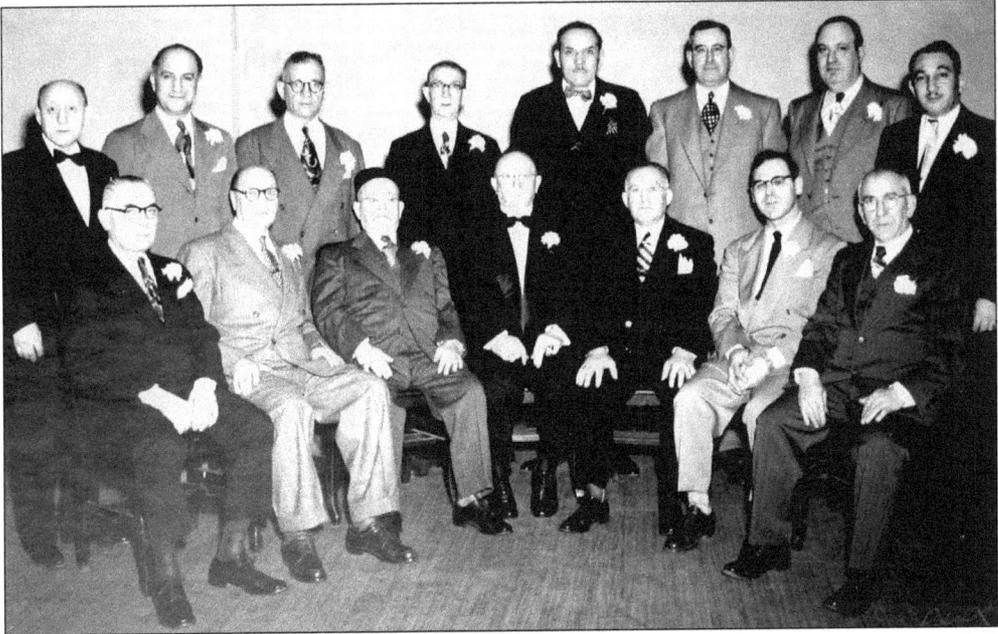

THE LINDEN STREET SHUL. Members of the Kneseth Israel congregation of the Linden Street Shul are pictured in 1951. They are, from left to right, as follows: (first row) Harry Trucker, Anthony Schik, Harry Vilensky, Samuel Zimmerman, Milton Dubin, Sam Shapiro, and Ephraim Kaplan; (second row) Jacob Pittle, Moe Wolfe, Samuel Fragin, David Davis, Harry Rubenfield, Simon Blumberg, Sidney Blumberg, and Herbert Fiaker. (Courtesy of Beth Shalom Synagogue.)

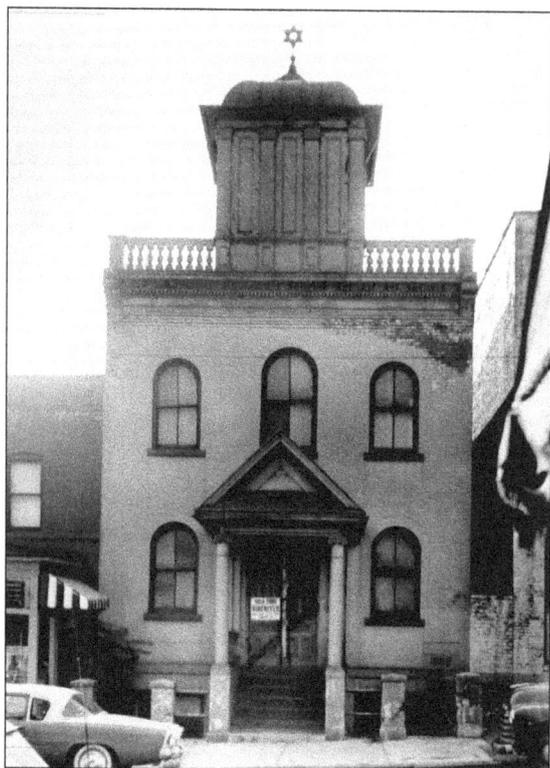

THE PENN AVENUE SHUL. The Penn Avenue Shul was also known as Bais Hamedresh Hagadol. It was founded in 1886 and later moved to Monroe and Olive Streets, where it became known as the Penn Monroe Shul. (Courtesy of Alan Firestone.)

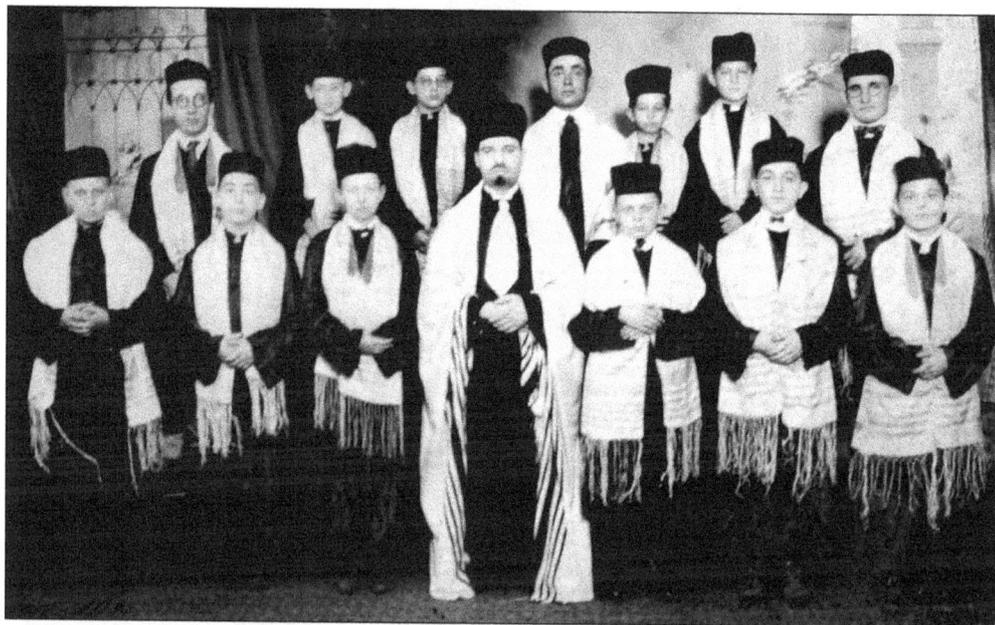

A BAR MITZVAH CLASS. This bar mitzvah class from the Penn Avenue Shul is pictured in 1919. From left to right are the following: (first row) Hyman Shaffer, Martin Brown, Packy Weisberger, Rev. Nathan Newmark, Lewis Cohen, Jack Plotkin, and Phillip Plotkin; (second row) ? Gold, Irving Block, Irwin Furman, Joe Levine, Paul Rosenstein, Perry Koslow, and Jay Kaufman. (Courtesy of the Plotkin family.)

18

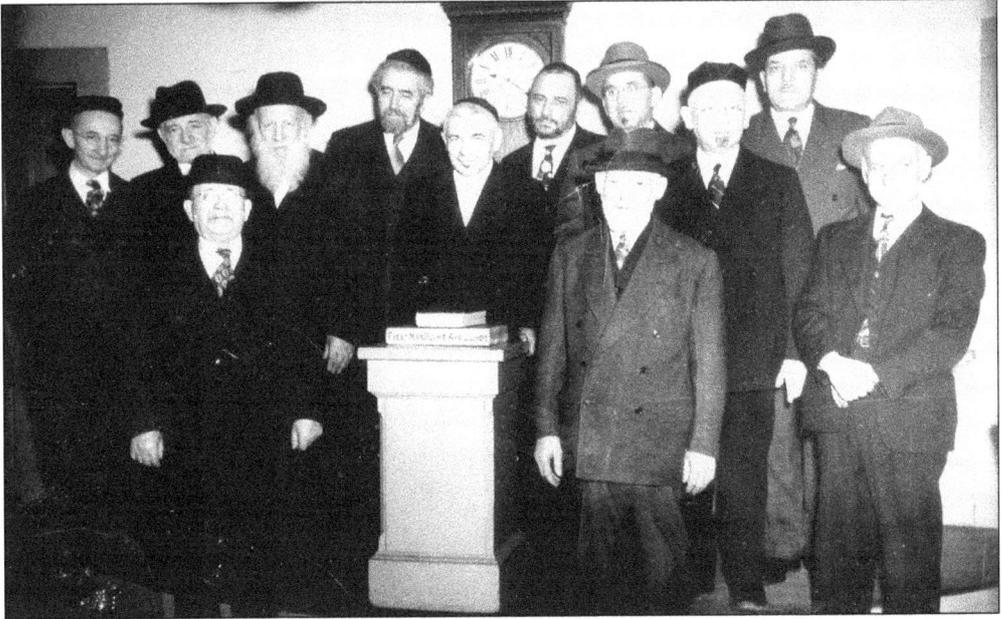

SCRANTON'S ORTHODOX RABBIS AND CHAZANS. Scranton's Orthodox rabbis and chazans are gathered in this photograph from the 1940s. From left to right are the following: (first row) two unidentified men and Don Shapiro (far right); (second row) Chazan Nadler, Ohav Zedek; Rabbi Jacob Glassman, B'Nai Israel; Rabbi Gottesman; unidentified; Rabbi Henry Yitzak Guterman, chief rabbi of Scranton; Chazan Horowitz, Machzikeh Hadas; Chazan David, Penn Avenue; Chazan Koerner, Linden Street; and Chazan Birnbaum, B'Nai Israel. (Courtesy of Syvia Eisenberg.)

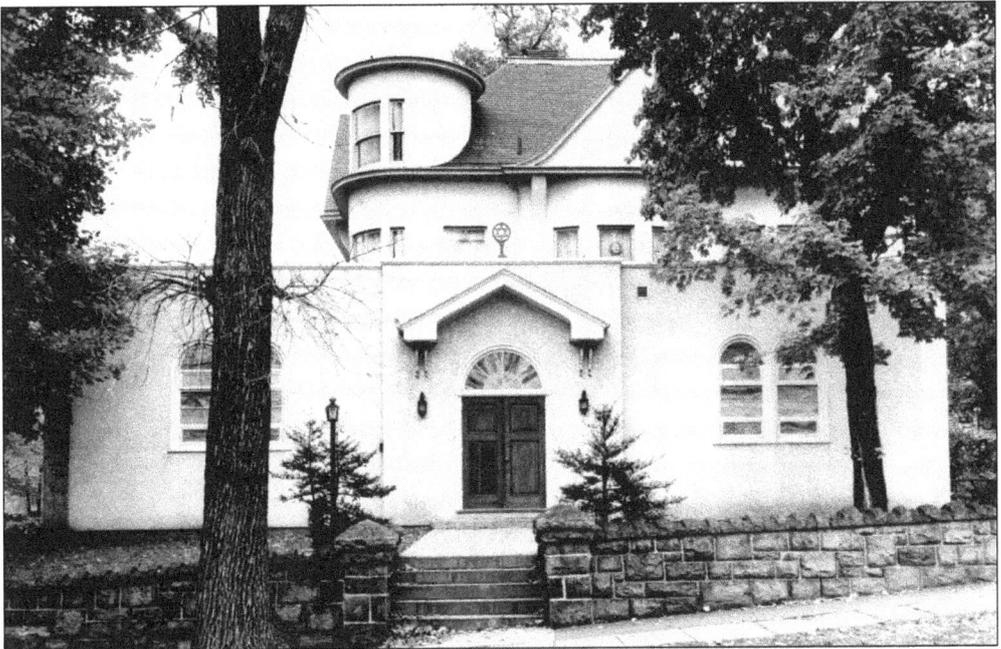

THE PENN MONROE SHUL. This shul, located at Monroe and Olive Streets, was renamed the Rabbi Guterman Shul when the beloved chief rabbi died in 1966. (Courtesy of Alan Firestone.)

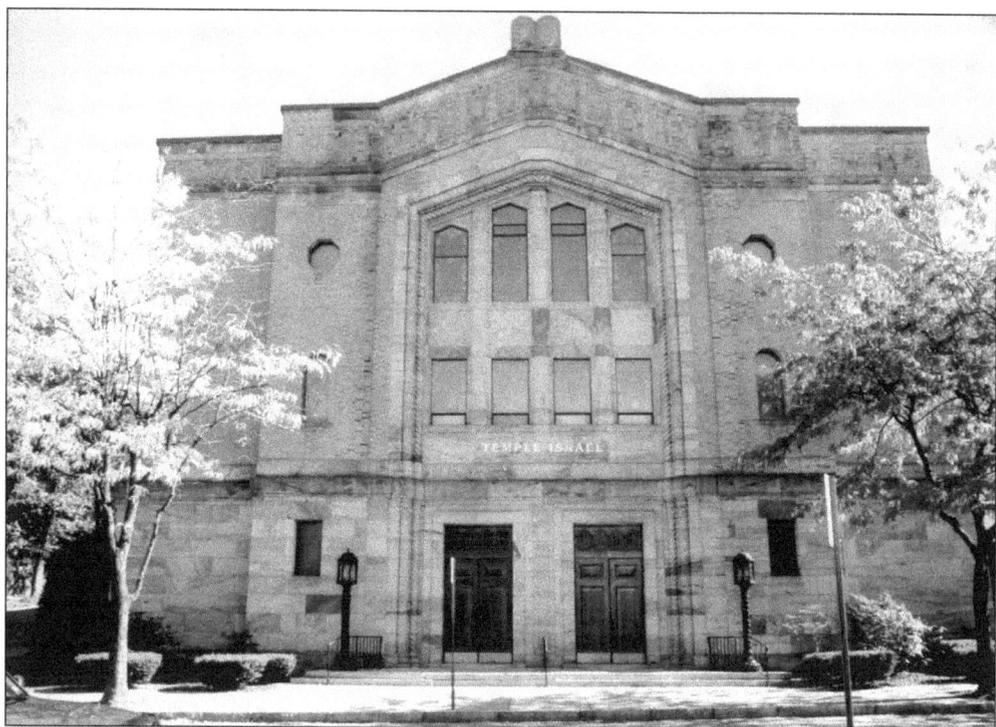

TEMPLE ISRAEL. Temple Israel of Scranton was founded in 1921. Two of the founding members were M. L. Goodman and H. R. Halprin. The congregation moved into this building, on the corner of Monroe and Gibson Streets, in 1926. (Courtesy of Alan Firestone.)

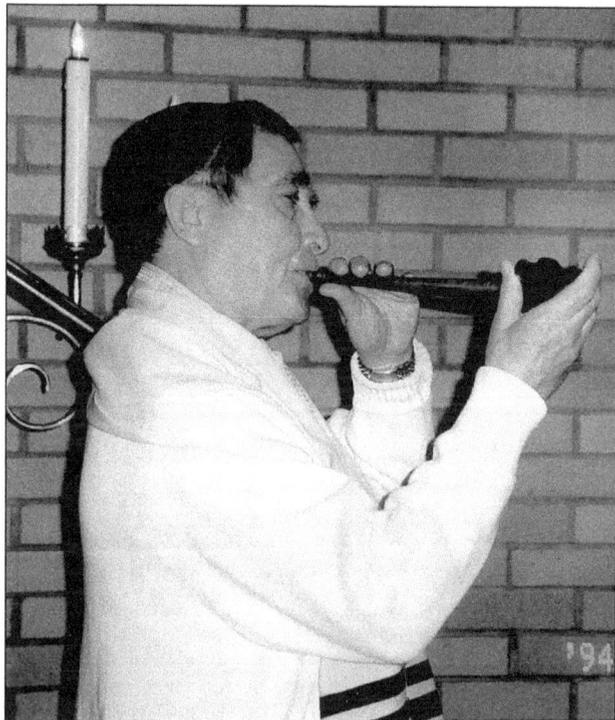

JOE HODIN BLOWING THE SHOFAR. Joe Hodin is shown blowing the shofar, the traditional ram's horn that proclaims freedom, at Temple Israel in 1994. (Courtesy of the Hodin family.)

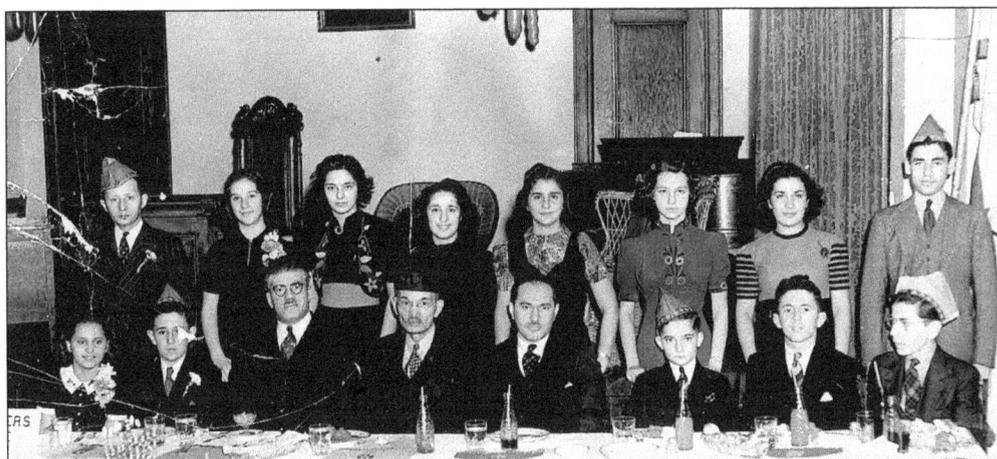

A TEMPLE ISRAEL DINNER. This dinner was held at Temple Israel in the 1940s. H. R. Halprin, one of the congregation's founding members, is seated fourth from the left. (Courtesy of Temple Israel.)

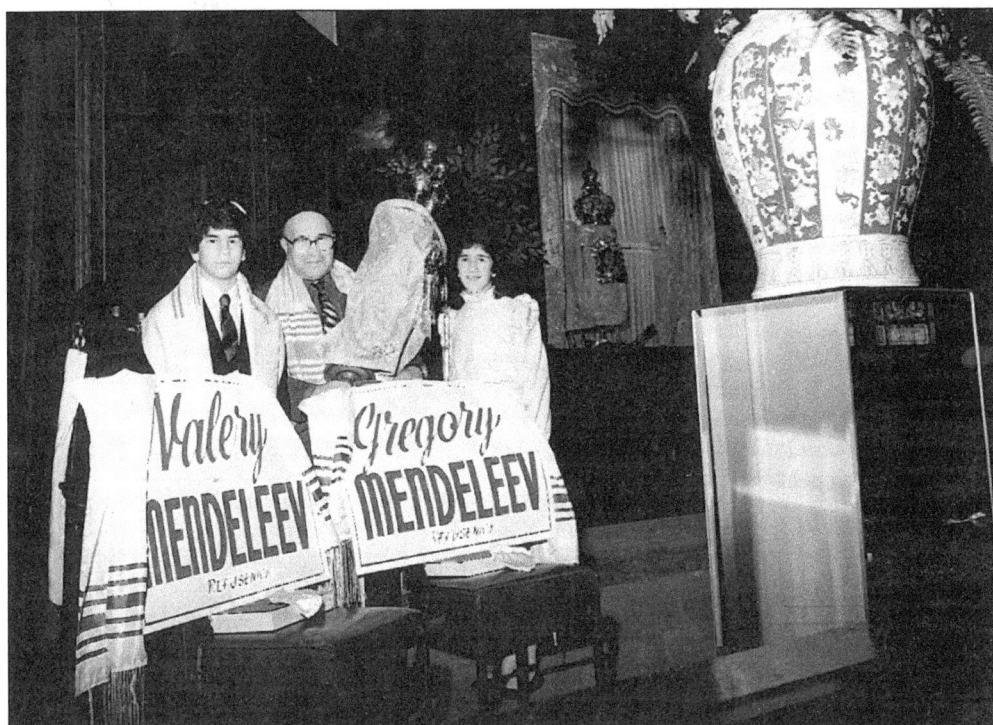

THE TWINNING OF THE TWINS. The Bernstein twins—Marc (left) and Dori—celebrated their b'nai mitzvah at Temple Israel in 1983. They celebrated with Russian twins in absentia who, because of Russian laws, were unable to practice this beautiful rite of passage. Also participating in the celebration is David Gladstein (center), a man who had come to live in Scranton after emigrating from the Soviet Union. (Courtesy of the Bernstein family.)

THE JUNIOR CONGREGATION OF TEMPLE ISRAEL. In 1938, the classes in the Junior Congregation

of Temple Israel were active and thriving. (Courtesy of Temple Israel.)

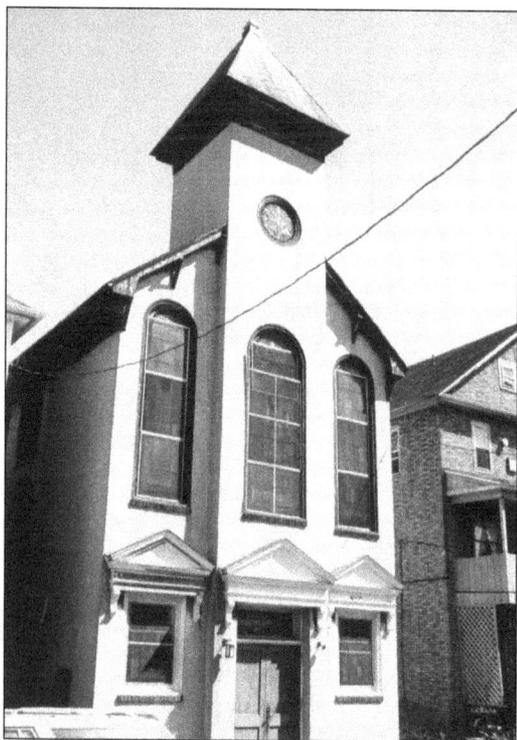

BICHOR CHOLIM OF OLYPHANT. In 1900, this Willow Street congregation (founded c. 1890) had the largest synagogue membership in the county. (Courtesy of Alan Firestone.)

AN OLYPHANT SYNAGOGUE SISTERHOOD PURIM PARTY. The Olyphant Synagogue Sisterhood held this Purim party in 1949. The members seen here are, from left to right, as follows: (first row) Elka Goldberg and Sylvia Spatt; (second row) Sylvia Mandel, Ruth Richter (rabbi's wife), Bea Glazier, Evelyn Baldinger, and Helen Pinkus. (Courtesy of Helen Pinkus.)

OHAV ZEDEK. This congregation, which originally started above an ice-cream parlor, bought this building in 1938 from the Holy Rollers Society. (Courtesy of Alan Firestone.)

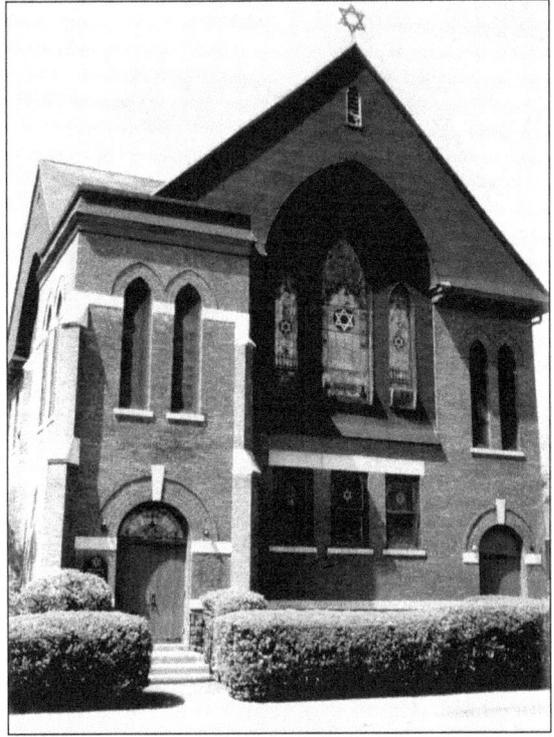

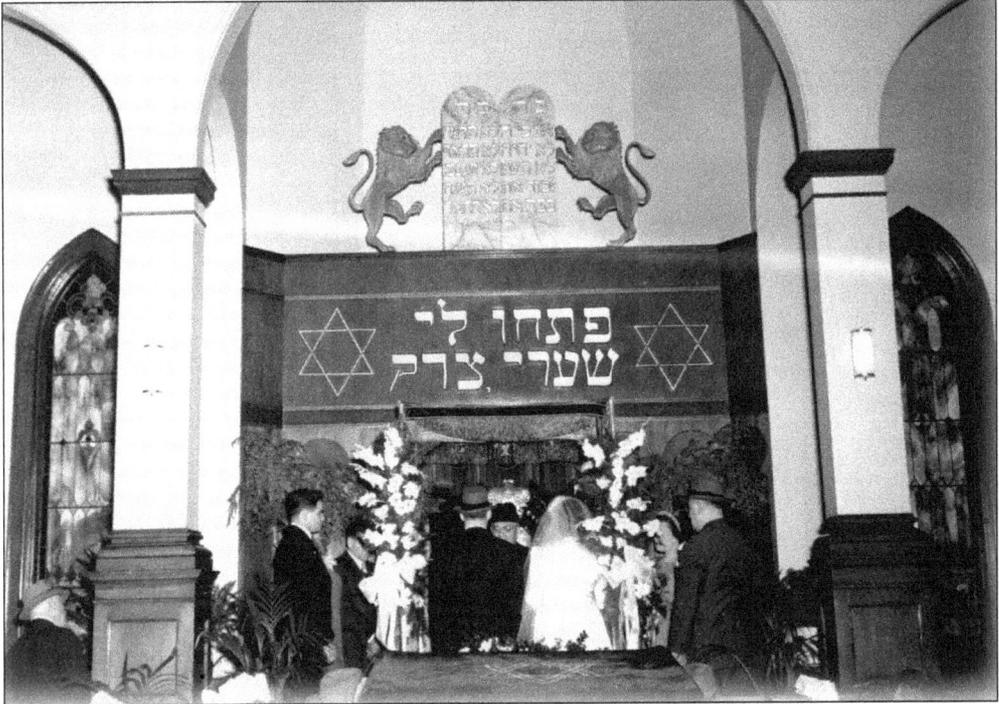

THE FIRESTONE WEDDING, OHAV ZEDEK. The main sanctuary of Ohav Zedek was the setting for the marriage of Ruth and Solomon Firestone. Rabbi Henry Guterman, chief rabbi of Scranton, performed the ceremony on February 20, 1949. (Courtesy of Alan Firestone.)

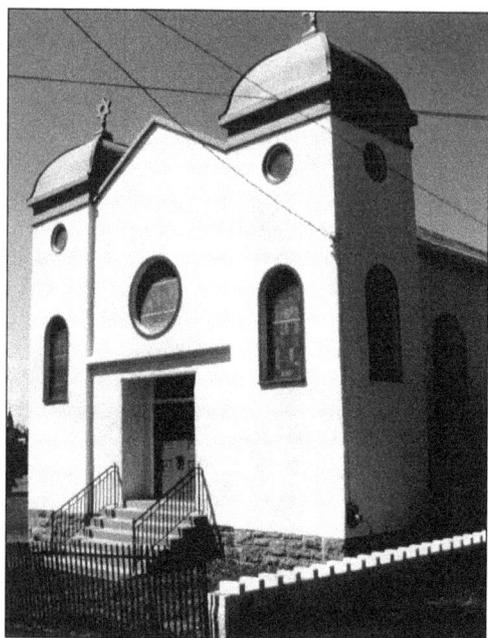

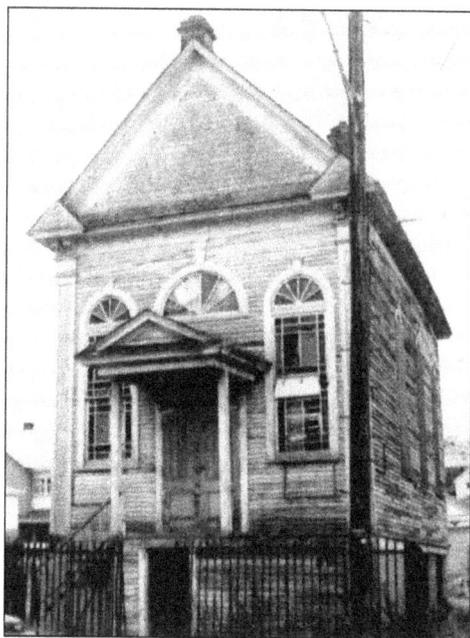

LEFT: TEMPLE OF ISRAEL OF DUNMORE. Founded in 1924, this is the oldest continuous Orthodox shul to practice in the same Lackawanna County location. Isadore Steckel has served as president since 1948. (Courtesy of Alan Firestone.) RIGHT: B'NAI ISRAEL OF JESSUP. Small congregations such as B'nai Israel ran "up and down the line," following the path of the Lackawanna Railroad. (Courtesy of Alan Firestone.)

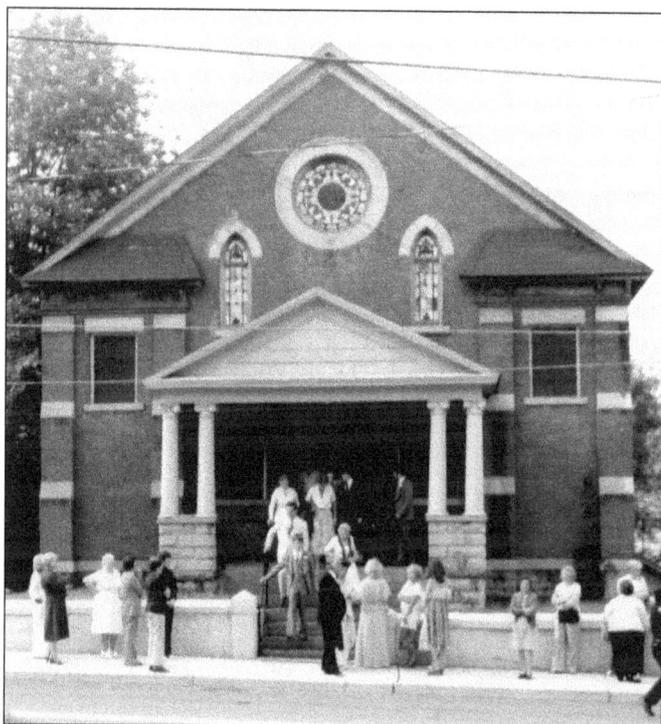

CONGREGATION AGUDATH SHALOM. Located on Pike Street in Carbondale, this congregation was founded in the 1890s. When the synagogue closed, its cornerstone was moved to the cemetery on Route 6. (Courtesy of Alan Firestone.)

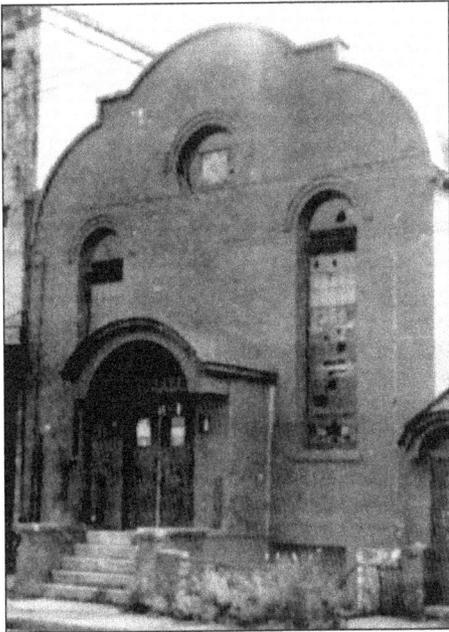

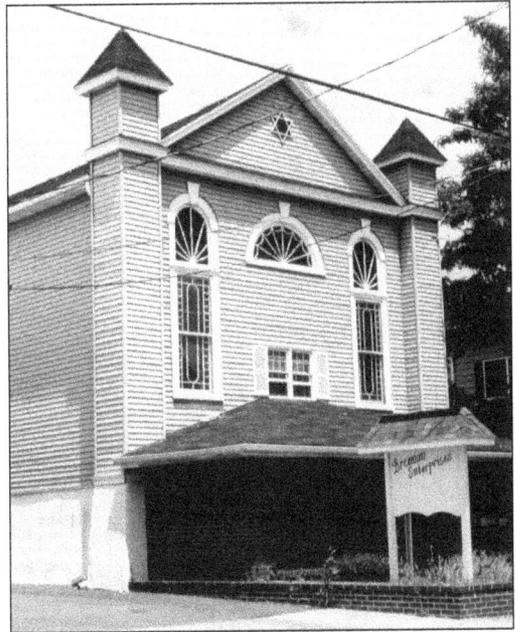

LEFT: ANSHE SFARD. This synagogue in the Flats section of Scranton was founded *c.* 1892 and was later absorbed by B'nai Israel. (Courtesy of Alan Firestone.) RIGHT: OHAV SHALOM OF DICKSON CITY. This Orthodox congregation was located in Dickson City. (Courtesy of Alan Firestone.)

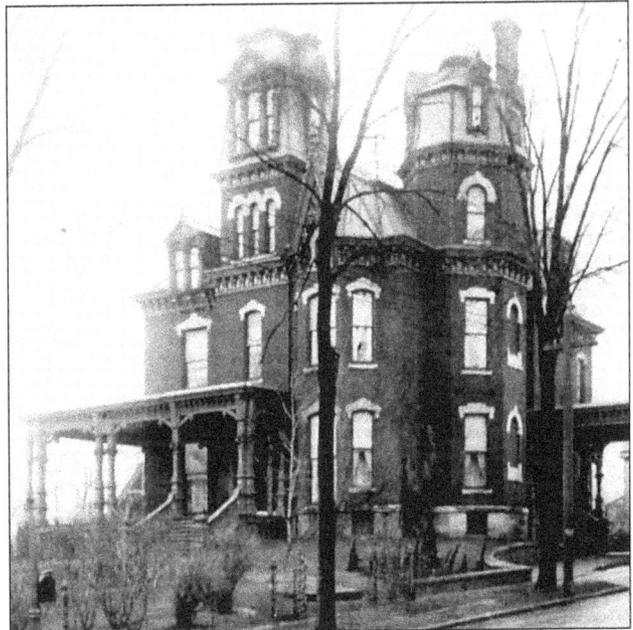

THE RED SHUL. This former mansion of the George Scranton family became the first home of Machzikeh Hadas in 1924. (Courtesy of Alan Firestone.)

LOUIS WOLF. Louis Wolf was the stern but beloved educator at Temple Israel for many years. (Courtesy of Shirley Hollenberg.)

HARRY KAPLAN AND HARRY MOSKOWITZ AT AHAVAS ACHUM. Ahavas Achum (Sefardishe Shul) Synagogue was located in the Flats section of Scranton. Harry Kaplan (left) and Harry Moskowitz are pictured there in 1953. (Courtesy of Ed Kaplan.)

Two

Community
Organizations

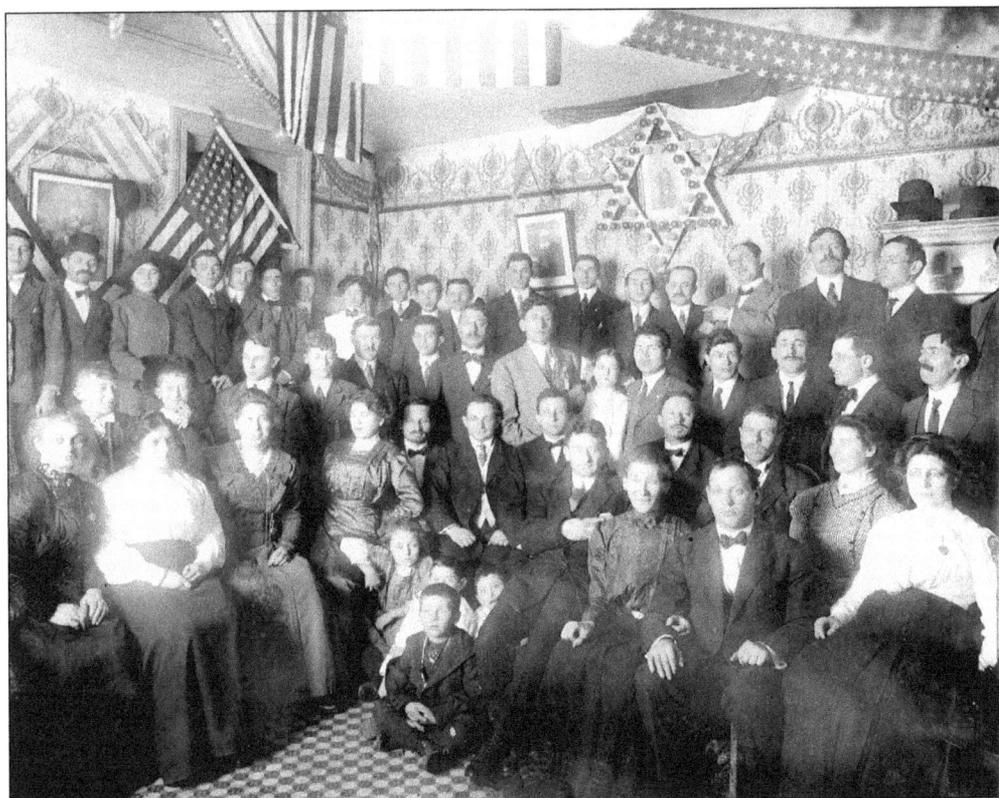

A YMHA Group with Star of David Decoration. Henry Levine (seated at center, behind the children) and Lena Levine (seated far right) were present at this gathering of the Young Men's Hebrew Association (YMHA) in the early 20th century. (Courtesy of Rachel Weisberger.)

FOR THE BETTERMENT OF HUMANITY

January 26th to February 11th

A HOME IN FIFTEEN DAYS

for the

Young Men's Hebrew Association

of Scranton, Pa.

CAMPAIGN HEADQUARTERS : Y. M. H. A. ROOMS, 322-324 ADAMS AVE.

"BE A BUILDER"

CAMPAIGN DIRECTORS
Samuel Samter
A. B. Cohen
David Landau

BUILDING COMMITTEE
Isadore Finklestein, Chairman
A. B. Cohen, Vice-Chairman
Charles Ball, Treasurer
Isaac Judkovics, Secretary
David Landau
Louis Grass
A. L. Schiller
Samuel Samter
Louis Oettinger
Oscar Kleeman
J. M. Temko
M. J. Finklestein

ADVISORY BOARD
Albert Kramer
Arthur Long
Leon M. Levy
I. Krotosky
B. Moses
Marcus Solomon
M. J. Cohen
Max Blume
J. M. Caplan
R. Solomon
S. Weinberg
Max Judkovics
Israel Ouslander
Sam Wertzberger
Max Kaplan
I. Greenberger
Dr. E. G. Roos
Meyer Kabatchnick
Simon Siegel
A. J. Levy
A. Newman
Rabbi I. Mortimer Bloom
Wolf Seidman
A. B. Brown, Pittston, Pa.
Hon. A. L. Sahm, Carbondale, Pa.

Scranton, Pa., January 22, 1914

Dear Friend:

We herewith enclose you a small prospectus, with reference to the Young Men's Hebrew Association of Scranton. It outlines, as you will observe, the need of a HOME for the Association, in order that it may accomplish its present objects and tells you something of what the Association has done in the past.

The prospectus contains data, which we believe you will find intensely interesting. Our Jewish citizens have agreed to bear the greatest part of the burden of this undertaking, and we ask the rest of our citizens to help as liberally in this movement for human betterment, as does the Jew in every commendable movement regardless of creed.

With the co-operation of the general public, our Association will be placed upon a basis of efficiency that will be a lasting benefit to our young men and to the public in general.

Representatives of our Committee will call upon you within the next few days, at which time we trust your response to the appeal on behalf of this worthy institution, will be prompt and liberal.

Sincerely yours,

SAMUEL SAMTER
A. B. COHEN
DAVID LANDAU
Campaign Directors

The Y. M. H. A. is a Mental, Moral, Physical and Social Elevator

THE YMHA'S "A HOME IN 15 DAYS" CAMPAIGN. The first meeting of the YMHA was held on September 28, 1909. As the membership grew, the "Home in 15 Days" campaign was started, and money was raised to build a new facility on Wyoming Avenue. The YMHA was a place where new immigrants could learn marketable skills, and it served as a home away from home for many of the young people of Scranton. The YMHA became the Jewish Community Center in the late 1950s and relocated to Jefferson Avenue. (Courtesy of the Jewish Community Center.)

THE PROGRAM FOR THE YMHA DEDICATION. This program documents the ceremonies for the 1915 dedication of the new YMHA building on Wyoming Avenue. (Courtesy of the Jewish Community Center.)

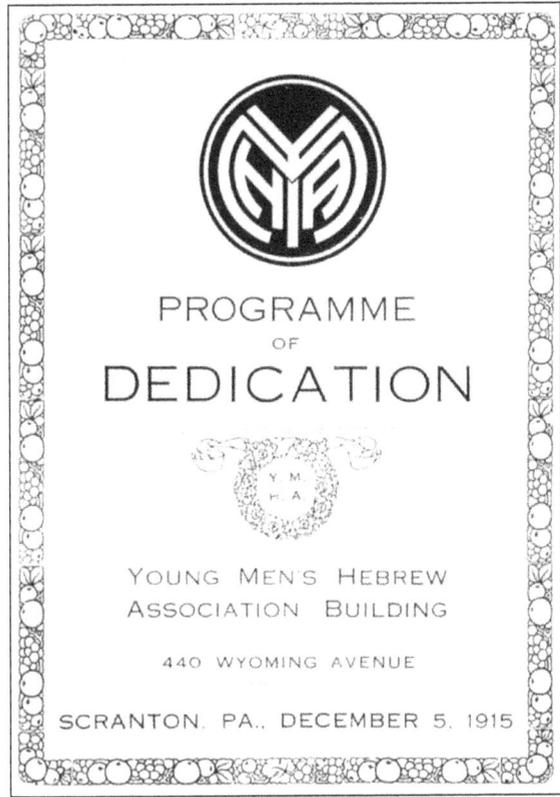

PROGRAMME
OF
DEDICATION

Y. M. H. A.

YOUNG MEN'S HEBREW
ASSOCIATION BUILDING

440 WYOMING AVENUE

SCRANTON, PA., DECEMBER 5, 1915

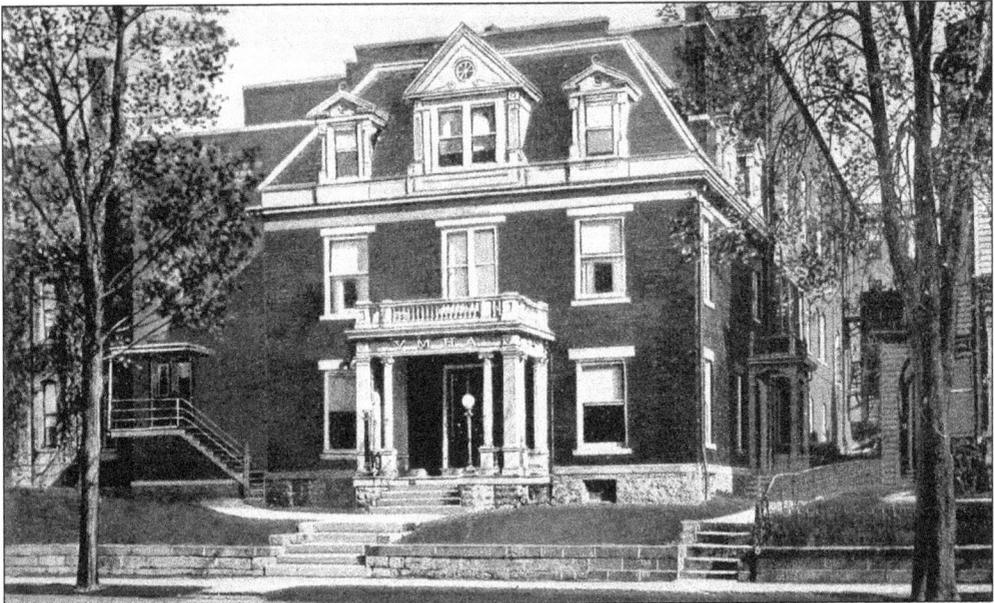

THE YMHA. The YMHA remained an active, vibrant agency for over 40 years. It was replaced by the Jewish Community Center in 1957. (Courtesy of Jack Hiddlestone.)

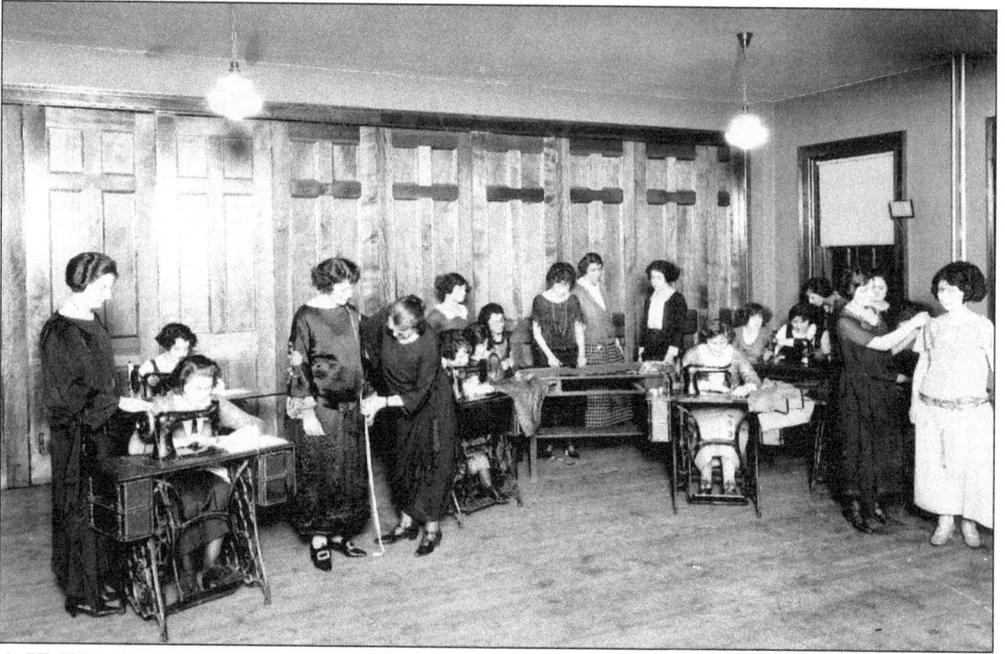

A YMHA WOMEN'S DRESSMAKING CLASS. One of the primary functions of the YMHA was to teach new immigrants employable skills. This photograph of a dressmaking class was taken in 1923. (Courtesy of the Jewish Community Center.)

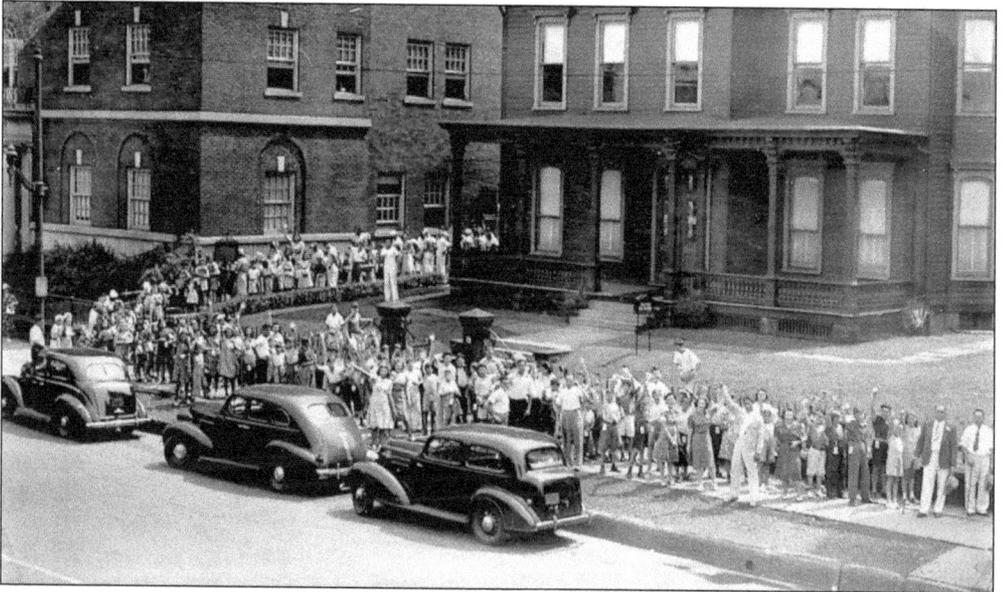

GALA DAY. This popular event (pictured in 1939) was celebrated annually by the YMHA. (Courtesy of the Jewish Community Center.)

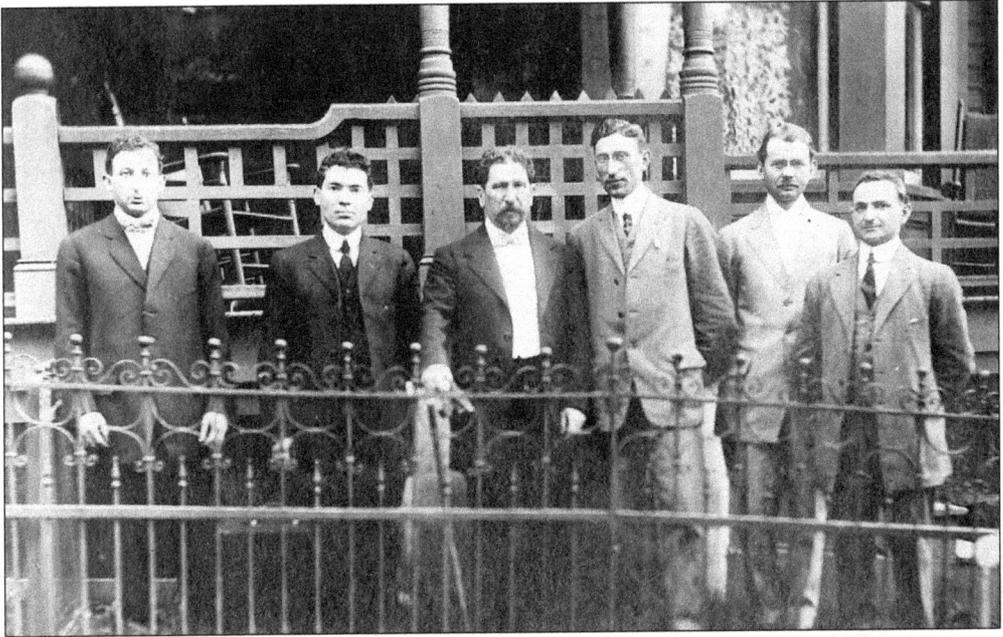

GREETING NAHUM SOKOLOW. Nahum Sokolow, a famous Zionist orator, visited Scranton in 1915 and 1922. Seen in this photograph are, from left to right, Max Kaplan, unidentified, Nahum Sokolow, Max Finklestein, Edward Weiss, and Henry Levine. (Courtesy of Rachel Weisberger.)

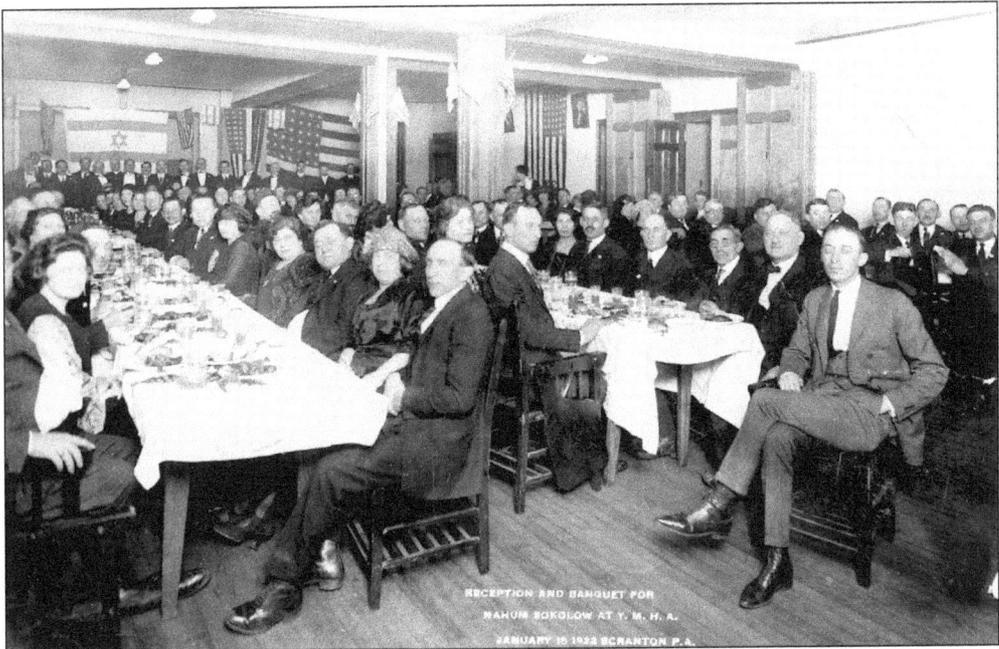

THE RECEPTION AND BANQUET FOR NAHUM SOKOLOW. The YMHA hosted a dinner for speaker Nahum Sokolow on January 18, 1922. (Courtesy of the Gruber family.)

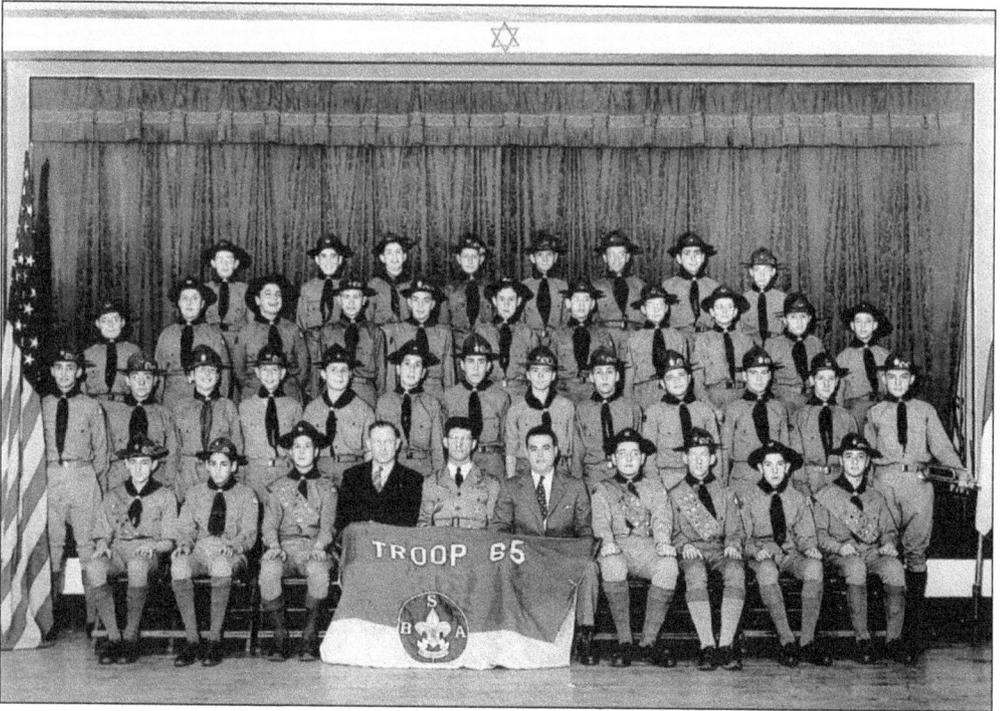

BOY SCOUT TROOP 65. Boy Scout Troop 65, pictured here in 1944, was sponsored through Temple Israel. (Courtesy of the Jewish Community Center.)

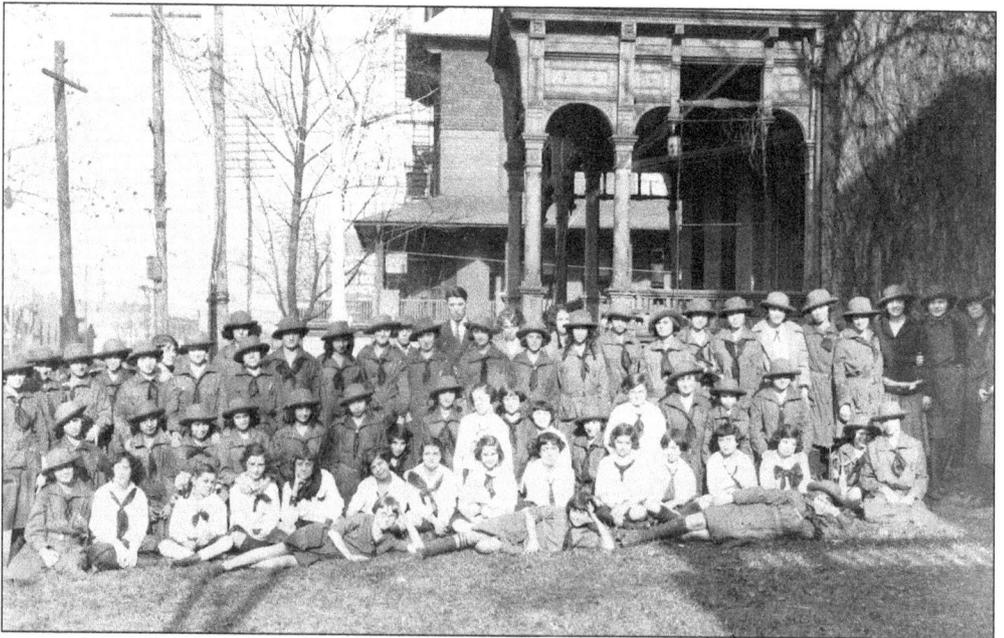

A YMHA GIRL SCOUT TROOP. This Scout troop is shown in 1917. (Courtesy of the Jewish Community Center.)

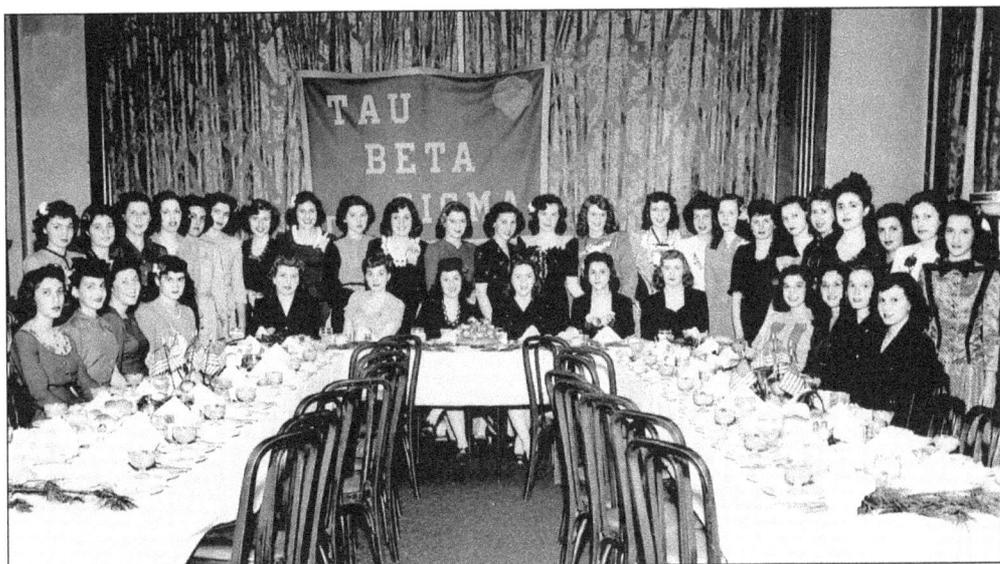

TAU BETA SIGMA SORORITY. The Tau Beta Sigma sorority, pictured here in 1943, was a popular organization for young women. (Courtesy of Malka Shapiro.)

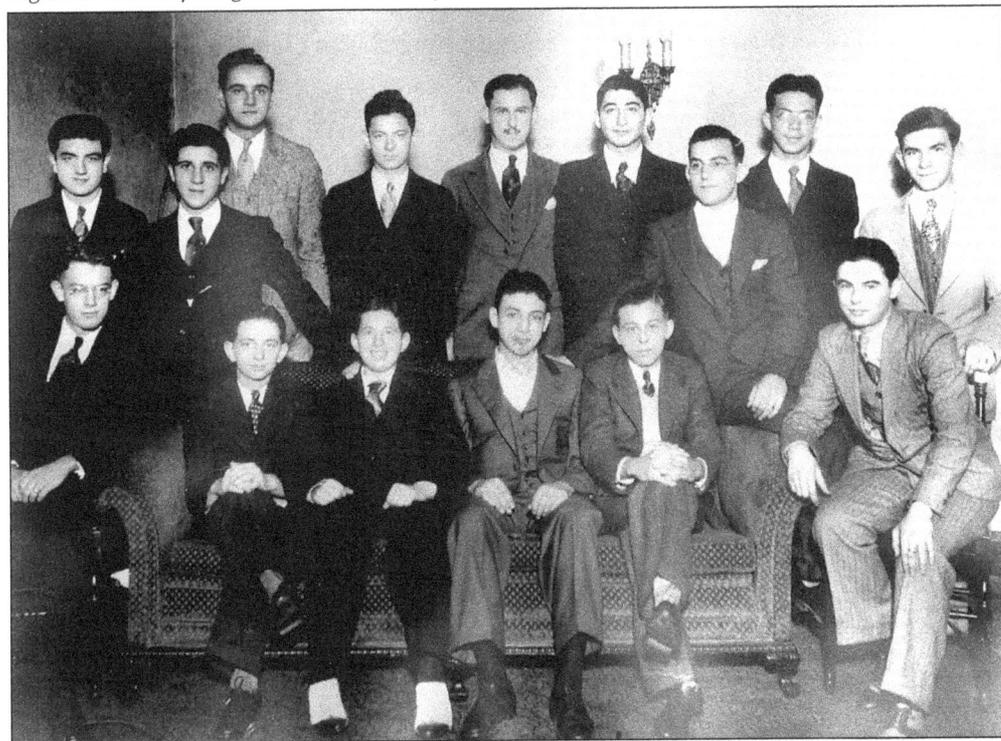

THE YMHA PALS CLUB. Organized in 1925, the Pals Club was a social group for young men. Club members pictured here are, from left to right, as follows: (first row) Joseph Eisenberg, Sam Zlatin, William Kaufman, Milton Frank, Seymour Weiss, and Ralph Winkler; (second row) Sam Plotkin, Louis Plotkin, and Abe Plotkin; (third row) Nate Frank, Israel Lulnick, Sidney Weiss (director of boys' activities), Joseph Levine, Joseph Wineburg, and Harold Pinkus. Irving Schwartz, the club's leader, is not pictured. (Courtesy of Syvia Eisenberg.)

35

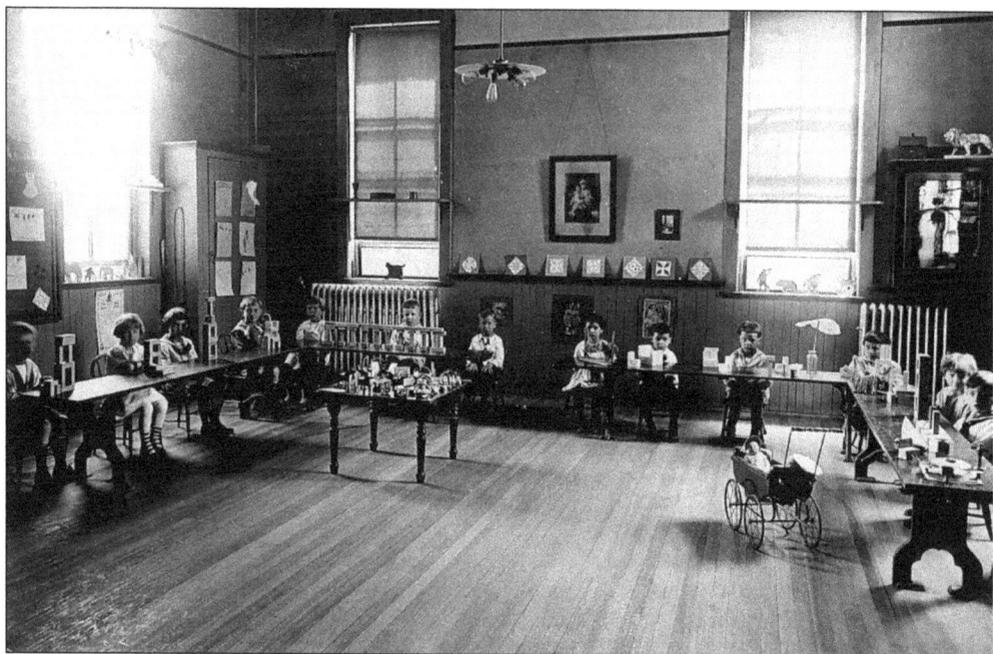

BAYARD TAYLOR ELEMENTARY SCHOOL. Pictured here is Richard Oppenheim's kindergarten class of 1921. (Courtesy of the Oppenheim family.)

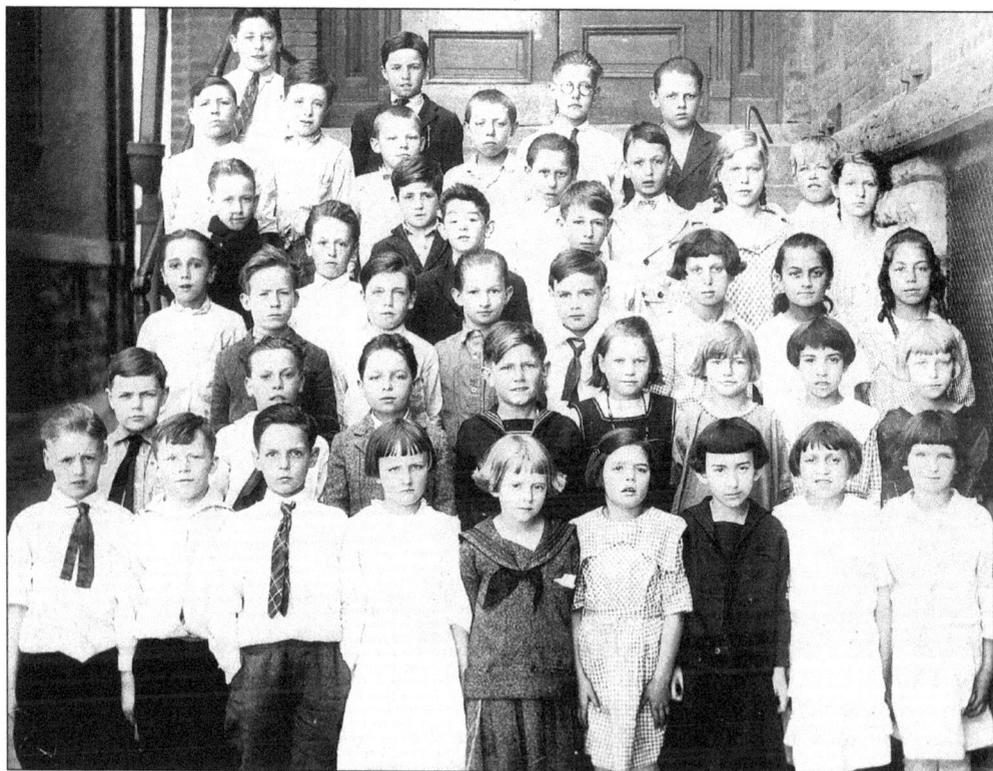

THOMAS JEFFERSON SCHOOL. Pictured with her classmates in 1922 is Bernice Cohen (in the first row, third from the right). (Courtesy of Faye Spatt.)

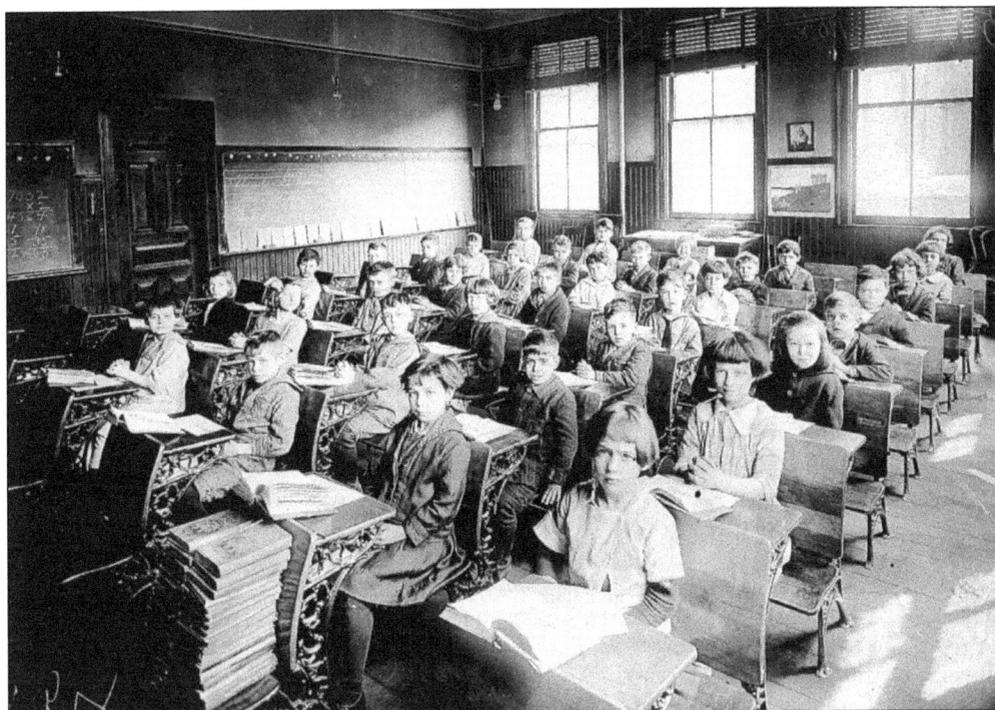

MADISON SCHOOL. Roz Gildar (seated at the first desk in the second row from the right) is shown with her classmates in the 1920s. (Courtesy of Nancy Weinberger.)

A HEBREW SCHOOL CLASS. Students are shown in a classroom at the YMHA in this 1920s photograph. (Courtesy of the Jewish Community Center.)

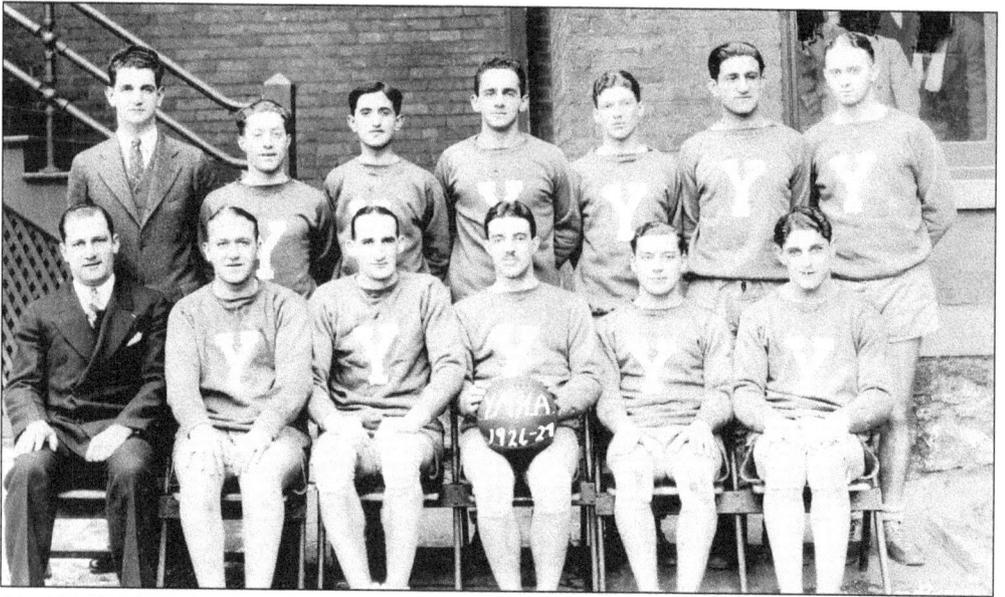

THE YMHA MEN'S BASKETBALL TEAM. The team for the 1926–1927 season includes, from left to right, the following: (first row) Sam Druck (coach), Bucky Dorfman, Sam Shair (executive director of the YMHA for 17 years), David Boginsky, Petey Rose, and George Levy; (second row) Irving Land (manager), Jack Cohen (substitute), David Miller, unidentified, Jack Mazess, Joe Falk, and Dr. Wolfgang (a dentist). (Courtesy of the Jewish Community Center.)

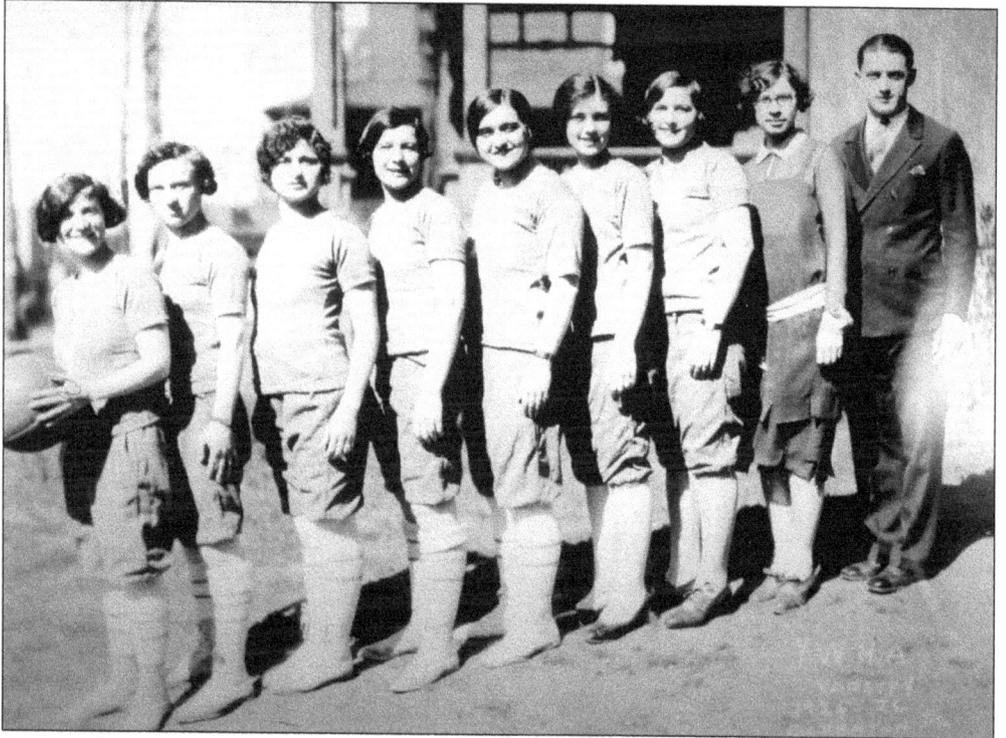

THE YMHA GIRLS' BASKETBALL TEAM. This photograph shows the team for the 1925–1926 season. (Courtesy of the Jewish Community Center.)

THE YMHA MEN'S BASEBALL TEAM. The men's baseball team is shown in 1922. Pictured clockwise from top right are Abe Wolfson, Jack Settler, Jack Riskin, Eddie Plottle, William Wolfgang, Sidney Leipman, Moe Alpert, and Monroe Brandywene. (Courtesy of the Jewish Community Center.)

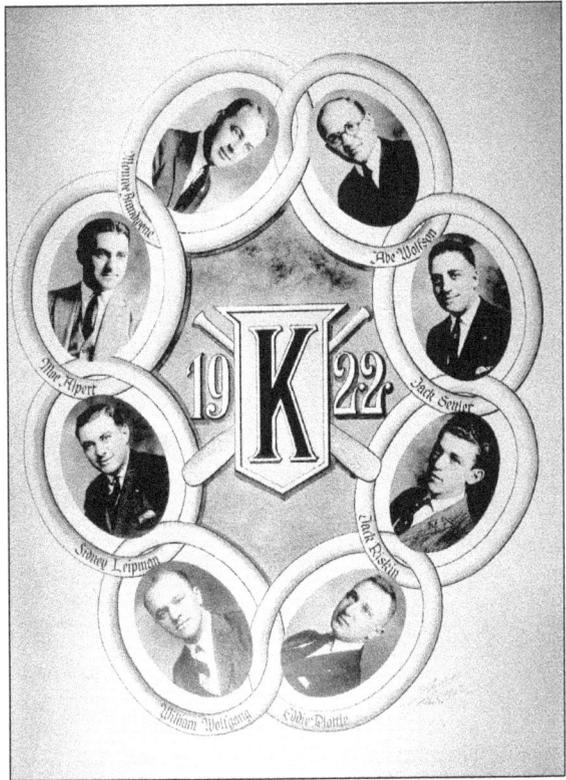

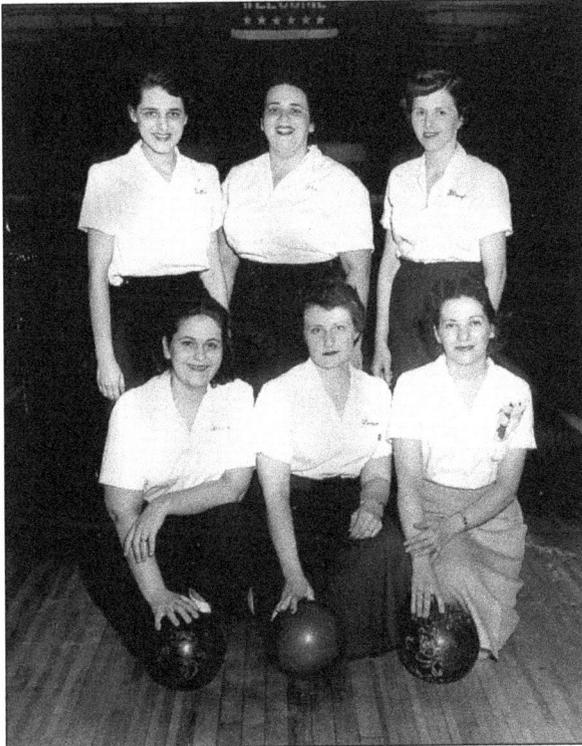

THE YMHA LADIES' BOWLING LEAGUE. Members of the bowling league are pictured in 1953. From left to right are the following: (first row) Irene Kessler, Lorraine Lefkowitz, and Ann Luger; (second row) Betty Schoenberger, Jean Weinberg, and Claire Rubinfeld Dubin. (Courtesy of the Jewish Community Center.)

MANNY GELB AT THE OLYMPIC TRIALS. Scranton boxer Manny Gelb (standing center) went to the Olympic trials in 1933. Although he did not find a place on the team, he was always a winner. The other three men here are not identified. (Courtesy of Natalie Solfanelli.)

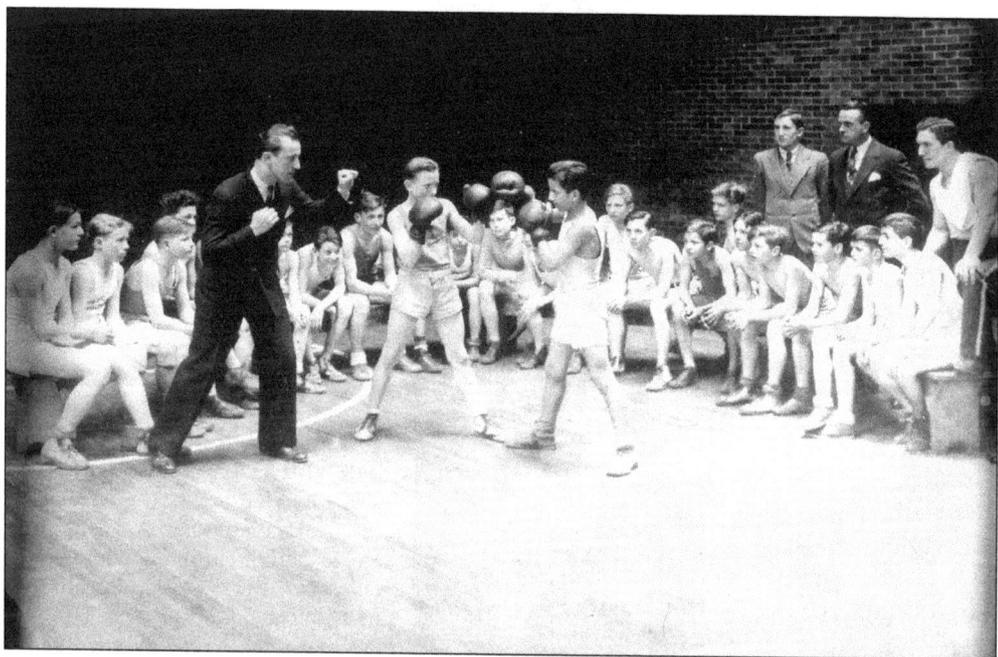

MANNY GELB'S SELF-DEFENSE CLASS. In this photograph from 1932, Manny Gelb teaches self-defense to Clarence "Fats" Robeson's junior high class, while Olympic prospect officials Jack Houlihan and Hoadley Hagen look on from the back. (Courtesy of Natalie Solfanelli.)

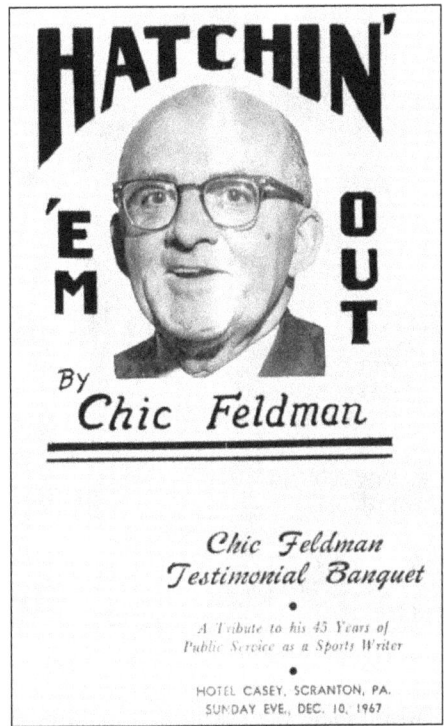

THE PROGRAM FOR THE CHIC FELDMAN TESTIMONIAL BANQUET. This banquet, held in 1967, was a tribute to Chic Feldman's 45 years of public service as a sportswriter. (Courtesy of Sara Morris.)

HATCHIN' 'EM OUT

By *Chic Feldman*

Chic Feldman Testimonial Banquet

•

A Tribute to his 45 Years of Public Service as a Sports Writer

•

HOTEL CASEY, SCRANTON, PA.
SUNDAY EVE., DEC. 10, 1967

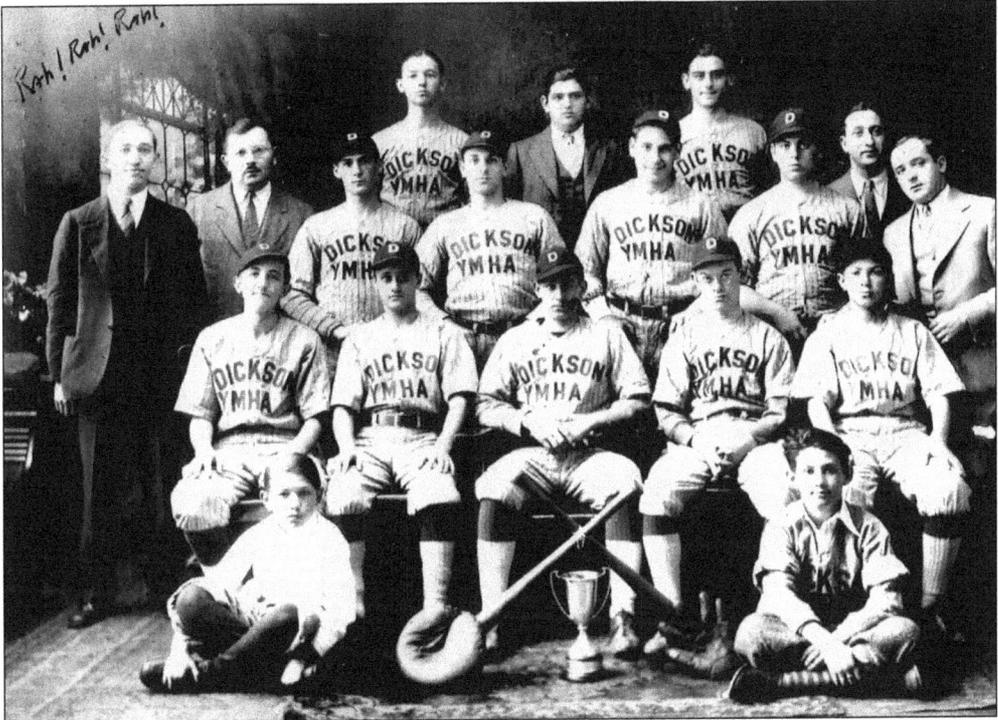

THE DICKSON CITY BASEBALL TEAM. Members of the Dickson City baseball team, including Joe Eisenberg (seated in uniform, second from right), are shown in the early 1900s. (Courtesy of Syvia Eisenberg.)

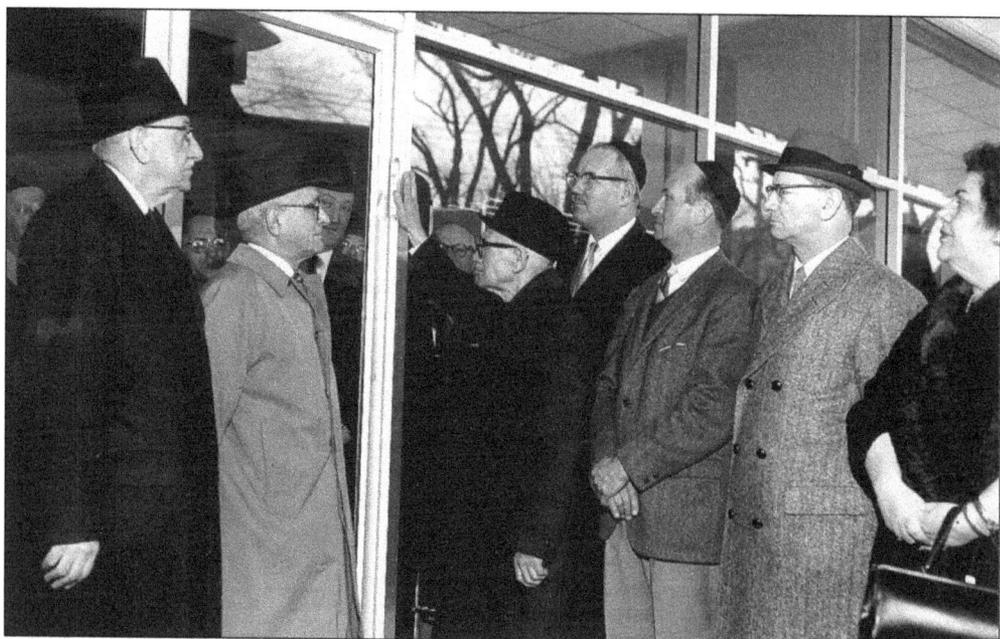

THE DEDICATION OF THE JEWISH HOME. Founded in 1915 as the Jewish Home for the Friendless, this institution served as an orphanage and as a home for the elderly. New facilities for the Jewish Home were dedicated in 1964. Rabbi Guterman is shown affixing a mezuzah to the building's door frame. (Courtesy of the Jewish Home.)

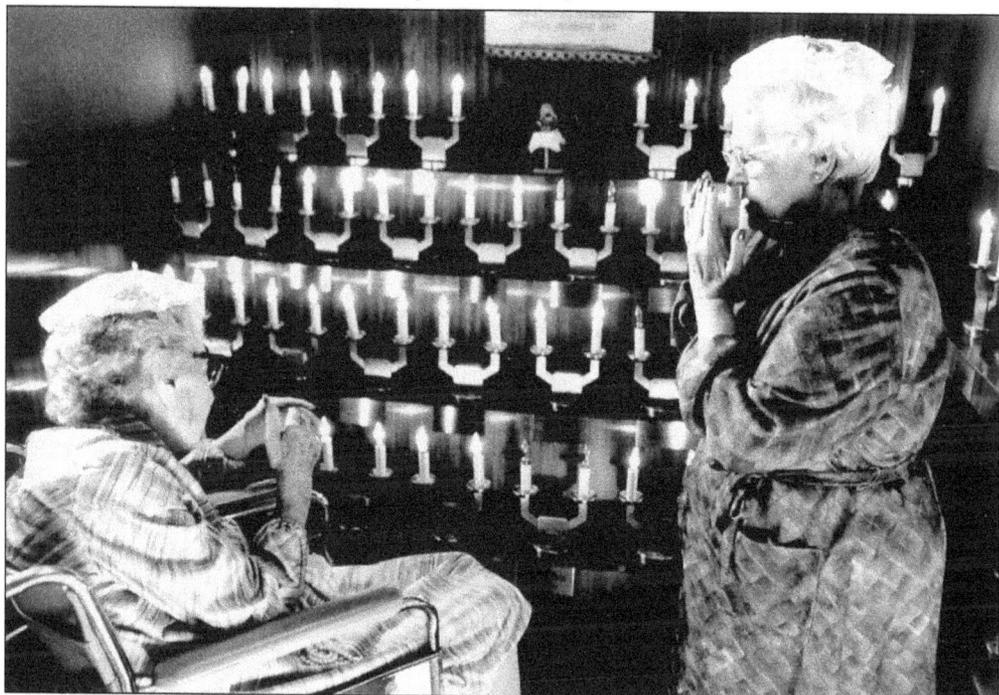

JEWISH HOME RESIDENTS BLESSING THE SABBATH CANDLES. During the late 20th century, many residents received physical and spiritual benefits from the services of the Jewish Home. (Courtesy of the Jewish Home.)

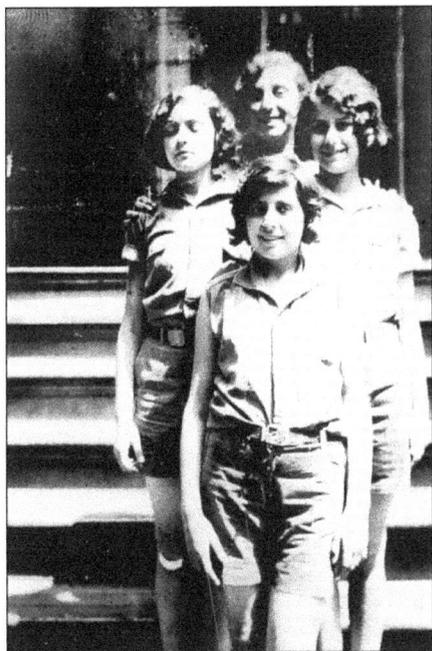

LEFT: CHILDREN WHO LIVED IN THE JEWISH HOME. Claire Eisner (back row, center) grew up in the home along with her two sisters in the 1930s. (Courtesy of Sara Eisner.) RIGHT: YOUNG RESIDENTS OF THE JEWISH HOME. The Jewish Home for the Friendless provided a homey and nurturing atmosphere for its residents. (Courtesy of Sara Eisner.)

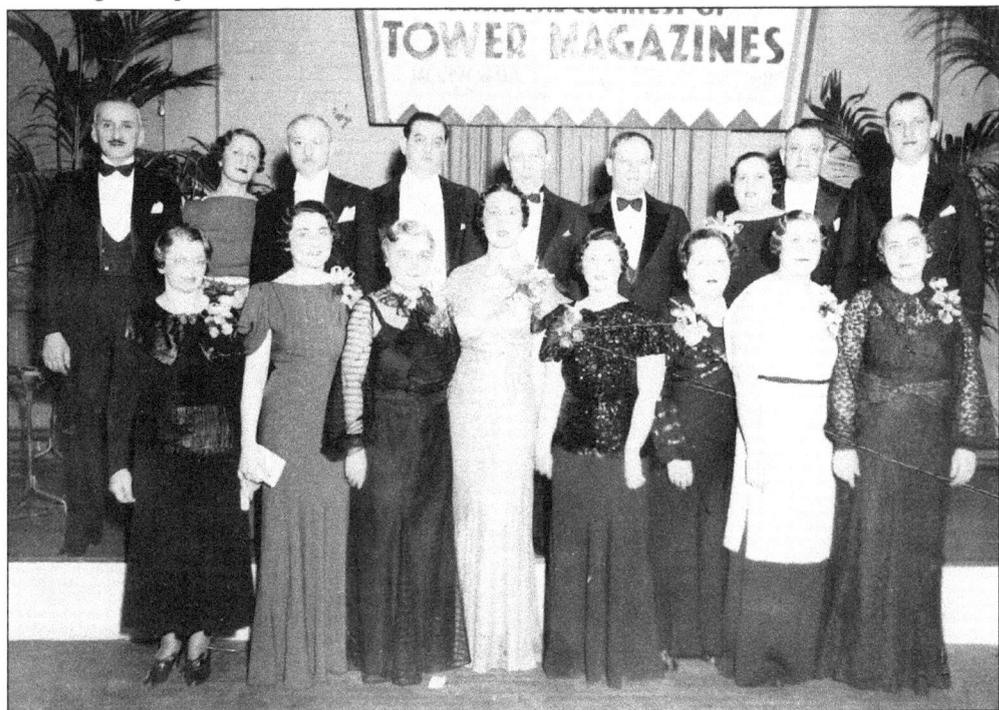

A JEWISH HOME FUNDRAISER. The Jewish Home held a formal ball each year to raise funds for this worthwhile institution. These guests are shown in 1935. (Courtesy of the Jewish Home.)

THE JEWISH COMMUNITY CENTER AND THE UNITED JEWISH APPEAL. Women played an important part in the annual Jewish campaign. Pauline Mack (top left) went on to become national president of Hadassah. (Courtesy of the Jewish Community Center.)

NATALIE GOODMAN BACHMAN. Elected in 1978 as the first woman president of the Scranton-Lackawanna Jewish Council, Natalie Goodman Bachman was a community leader for many years. (Courtesy of the Bachman family.)

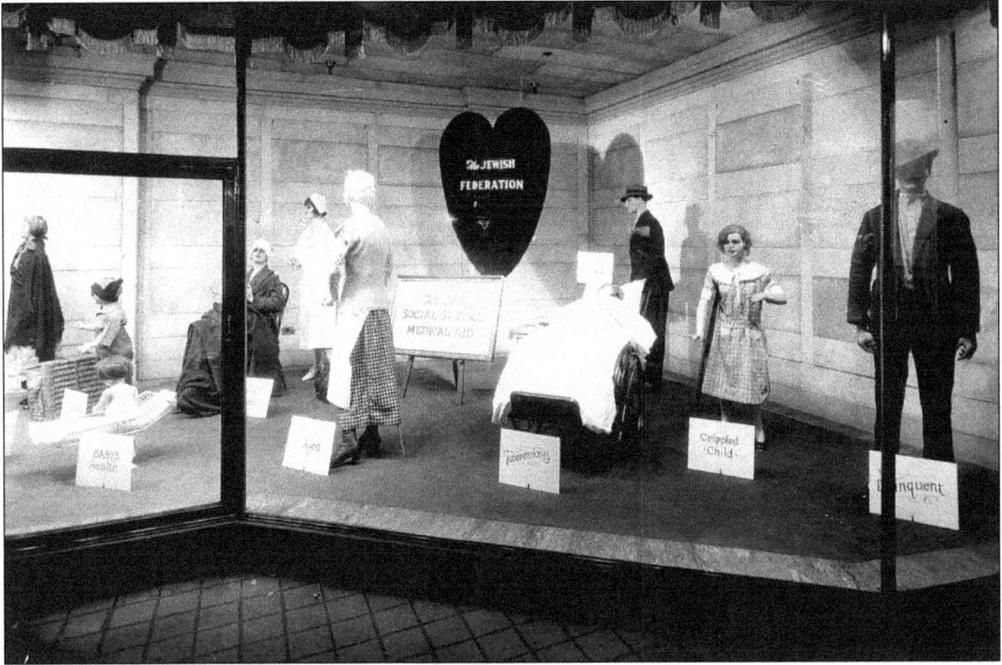

THE JEWISH FEDERATION. Organized in 1915, the Jewish Federation of Scranton provided a wide range of social services, as evidenced by this storefront display. The organization later became known as the Jewish Family Service. (Courtesy of the Jewish Family Service.)

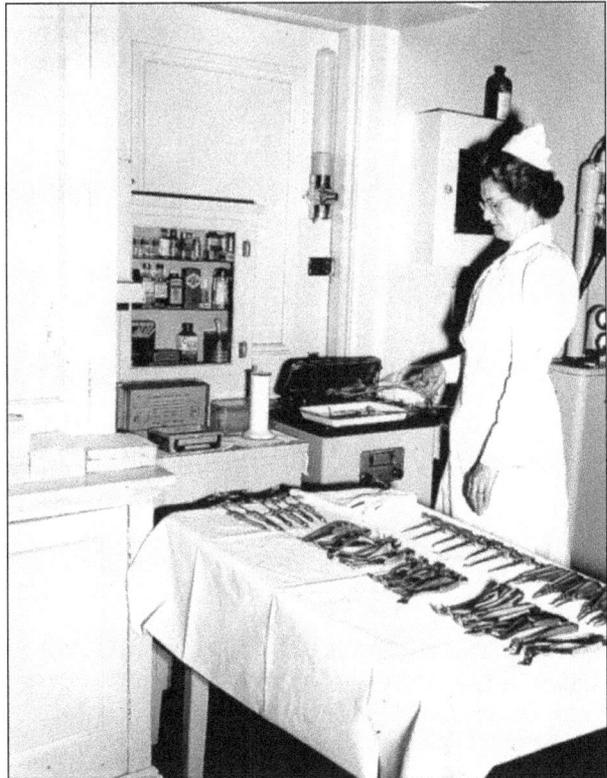

THE JEWISH FEDERATION DENTAL CLINIC. This free community clinic offered dental services to anyone in need. Local dentists provided pro bono dental care for these patients. (Courtesy of the Jewish Family Service.)

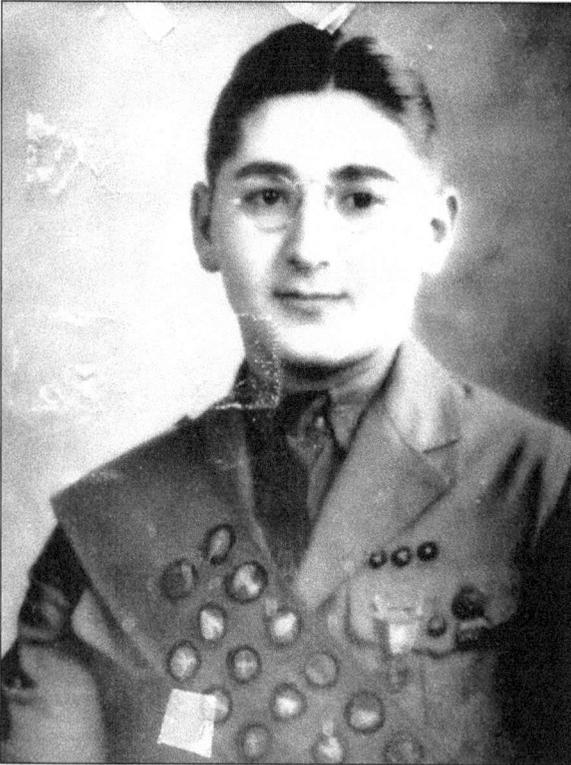

HERBERT BARTON. Herbert Barton was recognized in 1932 as the first Eagle Scout in Troop 65. At that time, Louis Wolf was Scout leader, Rabbi Max Artz was spiritual leader, and M. L. Goodman was president of Temple Israel. (Courtesy of Temple Israel.)

ARGUS. In 1947, the Greater YMHA Little Theatre Guild presented the play *Outward Bound.* (Courtesy of the Jewish Community Center.)

THE PLAYBILL FOR EAST LYNNE. *East Lynne* was performed by the YMHA Players in 1944. "Little" theater at the YMHA was an important part of the social scene in the Scranton Jewish community. (Courtesy of the Jewish Community Center.)

PLAYBILL

MASONIC TEMPLE

ENGAGEMENT EXTRAORDINARY

ONE PERFORMANCE ONLY

Wed. Eve., May 10th, 1944

DOOR OPEN 7:30 O'CLOCK FIRST CURTAIN AT 8:15 O'CLOCK SHARP

Following closely upon stupendous successes in London, Moscow, New York and other cities, where both the play and the players have been greeted at each performance with

UNRESTRAINED APPLAUSE

AND THE THEATRE WALLS HAVE RESOUNDED WITH

REPEATED SOUND OF APPROBATION

To all and sundry persons fortunate enough to secure tickets, the management has the honor to announce that, in response to popular demand

THE SCRANTON Y.M.H.A. PLAYERS

PROUDLY PRESENT

A GALA REVIVAL OF

EAST LYNNE

A THRILLING DRAMA OF LIFE IN THREE ACTS AND SIX SCENES
ADAPTED FROM THE NOVEL OF THAT NAME BY MRS. HENRY WOOD

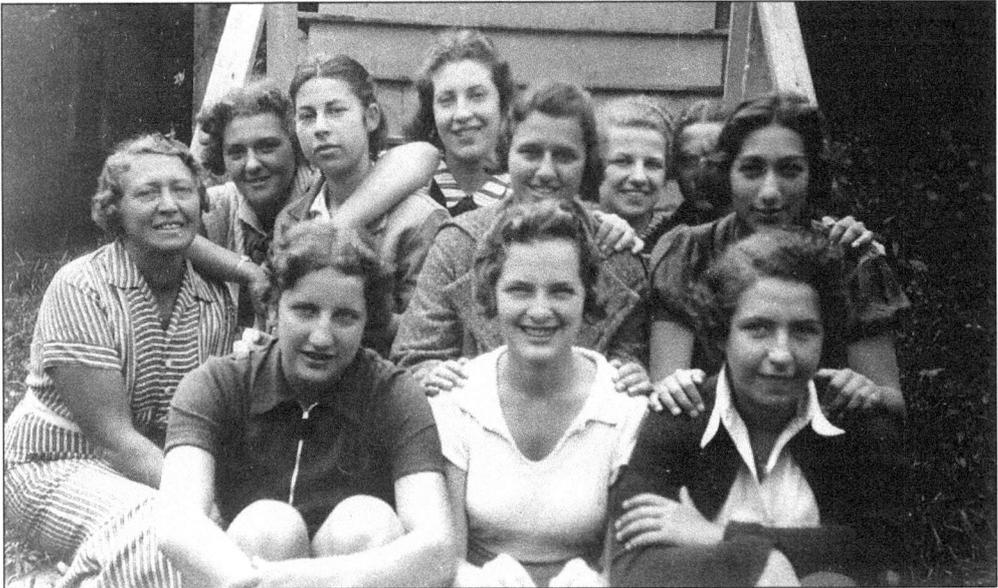

THE YOUNG LADIES' SOCIAL CLUB. This Jewish social group took a cottage at Harvey's Lake for two weeks in the summer of 1935. Pictured are, from left to right, the following: (first row) Hilda Gross, Ruth Elfenbein (Dickstein), and Bernice Joseph; (second row) Bea Joseph, Bea Levine, Elsa Feigenbaum (Laster), and Audrey Grossinger; (third row) Marion Fish (Nogi), Rachel Levine (Weisberger), Lillian Futeronsky (Stauss), and Miriam Dickstein (Schiowitz). (Courtesy of Rachel Weisberger.)

47

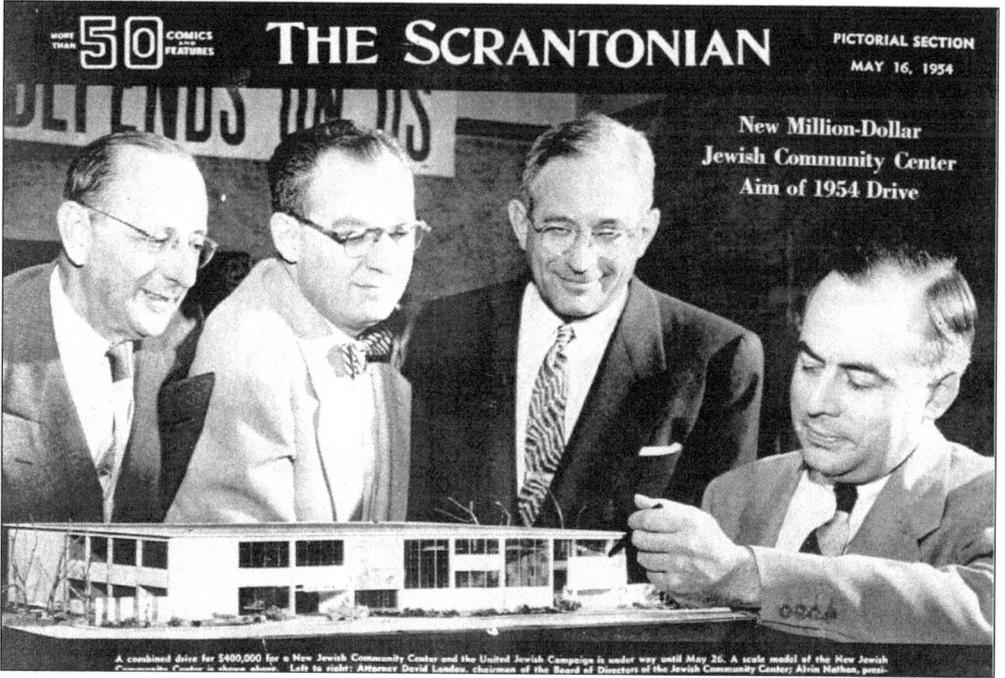

New Million-Dollar Jewish Community Center Aim of 1954 Drive

A combined drive for $400,000 for a New Jewish Community Center and the United Jewish Campaign is under way until May 26. A scale model of the New Jewish Community Center is shown above. Left to right: Attorney David Landau, chairman of the Board of Directors of the Jewish Community Center; Alvin Nathan, presi-

A DRIVE FOR THE JEWISH COMMUNITY CENTER BUILDING. Plans for a new Jewish Community Center were developed in 1954. Pictured here with a model of the facility are, from left to right, attorney David Landau, Alvin Nathan, Irving Harris, and Ellis Oppenheim. (Courtesy of the Jewish Community Center.)

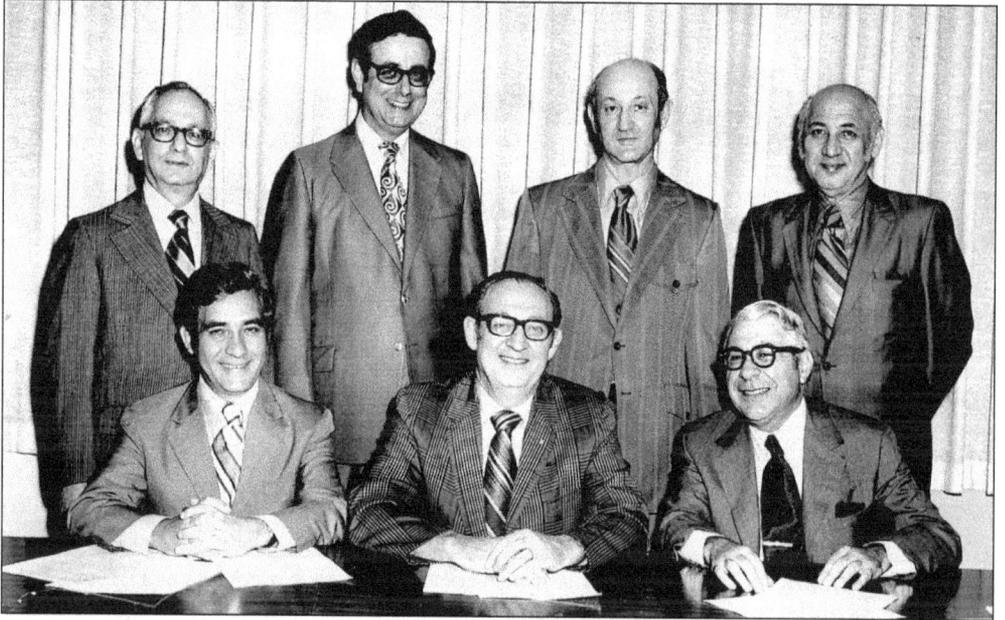

THE JEWISH COMMUNITY CENTER AND UNITED JEWISH APPEAL. This committee for the Jewish Community Center and the United Jewish Appeal includes, from left to right, the following: (first row) Joseph Hodin, Alvin Nathan, and Rabbi Simon Shoop; (second row) George Joel, Aaron Glassman, Bert Mushkin, and Julius Weinberger. (Courtesy of Melba Nathan.)

MATZOH BALL

Music By
HOWARD MILLER
and his Orchestra

J. C. C. AUDITORIUM
SATURDAY, APRIL 20, 1957
Dancing 10 Till ?

Admission $3.00 Per Couple (Tax Incl.)

A "MATZOH BALL" TICKET. The Matzoh Ball, held in 1957 at the Jewish Community Center, was one of the first social events held in the new building. (Courtesy of the Jewish Community Center.)

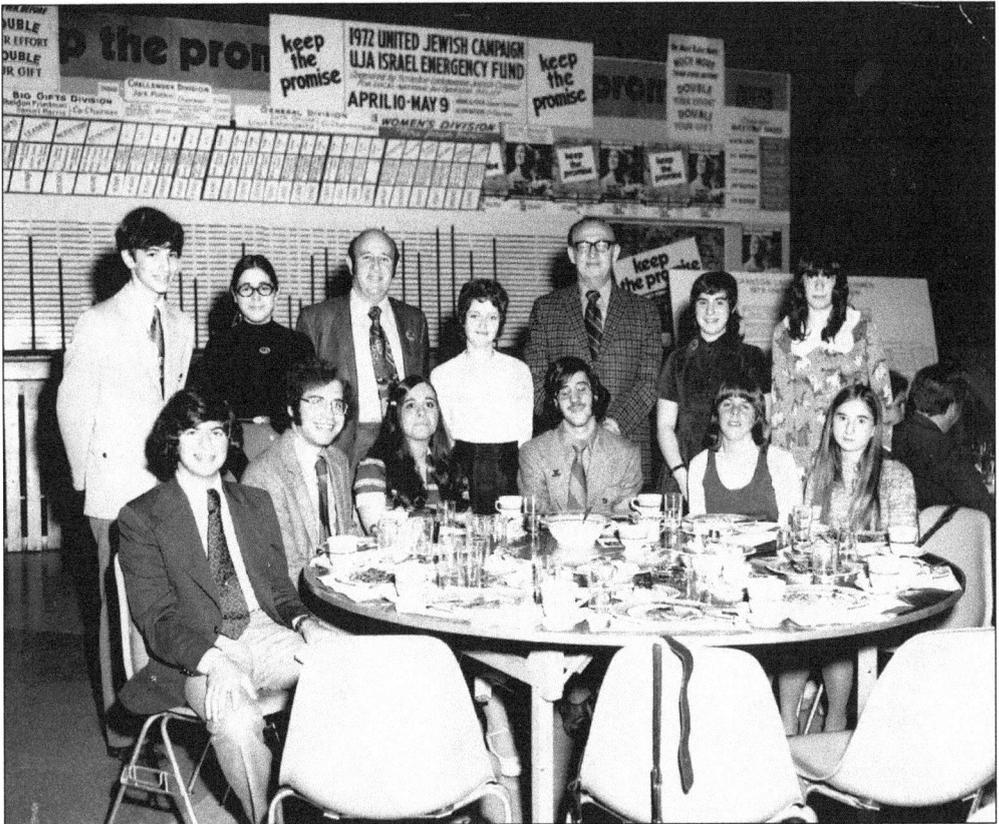

THE UNITED JEWISH APPEAL, YOUTH DIVISION. In 1972, these young people served as volunteers for the annual United Jewish Appeal. (Courtesy of Melba Nathan.)

49

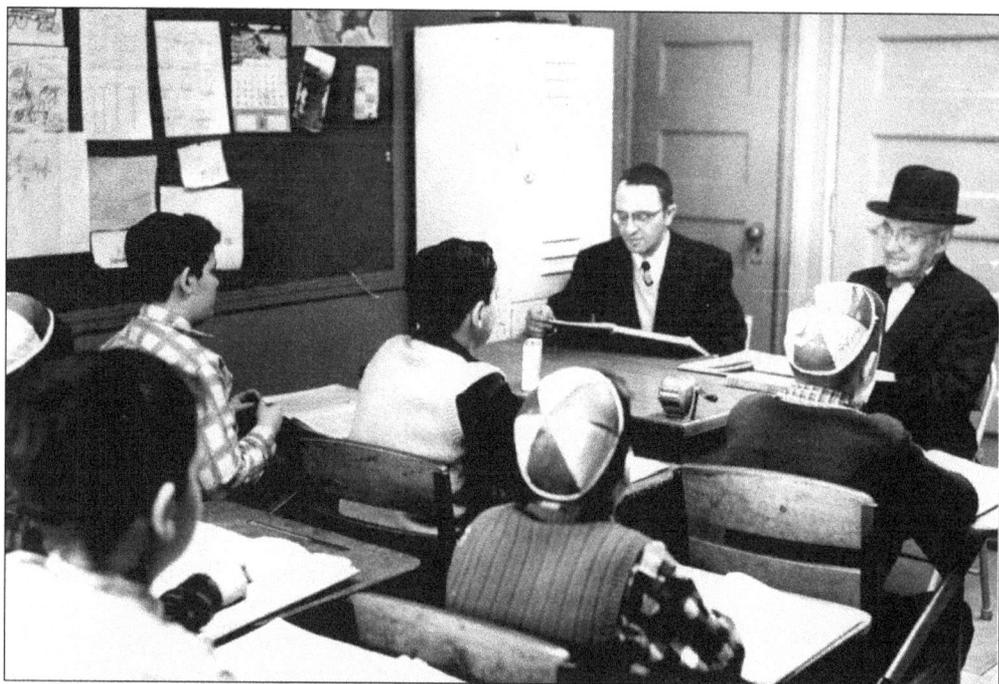

THE SCRANTON HEBREW DAY SCHOOL. The Scranton Hebrew Day School was founded in 1948. Dr. Louis Nulman (back left) conducts this class while Rabbi Henry Guterman looks on. (Courtesy of the Scranton Hebrew Day School.)

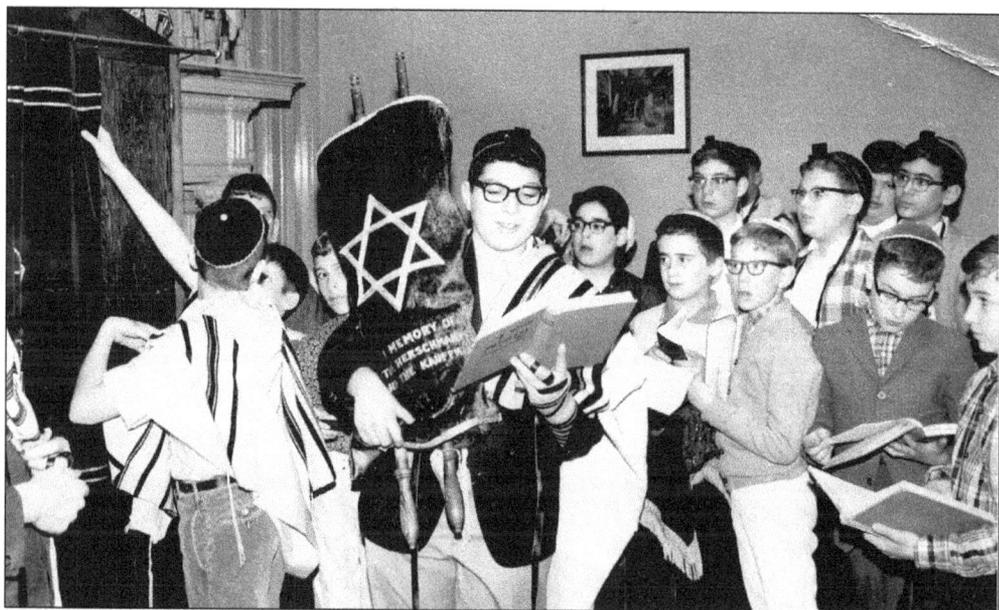

SCRANTON HEBREW DAY SCHOOL STUDENTS. The boys shown in this 1960s photograph are davening with the Torah. (Courtesy of the Scranton Hebrew Day School.)

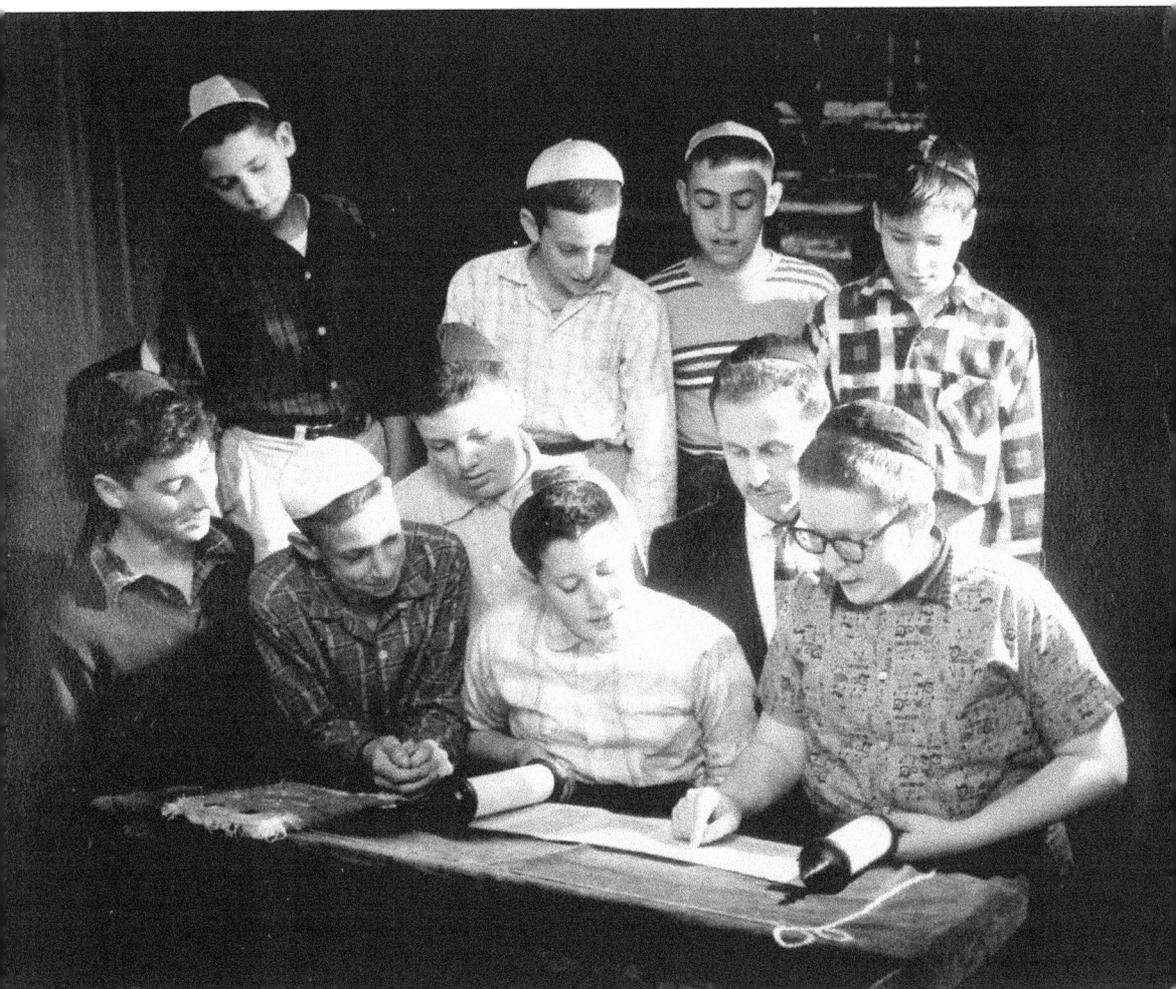

STUDYING THE TORAH AT THE SCRANTON HEBREW DAY SCHOOL. These young men are studying with Rabbi Jack Werbin in 1955. From left to right are the following: (kneeling) Alan Hirschenfeld, Ronald Troy, Jacob Schorr, Louis Shoop, Rabbi Werbin, and Sheldon Fink; (standing) Louis Eisner, Arthur Moskowitz, Bernard Troy, and David Adler. (Courtesy of Sara Eisner.)

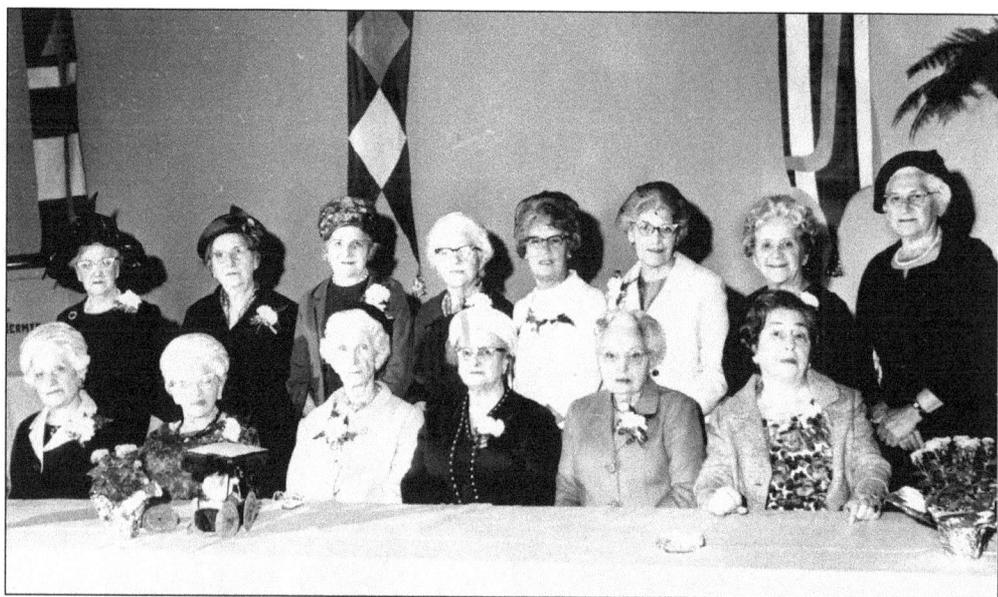

A Hadassah Founders' Luncheon. Original members of Hadassah, founded in 1920, were honored at a luncheon in 1966. From left to right are the following: (first row) Mrs. Fannie Kaplan, Mrs. Benkaim, Mrs. Reisman, unidentified, Mrs. Dora Cohen, and Mrs. Endfield; (second row) Mrs. Libby Myers, Mrs. Brandywene, unidentified, Mrs. Sara Bernstein, Mrs. Harris, Mrs. Suravitz, unidentified, and Mrs. Suravitz. (Courtesy of Helen Pinkus and the Hadassah Archives.)

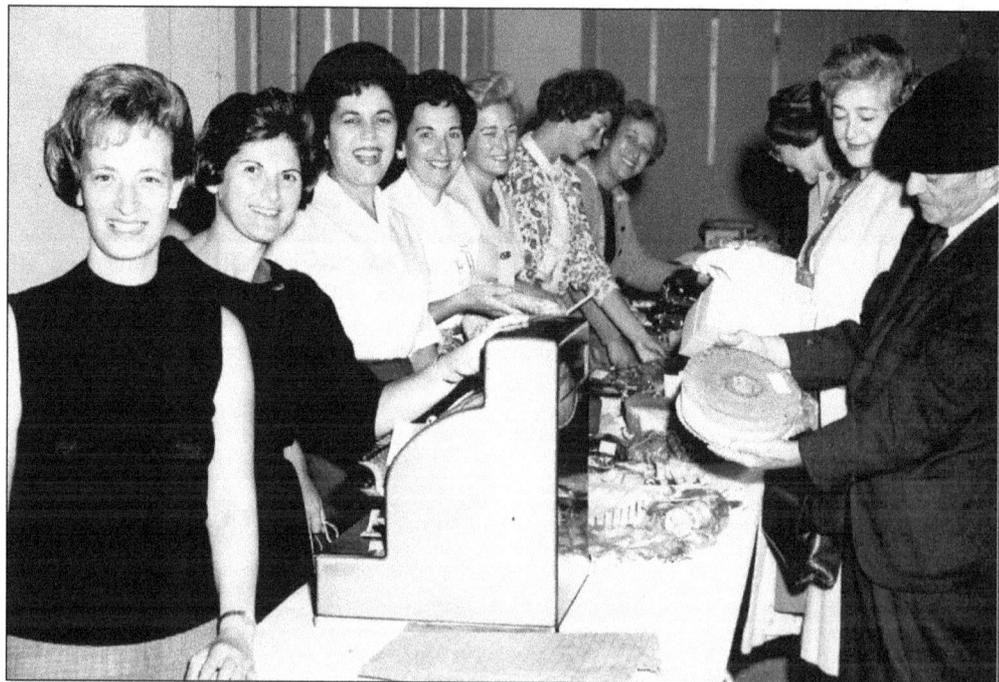

A Hadassah Bake Sale. Seen at this 1963 event are, clockwise from front left, Beverly Itzkowitz, Naomi Alamar, Irene Ruffman, Anita Plotkin, Ruth Albert, Sylvia Depicciotto, Rose Miller, unidentified, Ruth Dickstein, and Leo Levy. (Courtesy of Helen Pinkus and the Hadassah Archives.)

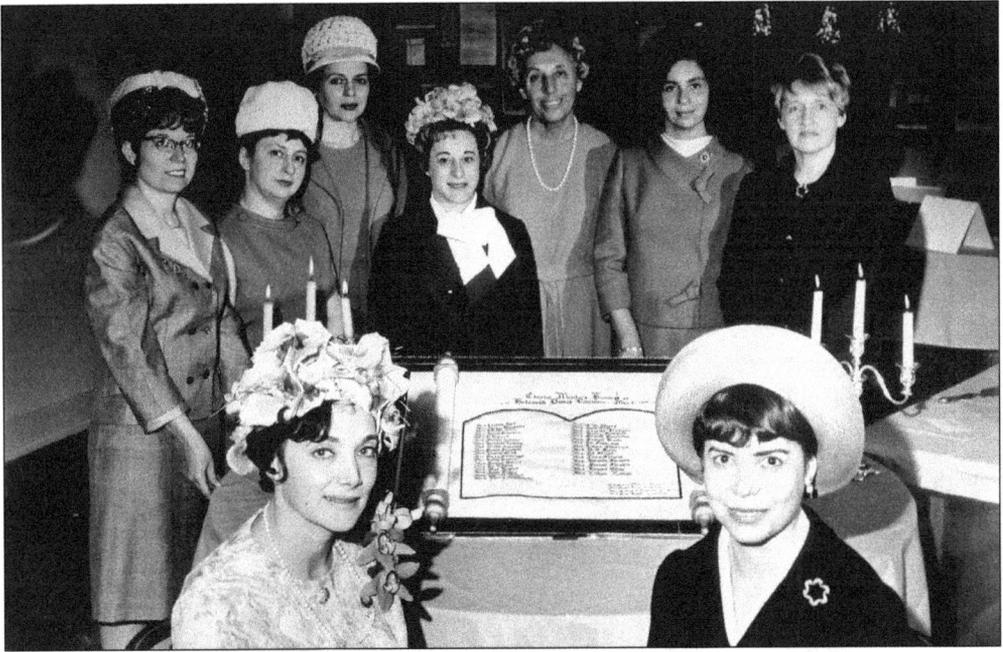

A HADASSAH LUNCHEON. Hadassah members seen at this 1966 luncheon are, from left to right, as follows: (front row) Charlotte Weisburger and Helen Pinkus; (second row) Esther Friedman, Sophie Maiman, Jenny Levy, Fay Bernstein, Esther Ginsburgh, Beverly Klein, and Kay Swartz. The scroll presented at this luncheon was made by Fannye Mittleman and contained the names of those women with life membership in Hadassah. (Courtesy of Helen Pinkus and the Hadassah Archives.)

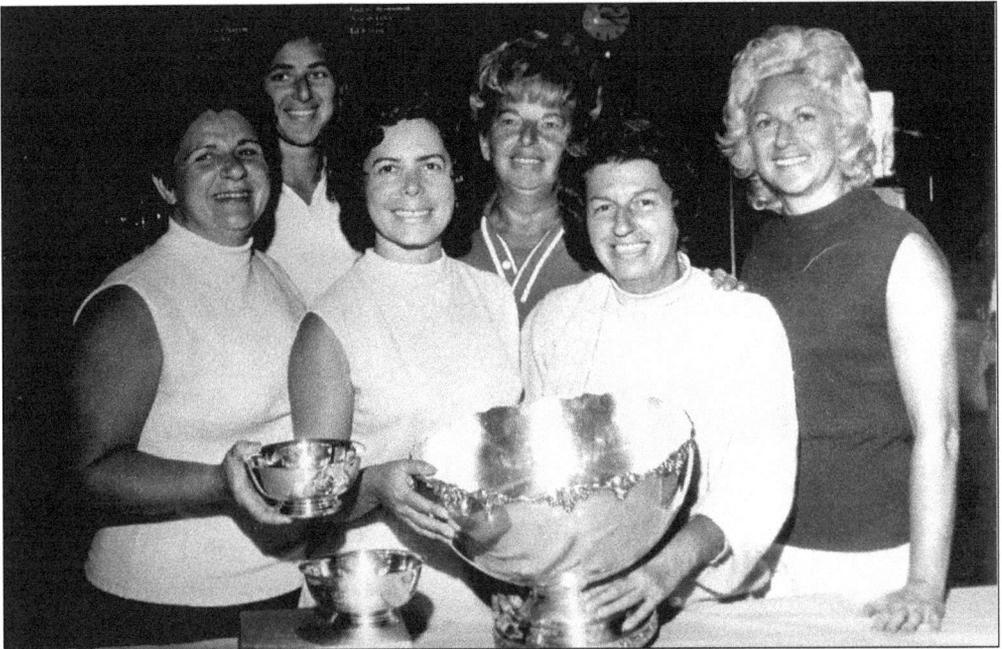

THE ESTHER LEVY-FLORENCE HARRIS MEMORIAL GOLF TOURNAMENT. This event was held in the 1960s at the Glen Oaks Country Club. From left to right are Romayne Brace, Lynn Pearl, Helen Pinkus, Muriel Greenfield, Minnie Nogi, and Marion Pearl. (Courtesy of Helen Pinkus.)

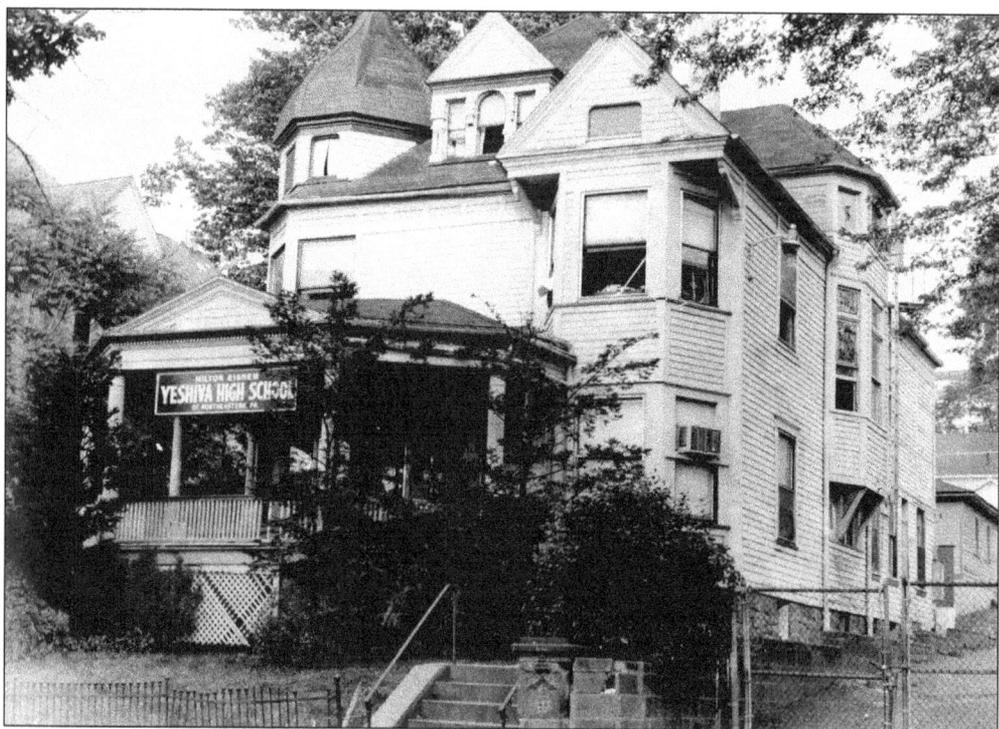

YESHIVA BETH MOSHE, THE MILTON EISNER YESHIVA. Yeshiva Beth Moshe was established in 1965 with 23 students—12 in the high school and 11 in the bais medrish. The original building was located at 538 Monroe Avenue. (Courtesy of Yeshiva Beth Moshe.)

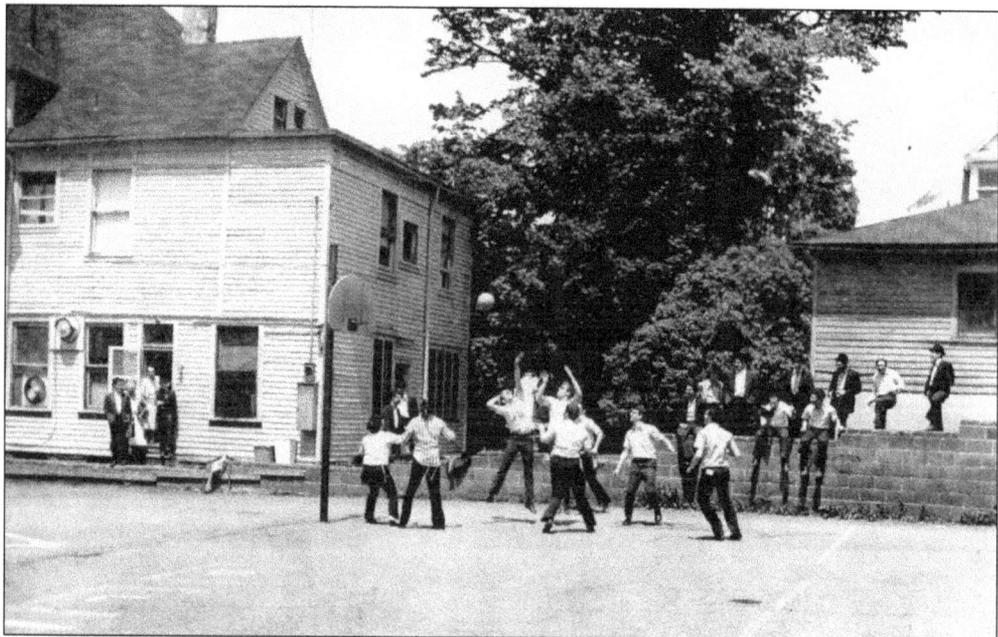

YESHIVA BETH MOSHE STUDENTS PLAYING BASKETBALL. The boys spent long days devoted to both secular and Hebrew studies, but did take some time out to play a little ball. (Courtesy of Yeshiva Beth Moshe.)

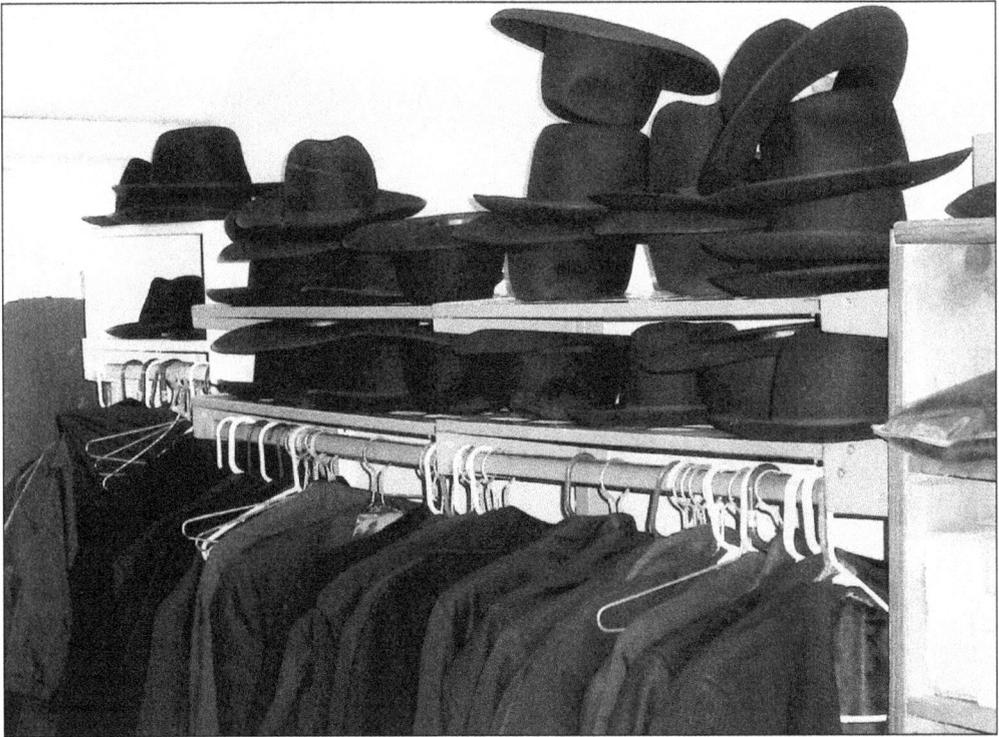

BLACK HATS AT YESHIVA BETH MOSHE. This artistic photograph, taken by Irwin Kalisher, shows the black hats that were worn by yeshiva students. (Courtesy of Irwin Kalisher.)

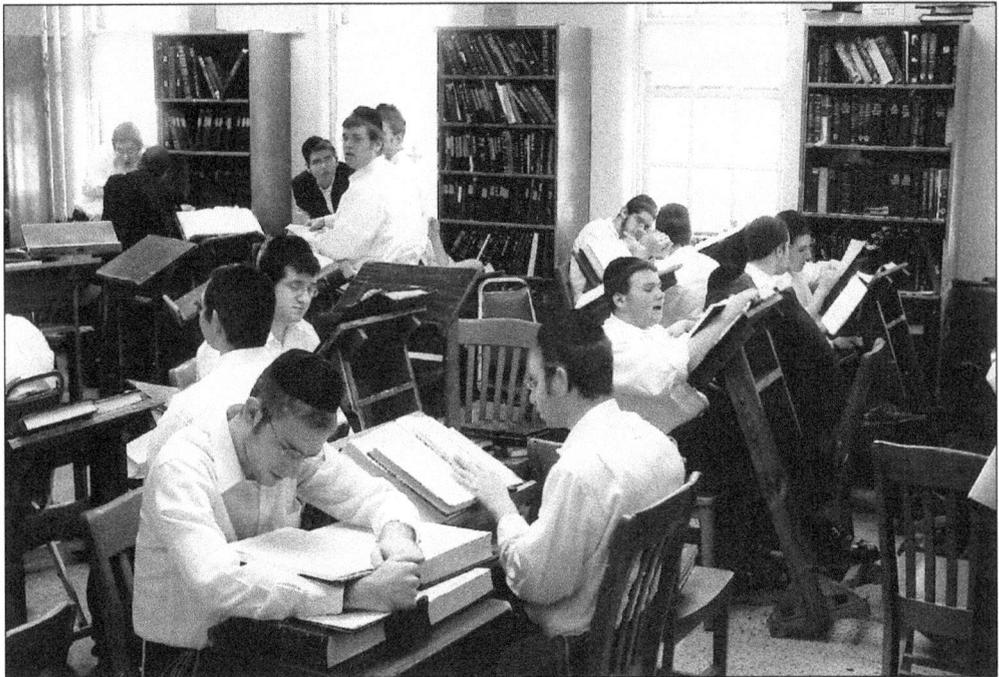

YESHIVA BETH MOSHE INDEPENDENT STUDY PROGRAM. Study with a chevrusa (study partner) is a time-honored tradition of the yeshiva. (Courtesy of Irwin Kalisher.)

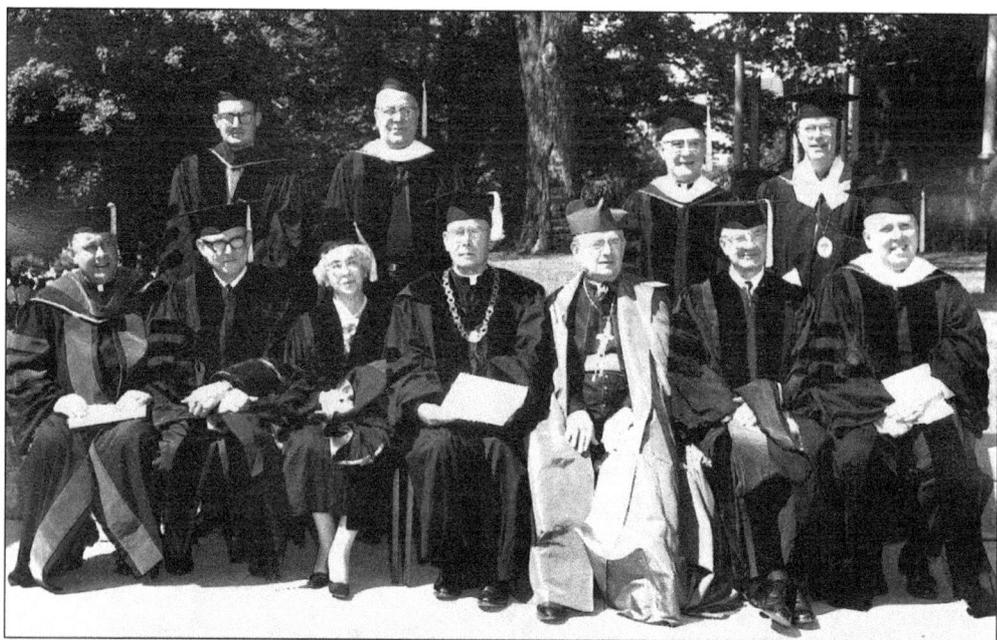

CONSTANCE OPPENHEIM, HONORARY DEGREE RECIPIENT. In 1964, Constance Oppenheim received an honorary doctorate from the University of Scranton. Pictured here with her fellow honorees, Constance is believed to be the first Jewish woman to receive such an honor. During the 2004 commencement ceremonies at the University of Scranton, her daughter-in-law Jane Oppenheim received the same honor. (Courtesy of the Oppenheim family.)

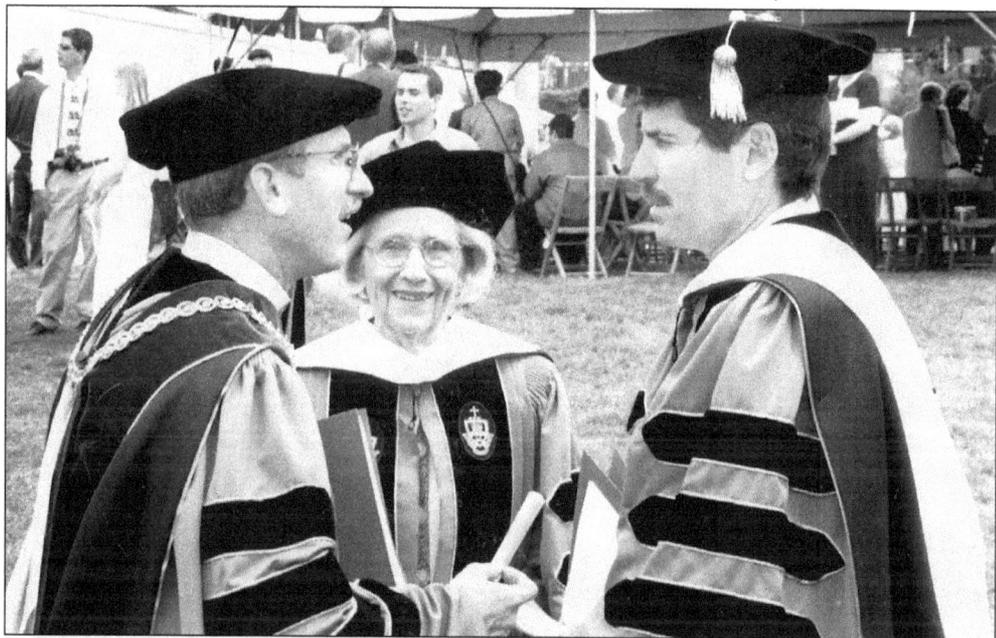

MAE GELB RECEIVING AN HONORARY DEGREE. Mae Gelb is shown in 2001 with Father McShane (left), president of the University of Scranton, and John Stossel as she receives her honorary doctorate. Her daughter Sondra Myers had previously been honored with the same award. (Courtesy of the Gelb family.)

Three

BUSINESS AND INDUSTRY

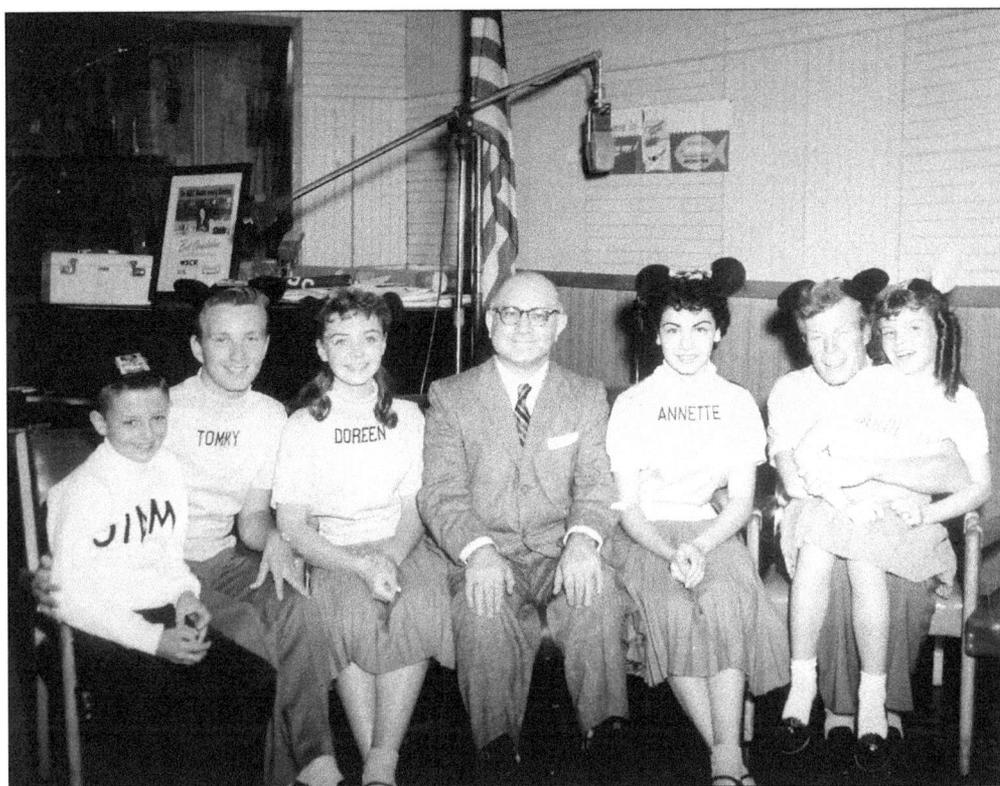

A MOUSEKETEER PROMOTION FOR THE YOUTH-O-PEDIC SHOE STORE. In the 1950s, the Mouseketeers made an appearance with two local children at Abe Plotkin's Youth-o-Pedic Shoe Store. The store carried all types of footwear, ranging from ballet slippers to fitted orthopedic shoes. (Courtesy of Abe Plotkin.)

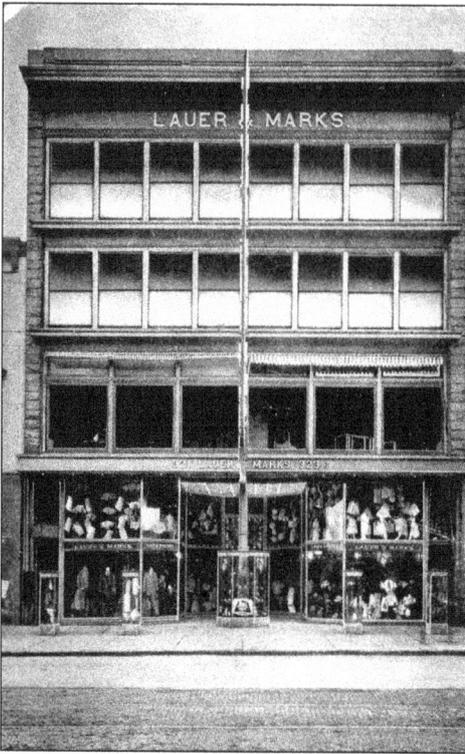

LAUER AND MARKS. In 1851, Jonas Lauer established a clothing store in Scranton. This building, photographed for a postcard c. 1900, was located at 321–323 Lackawanna Avenue, two doors west of the Bijou Theatre. (Courtesy of Jack Hiddlestone.)

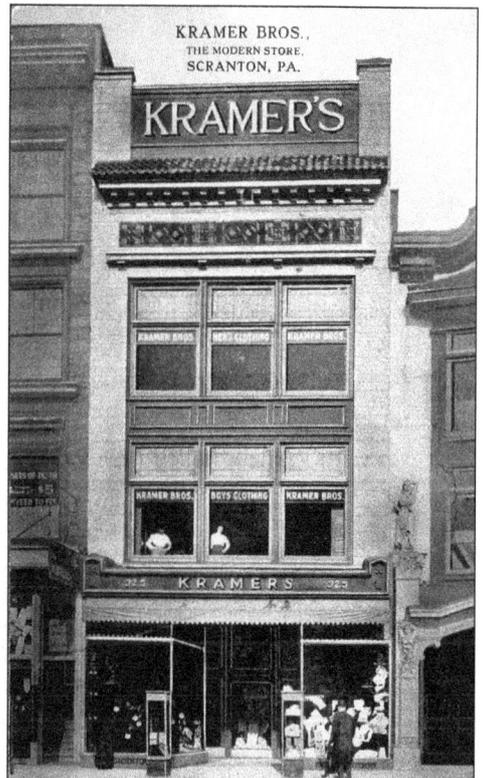

KRAMER BROTHERS. Established in 1849, Kramer's was one of the earliest businesses in Scranton. In 1875, Nathan Kramer opened his clothing store at 325 Lackawanna Avenue, and later, with his brothers as partners, established the Kramer Brothers store. The business continued operating as such until 1928, when Richman Brothers took over the location. This postcard image was produced c. 1916. (Courtesy of Jack Hiddlestone.)

MAX RICE. In the 1860s Max Rice joined his older brother Simon in Scranton. Together they ran a prosperous grocery store. (Courtesy of Elinor Ratner.)

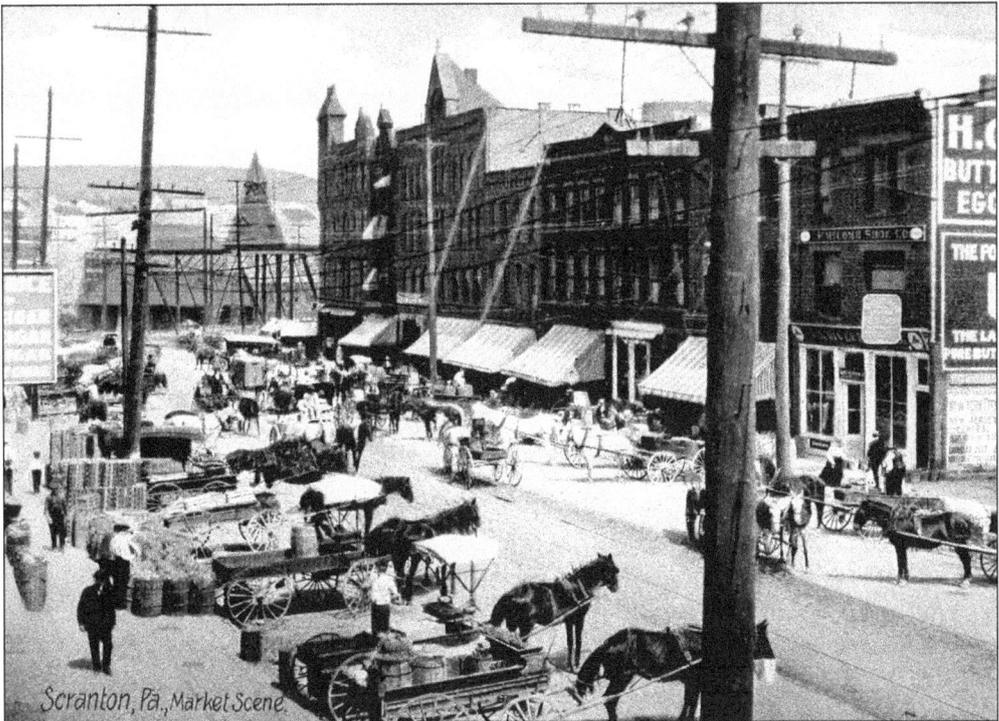

A MARKET SCENE, LACKAWANNA AVENUE. Throughout the late 19th and early 20th centuries, Lackawanna Avenue was a busy wholesale district, where Scranton's peddlers and vendors displayed their wares. The Lauer and Marks department store is on the right side of the 300 block of Lackawanna Avenue, with a Woolworth's next door. Samter's store is the large dark building at the left center, on the corner of Penn Avenue. (Courtesy of Jack Hiddlestone.)

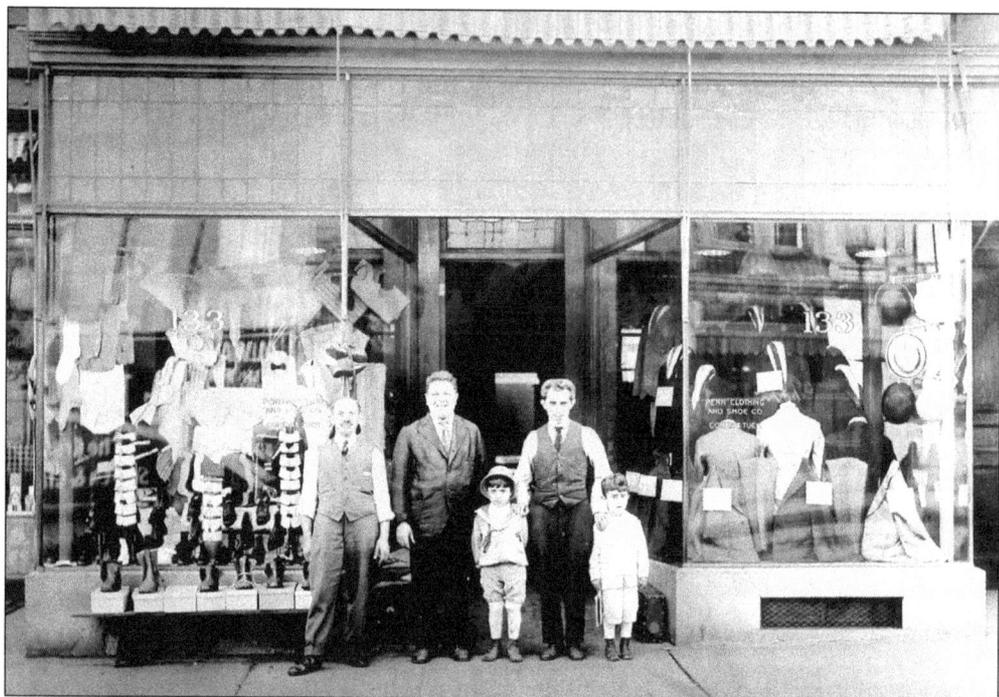

THE PENN CLOTHING AND SHOE COMPANY. Pictured in 1915, the Penn Clothing and Shoe Company was located at 133 Penn Avenue. Seen standing in front of the establishment are, from left to right, employee Sam Newman, co-owner Nathan Tuck, Isadore Cohen, co-owner Myer Cohen, and Milton M. Cohen. (Courtesy of Helen Pinkus.)

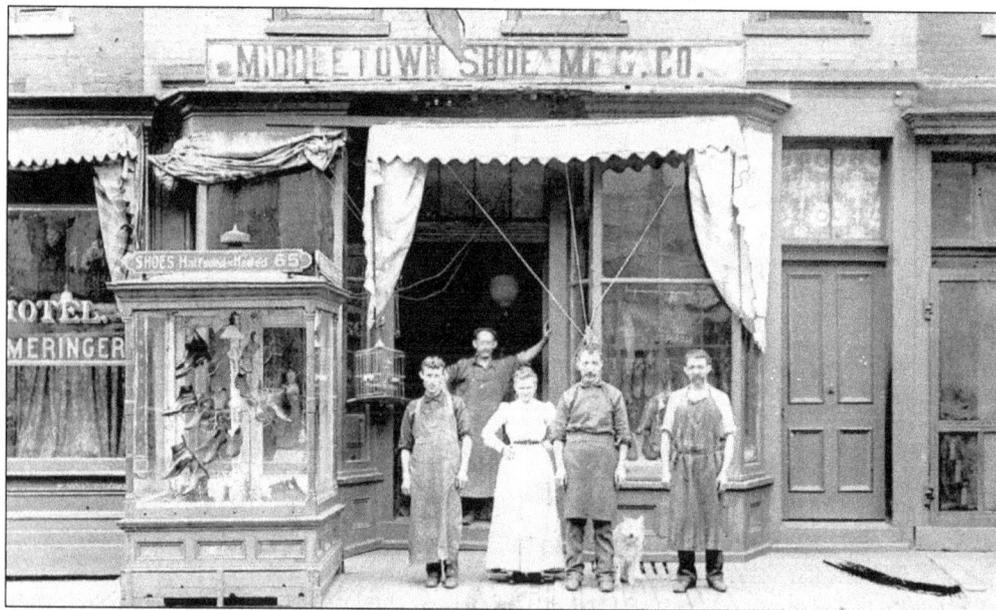

THE MIDDLETOWN SHOE MANUFACTURING COMPANY. The Middletown Shoe Manufacturing Company was located at 237 Penn Avenue during the 1890s. Pictured from left to right are Mr. Schlanger, Mr. Freedman, Mrs. Charlotte Schames (wife of Leopold), Mr. Leopold Schames, and Mr. Proper. (Courtesy of Faye Spatt.)

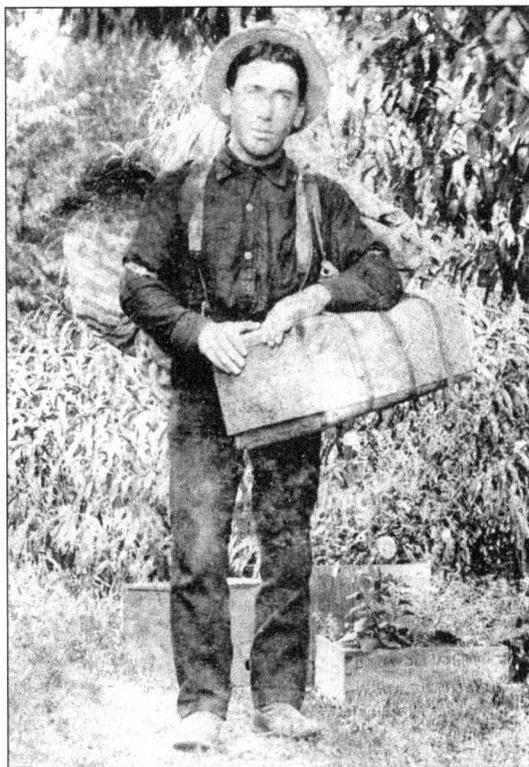

DAVID COHEN WITH A PEDDLER PACK.
In the early 20th century, David Cohen
began his business career as a peddler,
carrying goods from door to door.
(Courtesy of Faye Spatt.)

DAVID COHEN IN HIS MEN'S STORE. By the late 1920s, David Cohen (center) had established a
men's store on West Market Street in North Scranton. The two women here are not identified.
(Courtesy of Faye Spatt.)

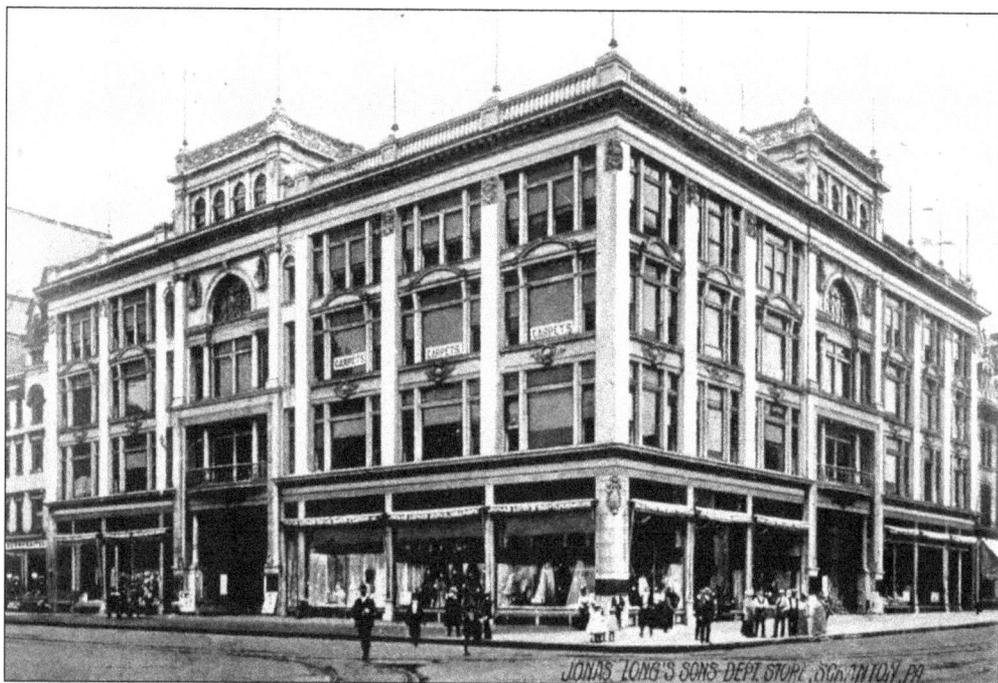

JONAS LONG'S. Located on the corner of Wyoming and Lackawanna Avenues, the building that housed the Scranton Dry Goods Company in the early 20th century was originally known as Jonas Long's. The Oppenheims purchased the building for their growing department store. The Scranton Dry Goods Company opened originally at 111–113 North Washington Avenue in 1912. Within a few short years, it expanded to a palatial eight-story business establishment that rivaled some of the finest department stores in larger cities. (Courtesy of Jack Hiddlestone.)

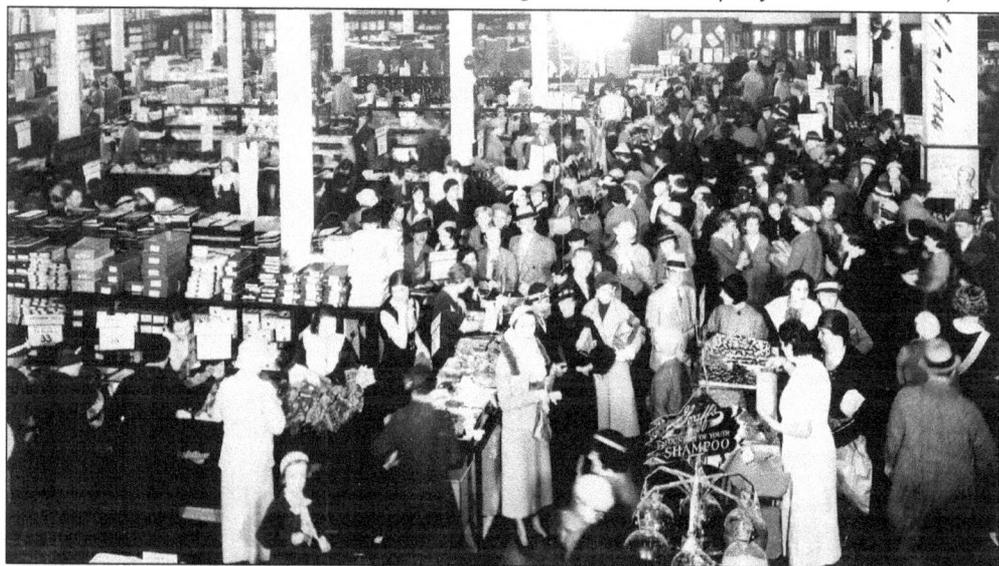

SHOPPERS AT THE SCRANTON DRY GOODS COMPANY. Shoppers flocked to this sale at the Scranton Dry Goods Company during the 1920s. The store was noted for having the first escalators in Pennsylvania. In 1962, when the store celebrated its 50th anniversary, there were 500 full-time employees, and another 300 were added during peak periods. (Courtesy of the Oppenheim family.)

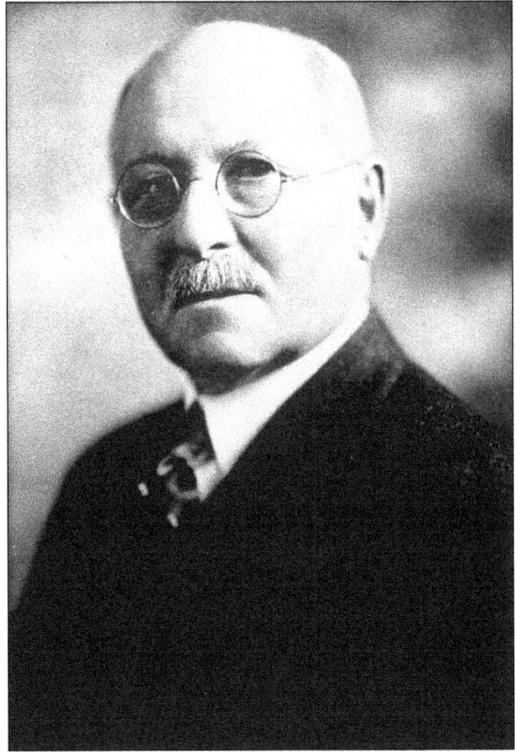

SAMUEL SAMTER. Samuel Samter was born in 1851 and arrived in Scranton in 1872. He was president of the Samter Brothers department store, and served as chairman of the board of the YMHA from 1914 until his death in 1928. (Courtesy of the Jewish Community Center.)

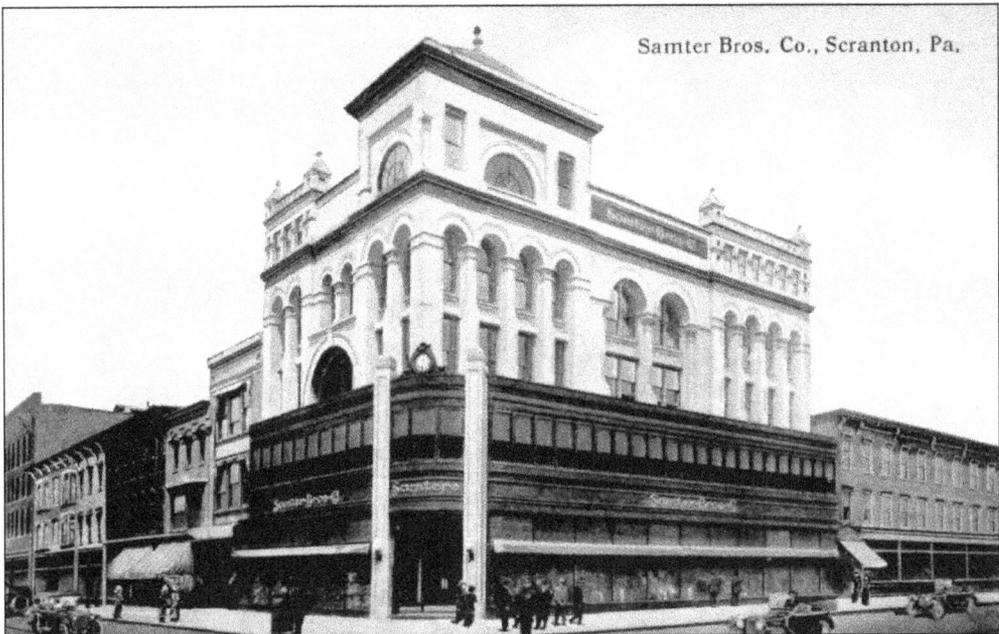

Samter Bros. Co., Scranton, Pa.

SAMTER BROTHERS. Samuel Samter opened his store soon after he arrived in Scranton in 1872. In 1888, he and his brother Ben acquired a site at the corner of Lackawanna and Penn Avenues, where they built the facility pictured on this c. 1900 postcard. One of Scranton's leading clothing stores for 97 years, Samter Brothers was sold to the nationally known Eagle Clothing Company in 1969. (Courtesy of Jack Hiddlestone.)

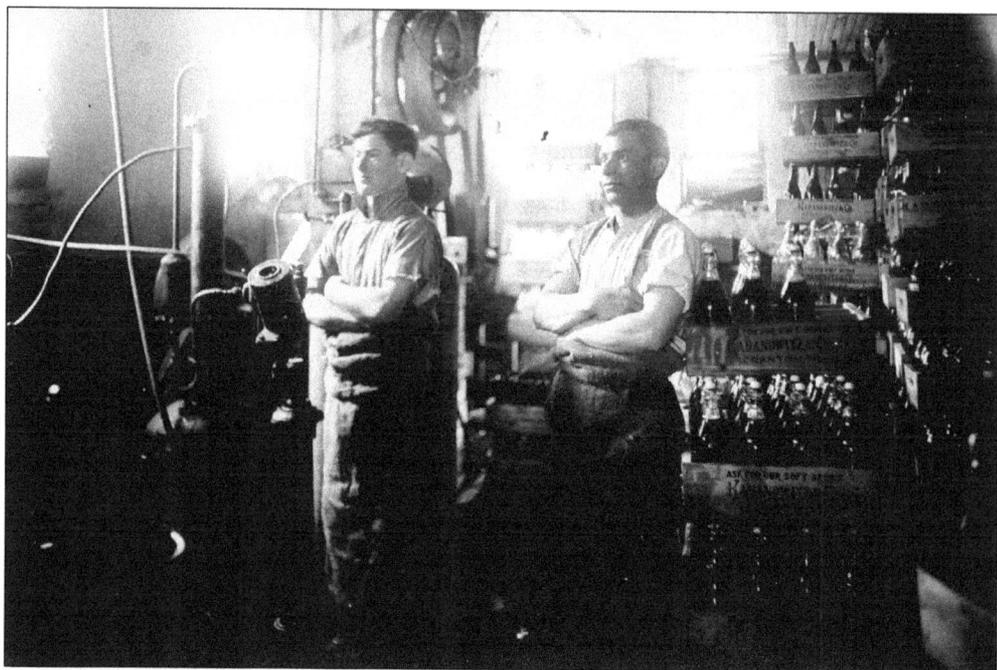

CRYSTAL SODA WAREHOUSE. The Crystal Soda Water Company was founded in 1907 by Harry Kahanowitz (on right) and has been family owned since that time. The business still makes the same fine product. The man on the left is not identified. (Courtesy of Crystal Soda.)

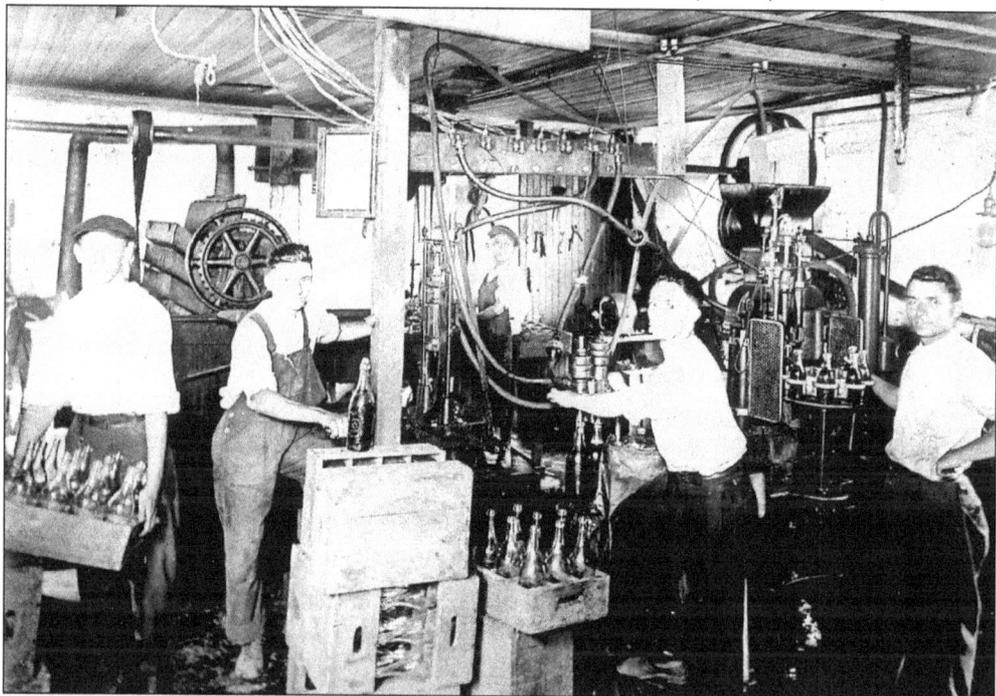

CRYSTAL SODA BOTTLING MACHINERY. Early bottles for Crystal Soda featured a Jewish star on the bottom. Among the men pictured here are Steve Sauage (second from the left) and Harry Kahanowitz (far right). (Courtesy of Crystal Soda.)

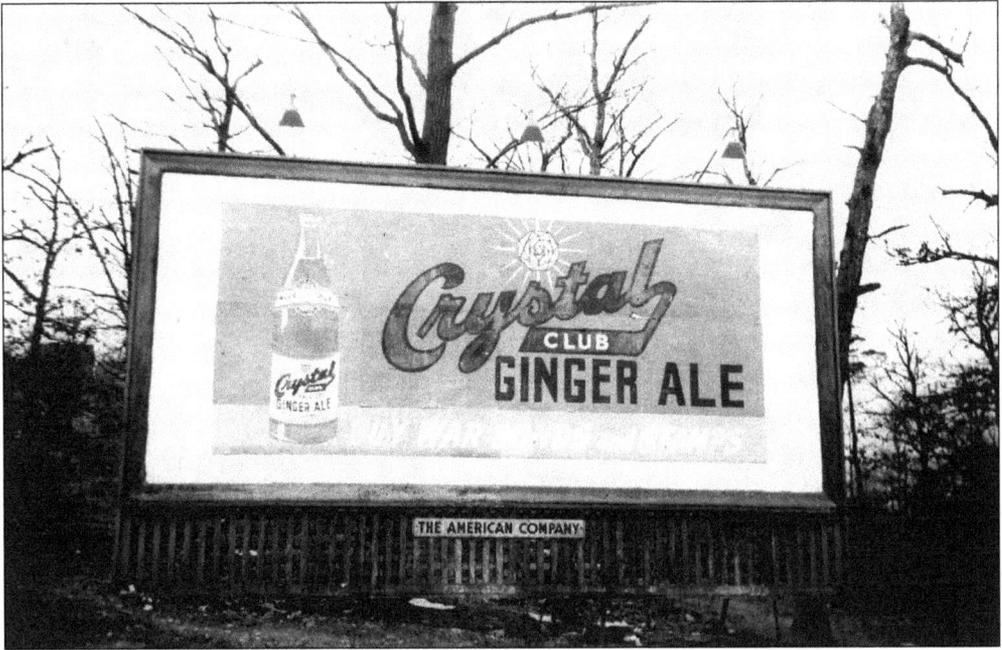

A CRYSTAL SODA BILLBOARD PROMOTING WAR BONDS. During the 1940s, Crystal Soda billboards featured slogans promoting war bonds. (Courtesy of Crystal Soda.)

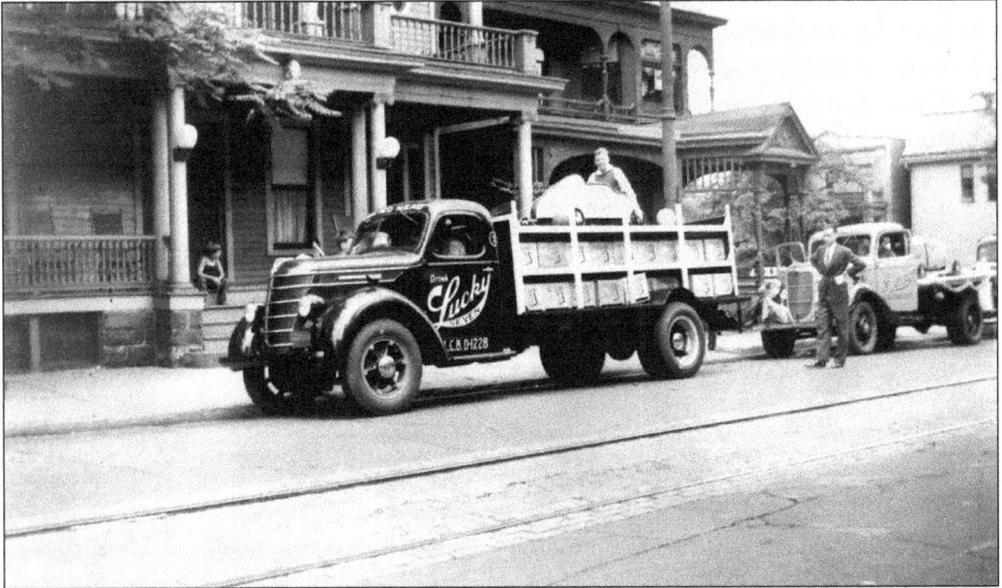

A CRYSTAL SODA DELIVERY TRUCK. This truck was painted with the "Lucky Seven" logo. It was a popular sight in Scranton's residential neighborhoods. (Courtesy of Crystal Soda.)

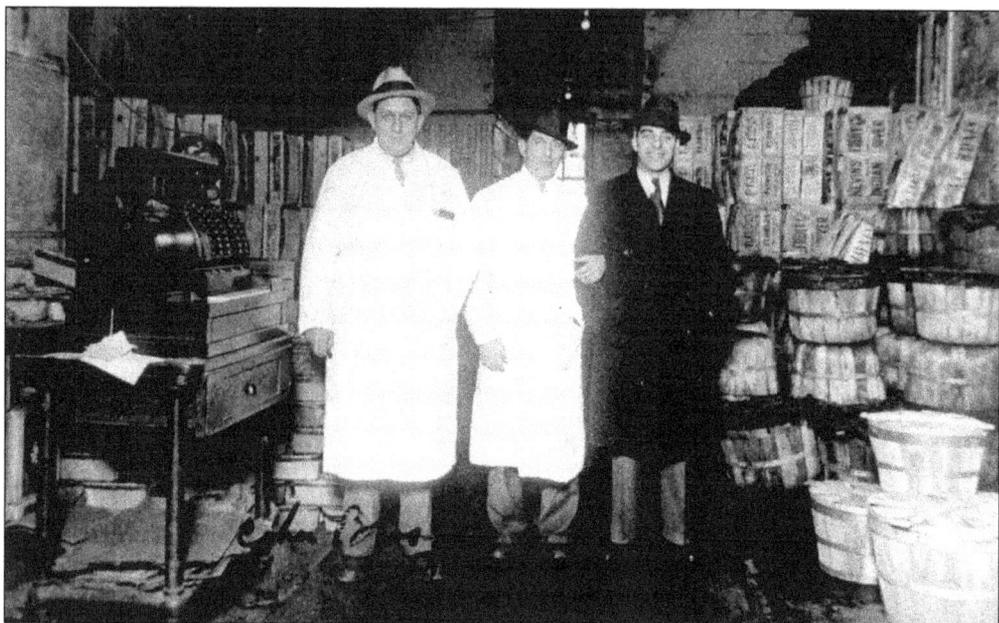

M. L. HODIN BUYING PRODUCE FROM THE COHEN BROTHERS. M. L. Hodin was born in Austria-Hungary. After serving with the Austrian army in World War I, he made his way to America with his wife, Bluma, and son, Billy. In 1923 the Hodins moved to Scranton and lived behind their Mount Vernon Street store. From these modest beginnings, the first Giant supermarket opened on Capouse Avenue in 1932. The business eventually expanded to 22 stores in northeastern Pennsylvania, New Jersey, and New York. M. L. Hodin's success in business was rivaled only by his service to the local community, as well as to Israel. (Courtesy of the Hodin family.)

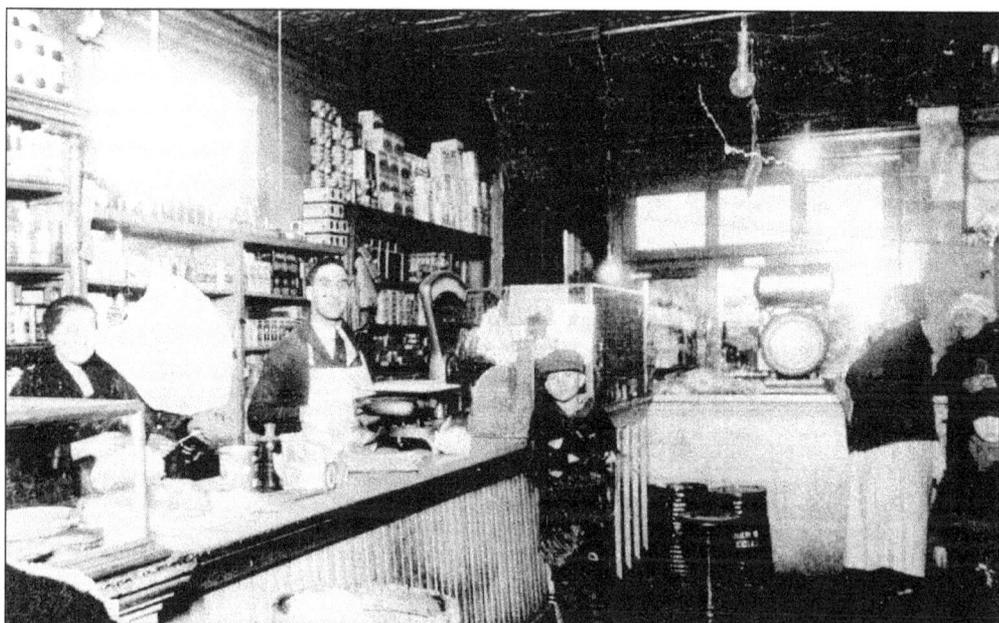

INSIDE THE GIANT SUPERMARKET. This early Giant grocery store was the predecessor of a chain of full-scale, ultramodern supermarkets. (Courtesy of the Hodin family.)

66

ISADORE AND FRIEDA SMERTZ KAPLAN. The Kaplans, pictured in the 1950s, owned a large meat processing establishment. The family was also involved in the founding of the Bank of Olyphant. (Courtesy of the Kaplan family.)

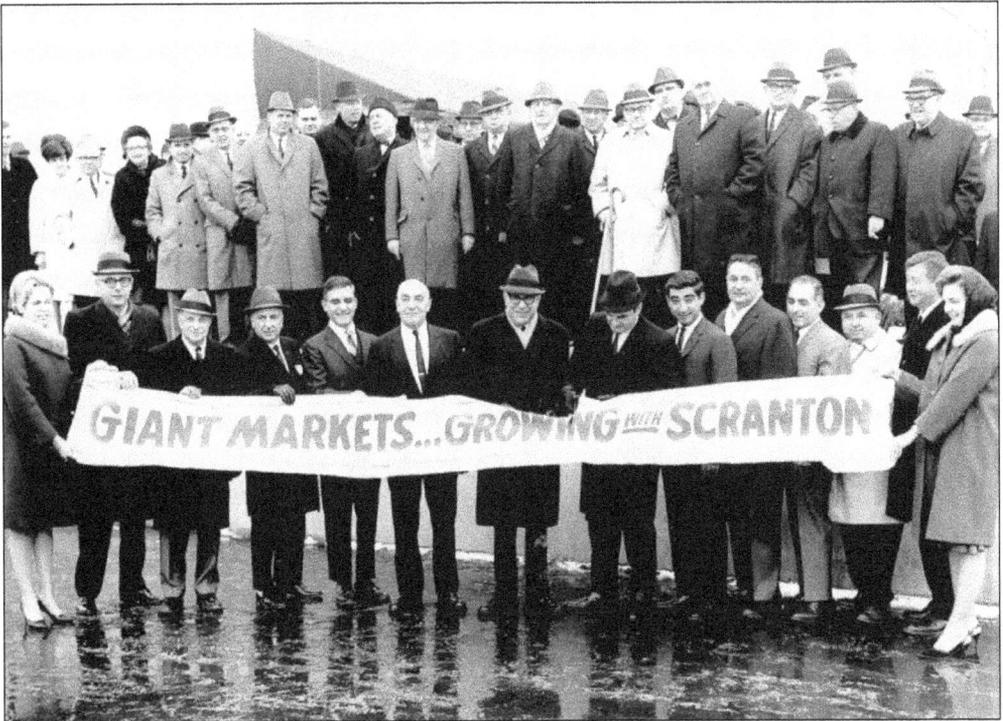

THE GIANT SUPERMARKETS. Founded in the early 1920s, Giant supermarkets remained in the family when the next generation of Hodins took over. (Courtesy of the Hodin family.)

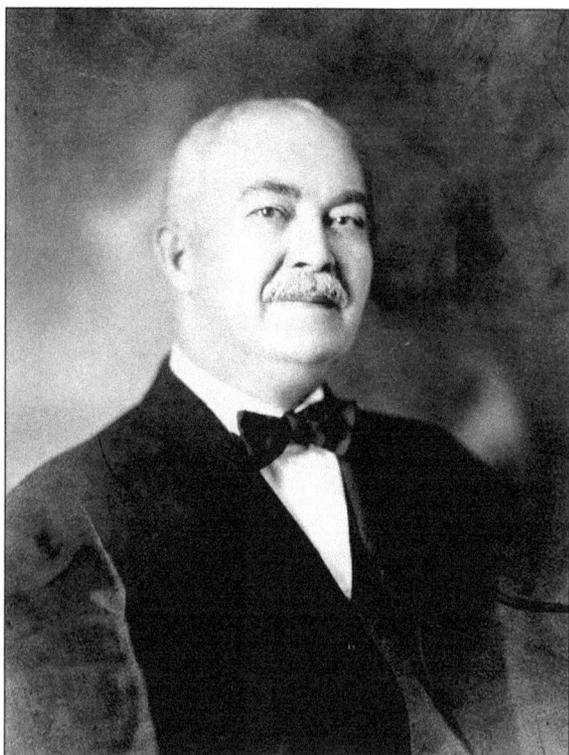

SIGMUND ROOS. Sigmund Roos was the owner of the S. Roos Meat Market, located on Wyoming Avenue, in the early 20th century. (Courtesy of Paula Roos.)

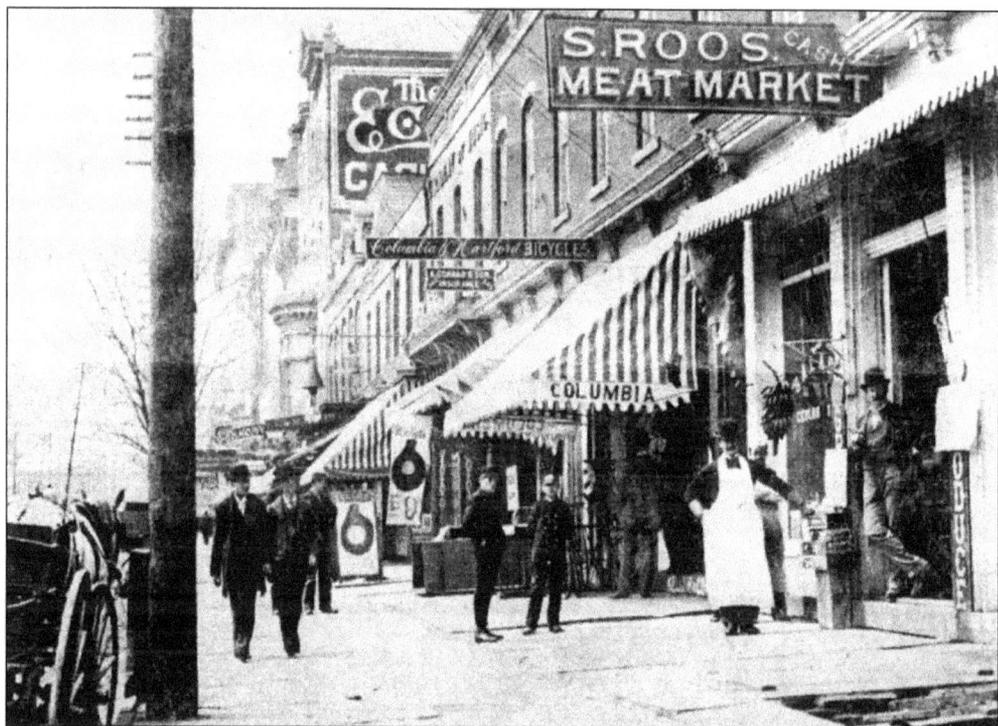

THE ROOS MEAT MARKET. This meat market was one of the many kosher butcher shops that catered to Scranton's Jewish population. (Courtesy of Paula Roos.)

THE MELBA DINER. Leonard (left) and Bob Baron are shown in 1937 in front of the Melba Diner, on Wyoming Avenue. (Courtesy of Bob and Dolly Baron.)

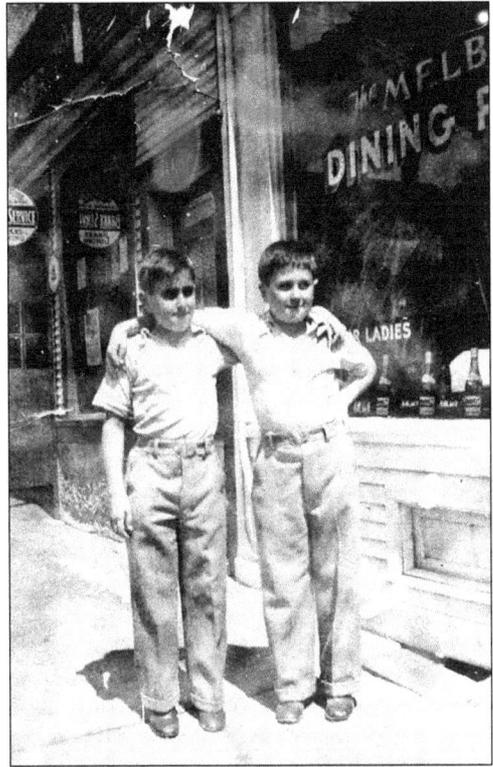

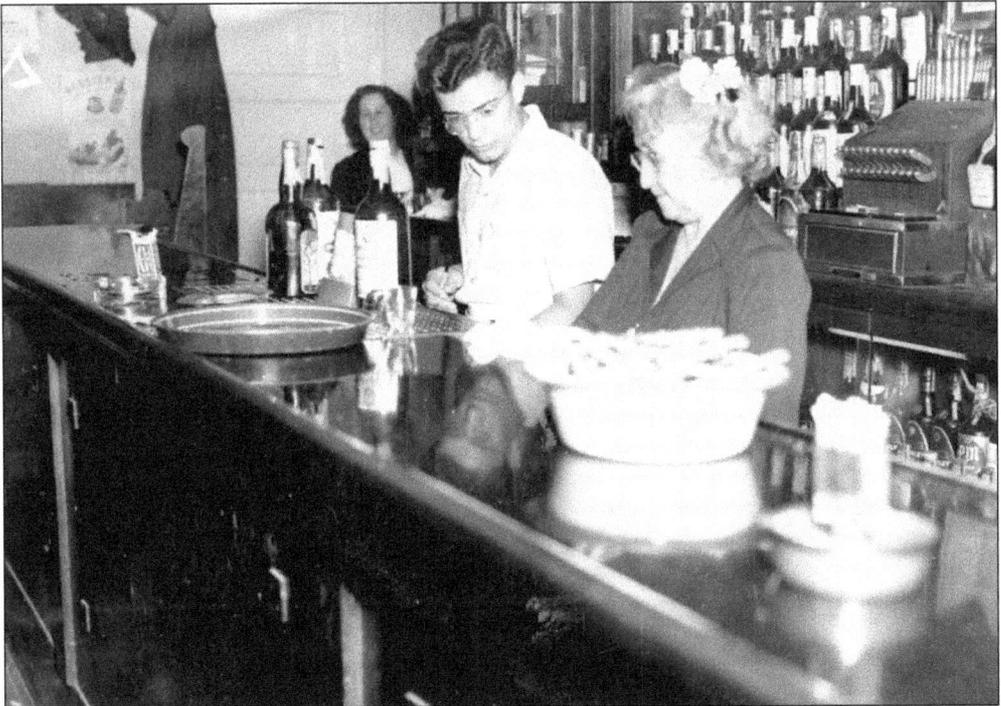

THE MELBA DINER INTERIOR. Betty Baron Pachter (back left), Fannie Baron (front right), and a bartender are shown inside the Melba Diner in 1942. (Courtesy of Bob and Dolly Baron.)

FREEDMAN'S BOOK STORE. This Yiddish advertisement for Freedman's Book Store was printed in Scranton during the early 20th century. (Courtesy of Temple Israel.)

A DAVID HARRIS AND COMPANY RECEIPT. In 1917, David Harris and Company sold wholesale dry goods, including muslin, curtains, wool socks, and collars. (Courtesy of Roslyn Sholin.)

New Phone 2338

SCRANTON, PA. *Sept 5* 191*8*

M *S. Tick Winola Pa*

To Eisner Bro's & Company, Dr.

MANUFACTURERS AND IMPORTERS OF

SWITCHES, PUFFS
TRANSFORMATIONS
POMPADOURS
WIGS

HUMAN HAIR GOODS

432 LACKAWANNA AVENUE
1422 Olive St

DYEING, CLEANING
AND DIPPING
A SPECIALTY

TERMS *2/30*

SOLD BY *N. B. Eisner*

290 1/2 of g Pmsts at 40 15 00
R. P. ins 12

15 12

the Balance of Pmsts will follow

AN EISNER BROTHERS AND COMPANY RECEIPT. Eisner Brothers and Company was a manufacturer of human-hair goods, as is noted on this receipt from 1918. (Courtesy of Roslyn Sholin.)

QUALITIZED
MADE ITS WAY THRU
UPHOLSTERED
THE BY ITS HIGH
FURNITURE

LEIPMAN-SMITH CO.

MANUFACTURERS OF

UPHOLSTERED FURNITURE

207-209 VINE STREET

SCRANTON, PA. *Jan. 3rd, 1923.* 192

4488

SOLD TO *S. Tick,*

3251 Birney Ave, Scranton, Penna.

SALESMAN

SHIPPED VIA _____ . O. B. FACTORY

TERMS: *2--30*

Quantity	No.	Covering	Description	Price	Amount	Total
1	1025½	Chase Fl. Taupe No.	S. C. B.		300.00	
		Pleated arms, and double bands.		20%	600	
					294 00	

Pd Mch 22 1924

Please take notice that no returned goods will be accepted by us unless the return has been previously agreed upon. If prices or terms are not correctly stated on invoice, return to us at once for correction. All claims and payments to be made direct to the house. All errors of any nature must be made within five days after receipt of goods.

A LEIPMAN-SMITH COMPANY RECEIPT. In 1923, the Leipman-Smith Company offered custom furniture-upholstery services. (Courtesy of Roslyn Sholin.)

CLAIMS OF ANY KIND MUST BE MADE WITHIN FIVE DAYS AFTER RECEIPT OF GOODS.

Shipped

N. B. Levy and Bro.
WHOLESALE JEWELERS.

JOBBERS IN
American Watches, Diamonds,
Silverware, Optical Goods,
Clocks, Materials, Tools.

COAL EXCHANGE BUILDING.

Scranton, Pa., 189

Sold to Terms:

N. B. Levy Jewelers Letterhead. This elaborate stationery from 1896 reflected Levy's stock of luxury goods. (Courtesy of the Levy family.)

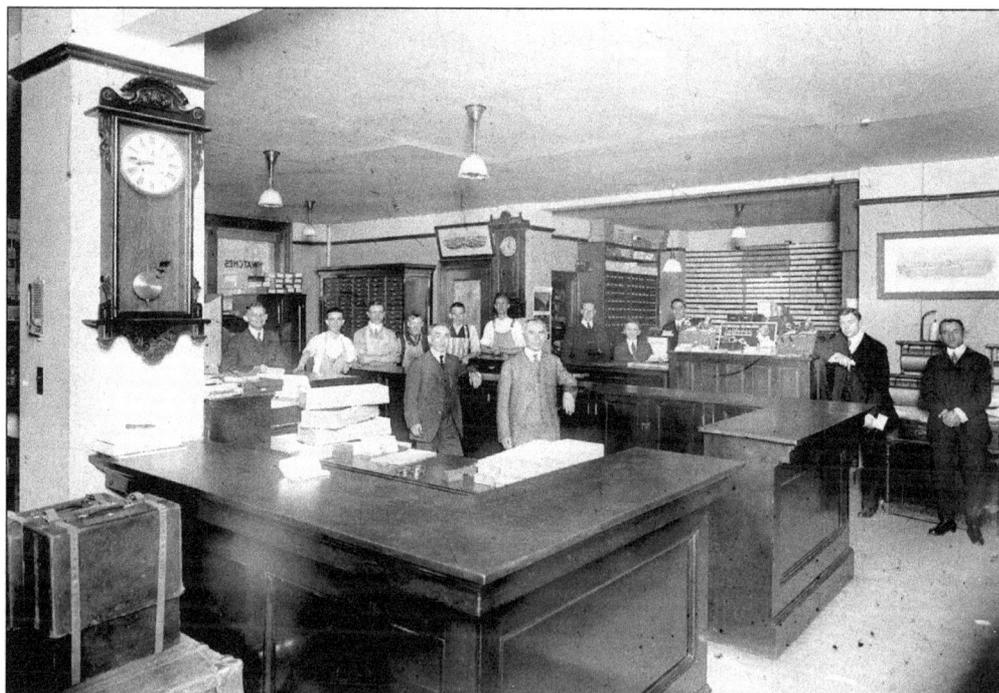

The N. B. Levy Jewelers Office. Even in its early days, N. B. Levy offered a wide range of elegant jewelry. This photograph dates from 1916. (Courtesy of the Levy family.)

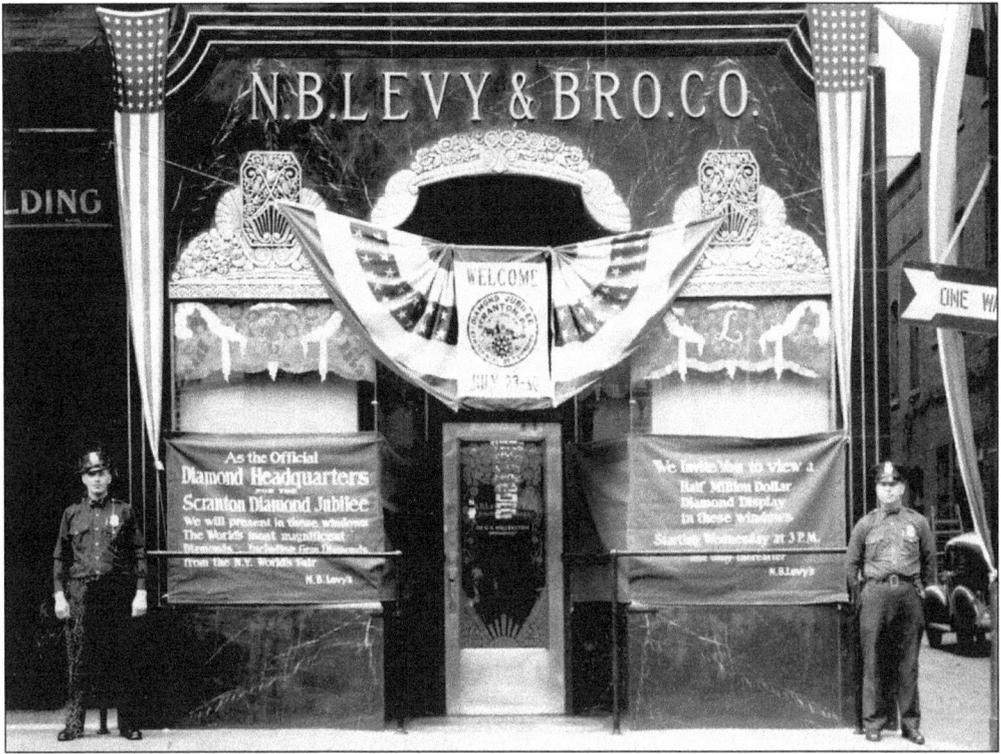

N. B. Levy Jewelers. The oldest continuously operating Jewish business in Scranton, N. B. Levy Jewelers was established in 1880 by Nathan Levy and his brother Kalman. Pictured here is the company's beautiful Wyoming Avenue store, which is still in operation. (Courtesy of the Levy family.)

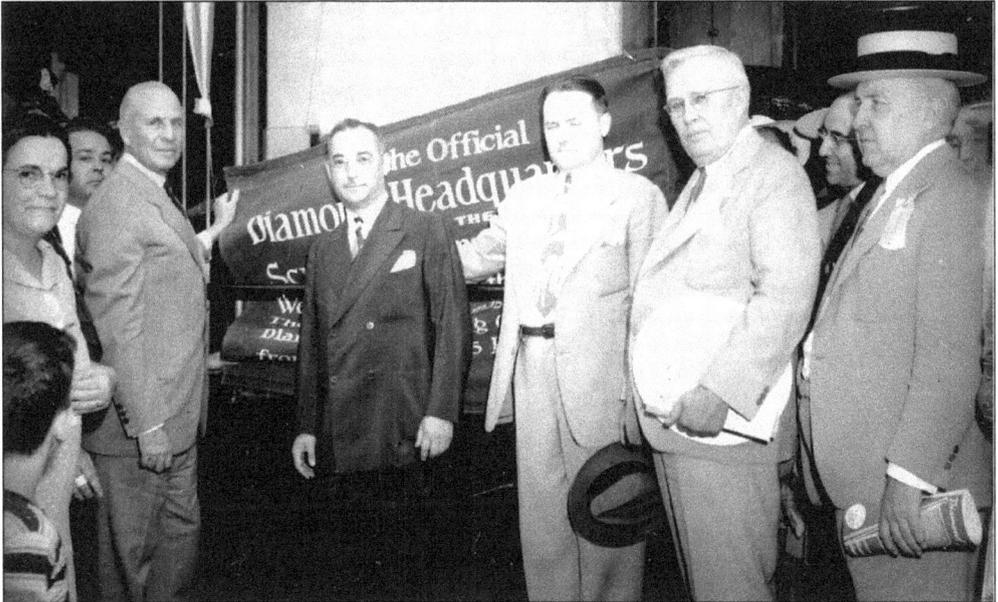

The N. B. Levy Jewelers Dedication. A ceremony was held to celebrate the company's expansion to its new headquarters on Wyoming Avenue. (Courtesy of the Levy family.)

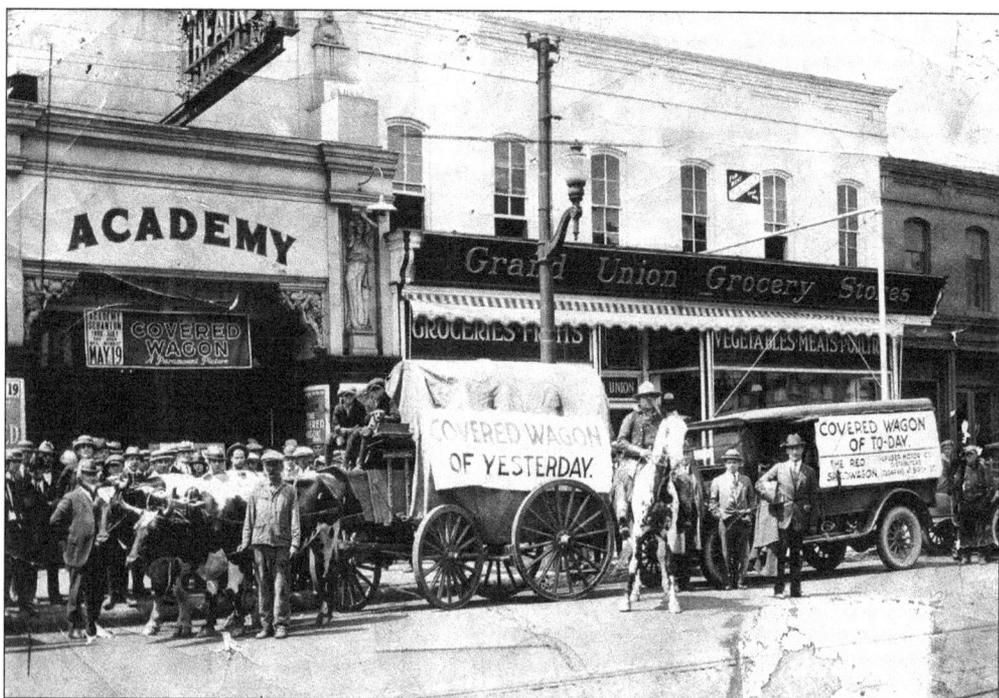

A Gruber Motor Company Promotion. This promotion for the movie *Covered Wagon*, which played at the Academy Theatre on Wyoming Avenue, was sponsored by the Gruber Motor Company in 1923. Owner Bernett Gruber is pictured standing on the right, in front of the "Covered Wagon of To-day."

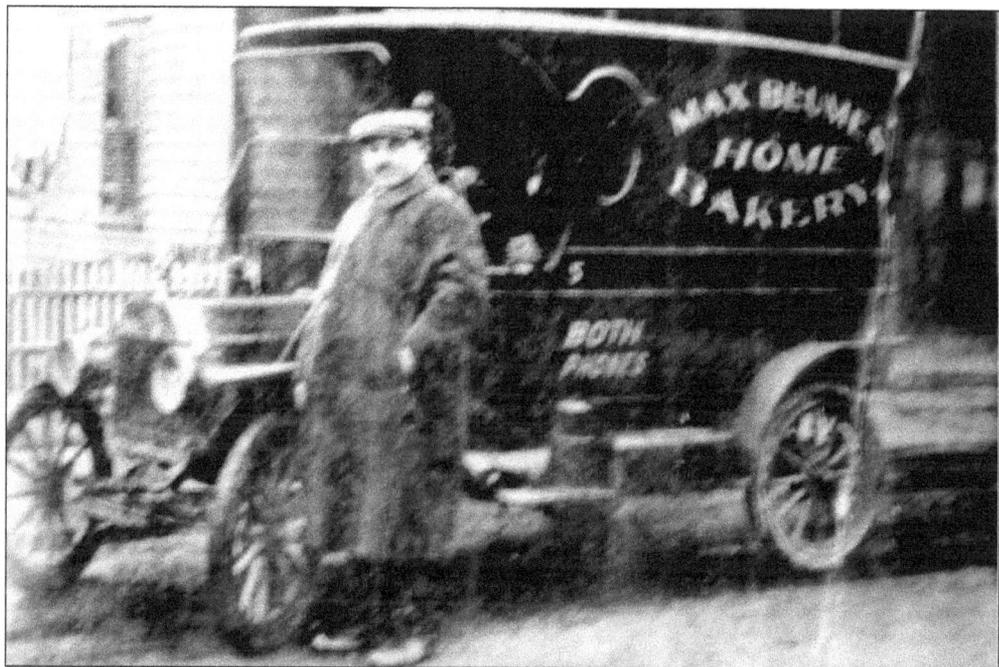

Max Blume's Bakery. Max Blume is shown with his delivery truck *c.* 1915. (Courtesy of Vera Gordon.)

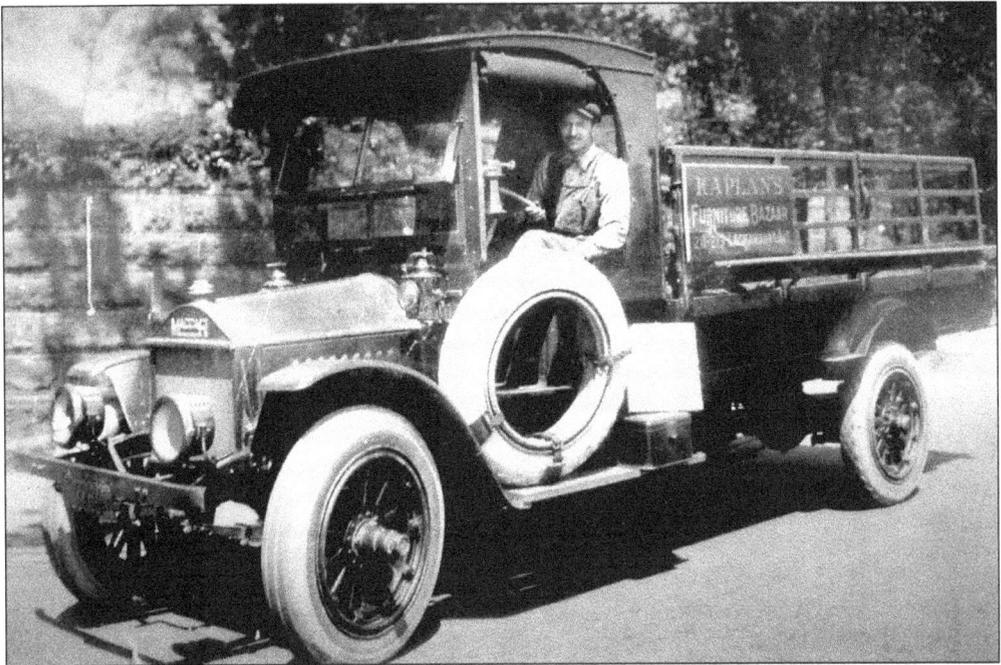

A KAPLAN'S DELIVERY TRUCK. Founded by Morris Kaplan in 1896, Kaplan's Furniture Bazaar was just one of many businesses in the bustling Scranton retail district that developed between Lackawanna, Spruce, Wyoming, and Washington Avenues in the early 1900s. Although Kaplan's first location was 177 Penn Avenue, the business moved to 513 Lackawanna Avenue in 1903. In 1924, Louis and Max Kaplan (Morris's brothers) moved the business to 211–213 Lackawanna Avenue, and finally, in 1969, relocated to Route 6. Kaplan's Furniture closed its doors just shy of its 100th birthday. This photograph was taken *c.* 1924. (Courtesy Margie Rosenberg.)

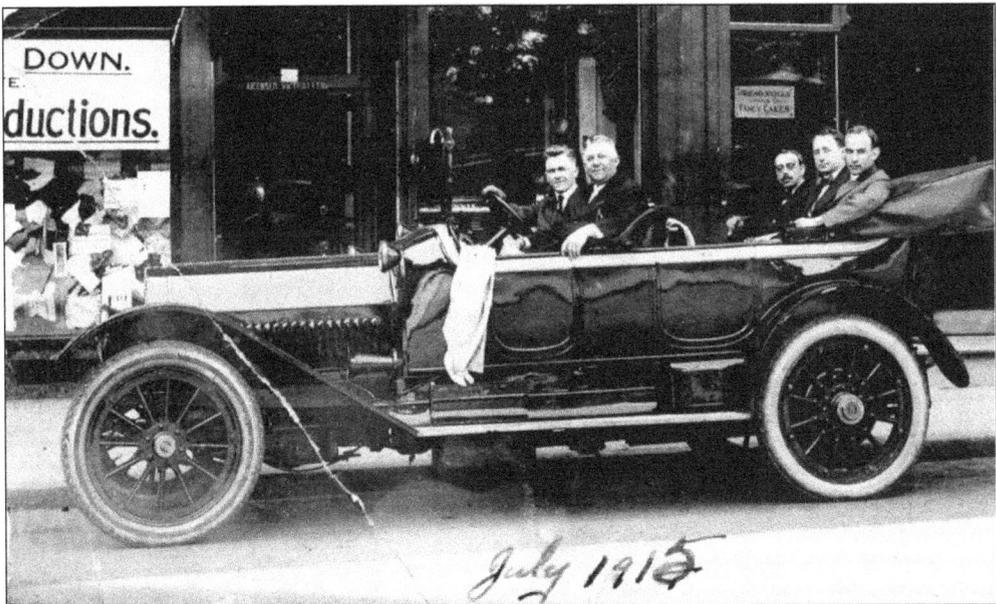

I. E. OPPENHEIM AND FRIENDS. I. E. Oppenheim (seated in back, far right) joins friends on a car ride in 1915. (Courtesy of the Oppenheim family.)

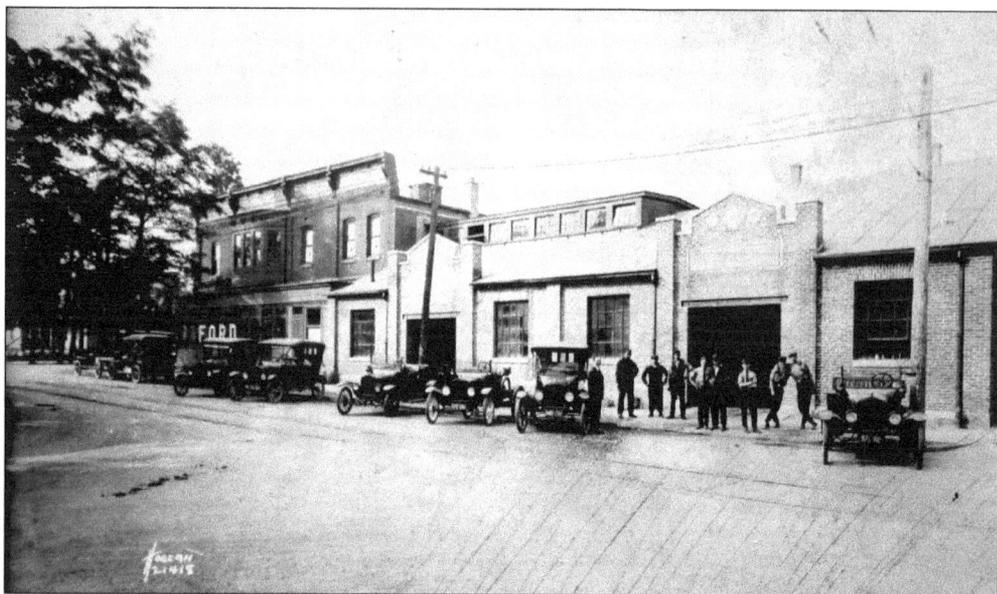

Gruber's Ford Dealership. Bernett Gruber owned this Ford dealership on Cedar Avenue in the early 20th century. (Courtesy of the Gruber family.)

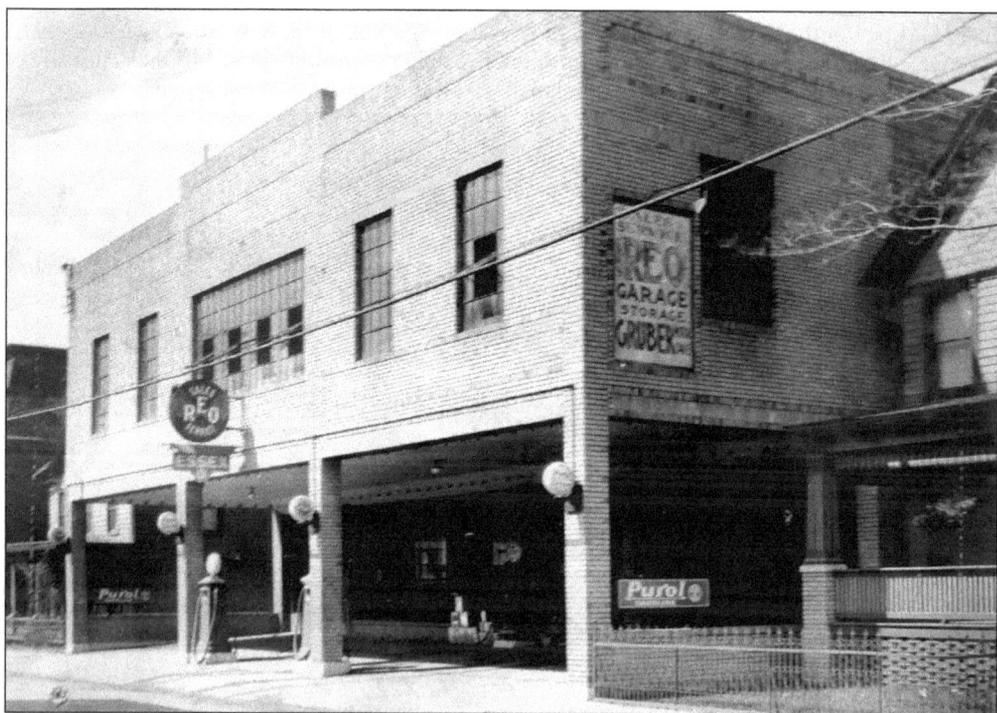

Gruber's REO Dealership. Bernett Gruber eventually sold his Ford facility and purchased a REO dealership in Carbondale. (Courtesy of the Gruber family.)

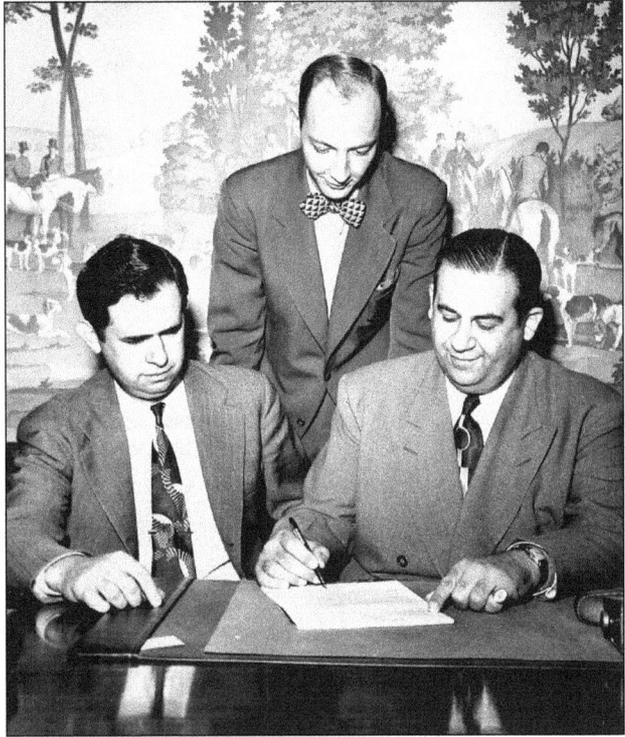

A. LEVENTHAL AND SONS. Founded in 1898, A. Leventhal and Sons still produces dental supplies and equipment. Oscar Leventhal (left), Joe Leventhal (center), and Bill Naegli are pictured at the opening of the new Leventhal Building on Moosic Street in 1950. (Courtesy of the Leventhal family.)

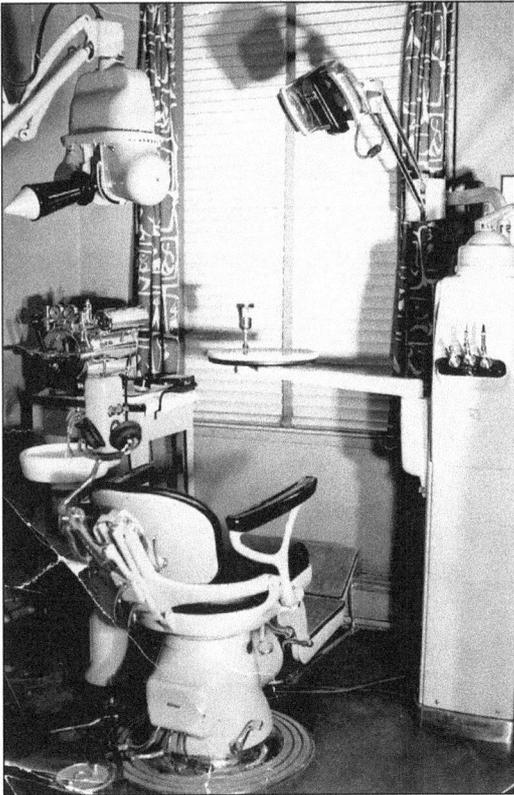

EARLY DENTAL EQUIPMENT. A. Leventhal and Sons produced dental equipment such as this in the early 20th century. (Courtesy of the Leventhal family.)

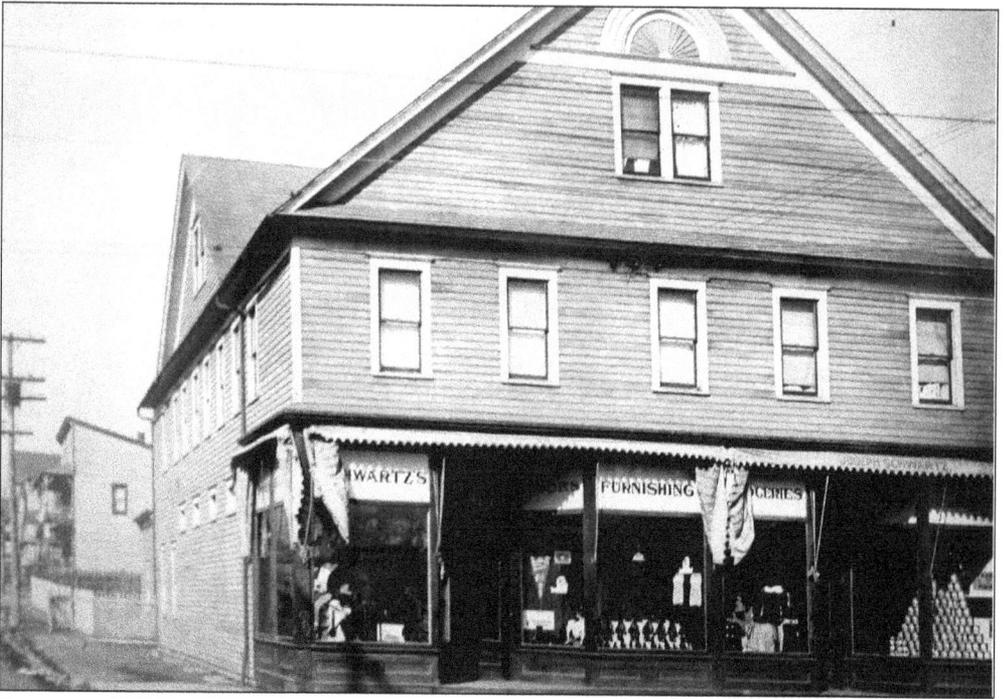

SCHWARTZ'S MEN'S SHOP. Located on Main Street in Old Forge, the Schwartz building was constructed in 1905 by Joseph Schwartz. His son William started a popular men's shop that remained in business for 93 years as the following two generations of the Schwartz family continued its operation. The small grocery on the right is that of Sam Birnbaum. (Courtesy of the Schwartz family.)

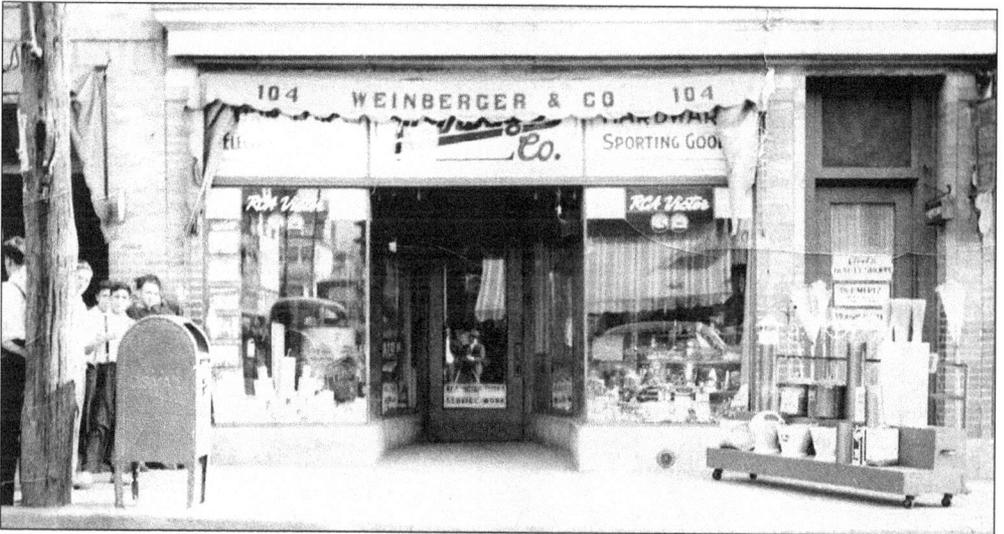

WEINBERGER'S HARDWARE STORE. Weinberger's was a familiar sight on Main Street in Old Forge for many years. (Courtesy of Nancy Weinberger.)

MAX FALLK

DEALER IN

Fancy Dry Goods, Silks and Laces

107 MAIN STREET

CLOSED SATURDAYS

Old Forge, Pa., _Oct 15,_ 191_8_

7 Blankets	@	2.75	$19.25
5 "	"	2.25	11.25
6 "	"	2.95	17.70
			$48.20
Oct. 16			
12 yds Toweling @ .15			1.80
			50.06

A MAX FALLK DRY GOODS RECEIPT. This receipt from Max Fallk's store was for the purchase of blankets and was stamped by the Old Forge Borough Department of Health. It is believed that the blankets were purchased during the flu epidemic of 1918 and were to be used in a temporary hospital. Notice that the business was closed on Saturdays. (Courtesy of David Fallk.)

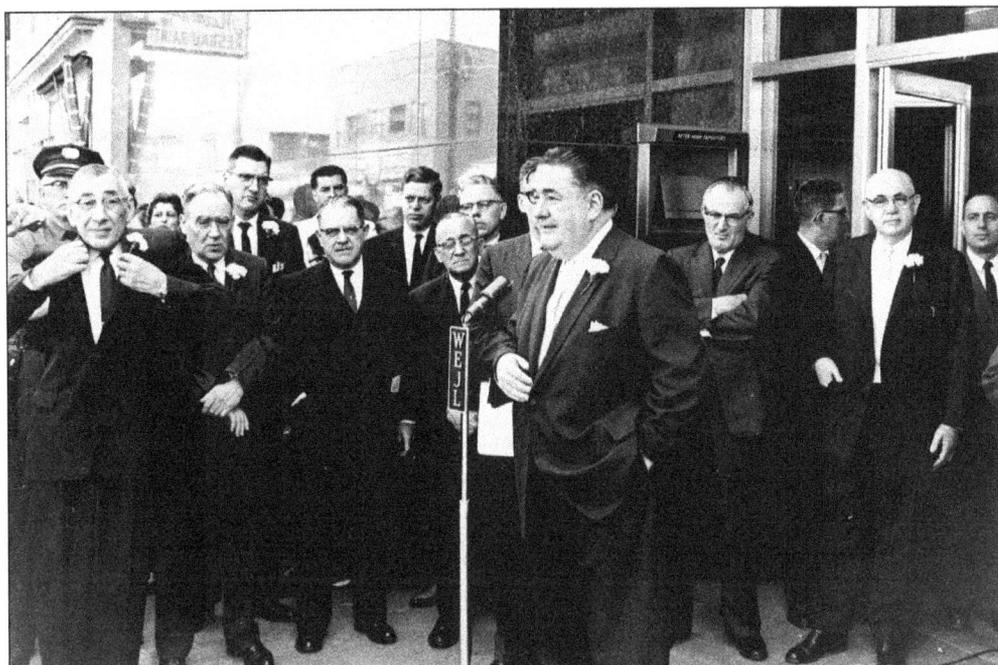

THE OLD FORGE BANK OPENING. Dedication ceremonies for the Old Forge Bank were held in 1961. Among the people pictured here are Gus Weinberger (far left) and Morris Gelb (far right). (Courtesy of the Gelb family.)

M. L. GOODMAN. Pictured in the early 20th century, M. L. Goodman was co-publisher of the *Scranton Tribune* and the *Scrantonian*. (Courtesy of Barbara Ehrenpreis.)

HERMAN GOODMAN. Herman Goodman, shown in the 1960s, was co-publisher of the *Scranton Tribune*. (Courtesy of Barbara Ehrenpreis.)

JOSEPH THE FURRIER. Joseph the Furrier was a prominent retail institution in downtown Scranton for 99 years. The originator of the business was Julius Joseph, who came to Scranton from Germany in the late 19th century and established Joseph's Fur Shop in 1892. His son Philip, and later, grandsons Harold and Joel, continued the business until it was closed in November 1991, a few months short of its 100th birthday. Pictured in 1954 are, from left to right, the following: (first row) Harold Joseph, Emily Lispi, Philip Joseph, Laura Purdy, and Lillian Dorsey; (second row) Irving Greenberg, Edward Freeman, and Joel Joseph. (Courtesy of Joel Joseph.)

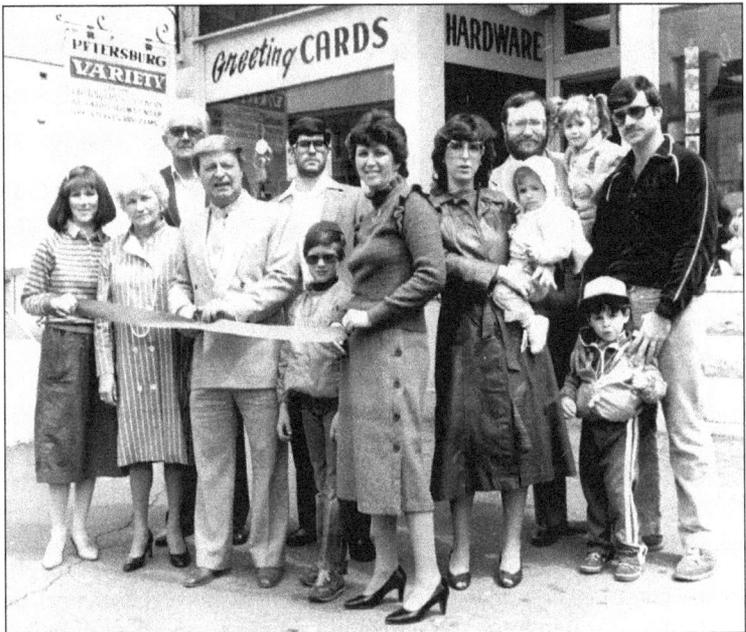

THE PETERSBURG VARIETY STORE. The Blatt family is shown in the 1980s at the opening of their Petersburg Variety Store, located at Petersburg Corners in Scranton's Hill section. (Courtesy of the Blatt family.)

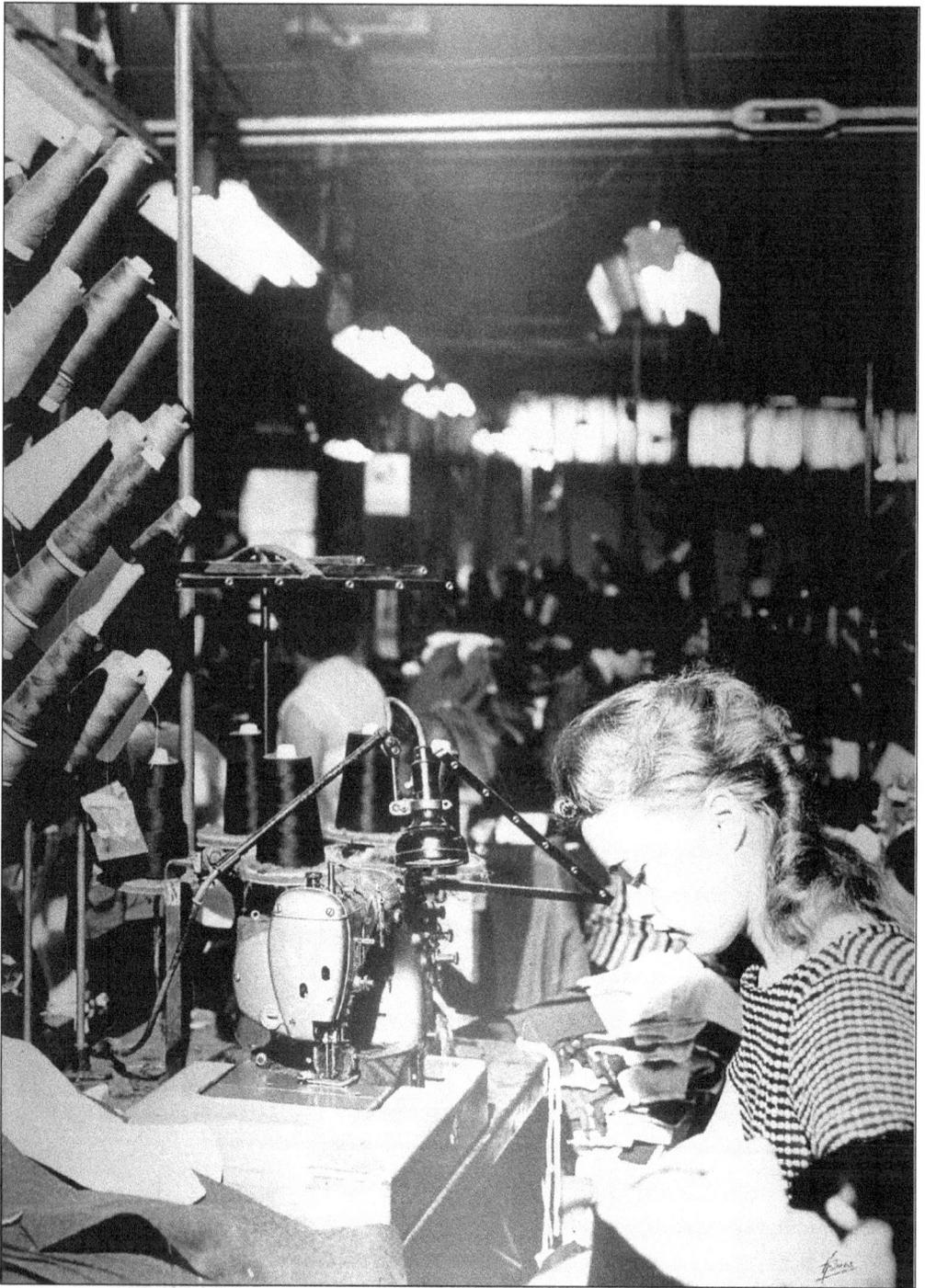

WORKING IN THE TEXTILE FACTORIES. With a ready source of power and an abundant labor force, textile manufacturing thrived in northeastern Pennsylvania. During the 20th century, many Scranton residents, including the woman shown in this 1960s photograph, were employed in the city's needle trades. After World War II, however, competition from abroad seriously affected the local industry. (Courtesy of Ed Brandes and Alperin Incorporated.)

Four

CIVIC AND PROFESSIONAL ACTIVITIES

GERTRUDE LEHMAN FREEDMAN.
Civic leader Gertrude Lehman
Freedman is shown at Allied
Rehabilitative Services in 1960.
She was active in employment
counseling, rehabilitation
services for individuals with
disabilities, and youth programs.
(Courtesy of Paula Wasser.)

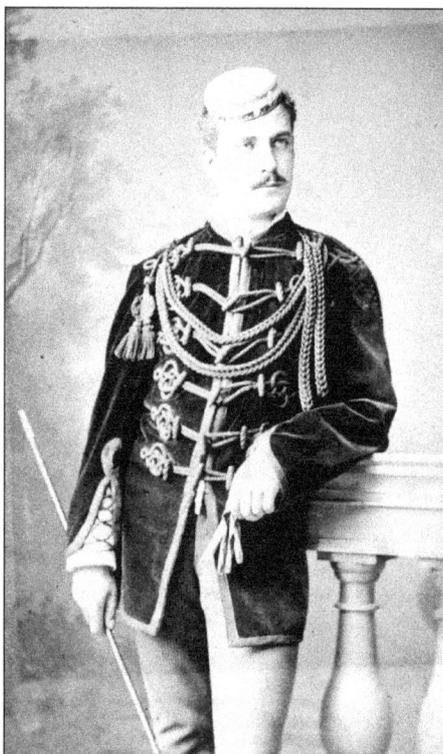

DR. ELIAS ROOS IN HEIDELBERG. Dr. Elias Roos was trained as a surgeon at the prestigious medical school in Heidelberg, Germany. He is shown wearing his cadet uniform in the 1870s. (Courtesy of Elinor Ratner.)

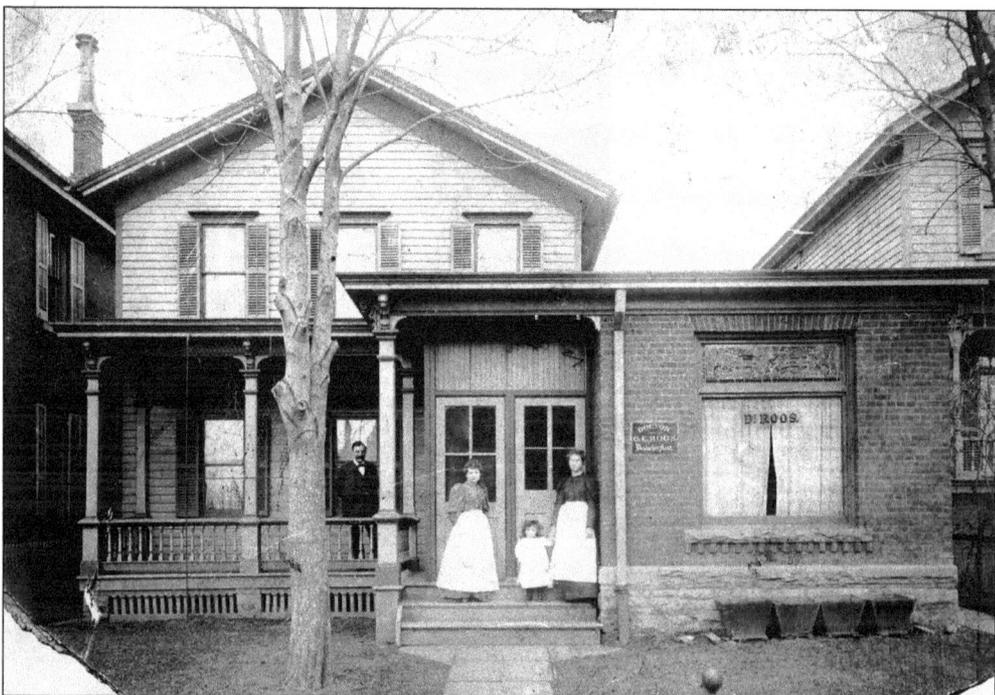

DR. ELIAS ROOS'S OFFICE. Dr. Elias Roos immigrated to the United States in 1880 and came directly to Scranton to join his uncle Simon Rice, a Scranton businessman. In Scranton, Roos maintained an office in his home, at 232 Adams Avenue. (Courtesy of Elinor Ratner.)

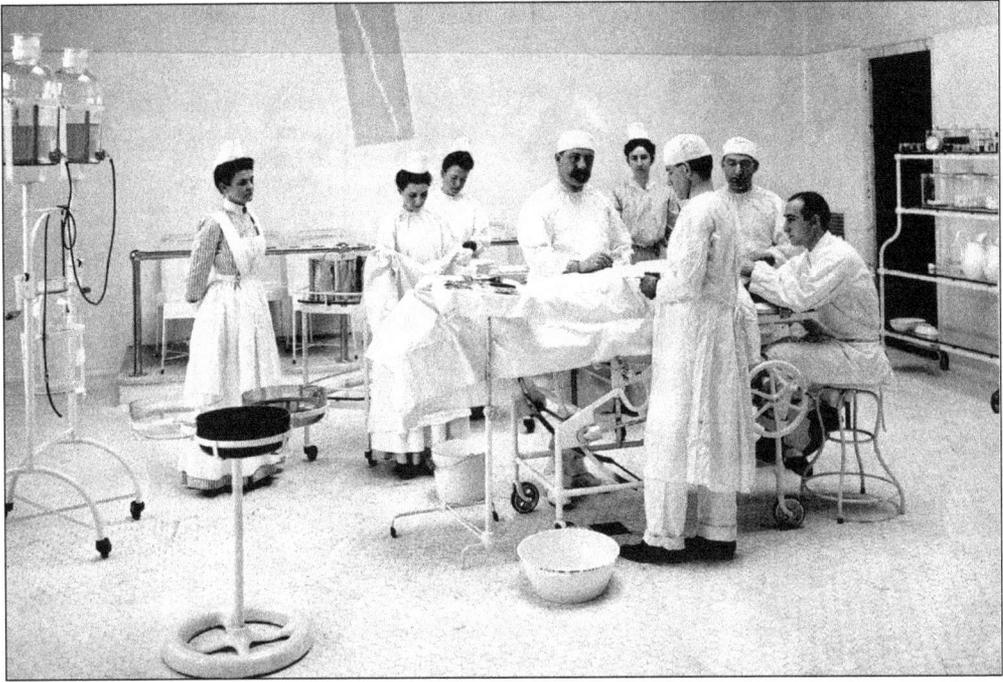

DR. ELIAS ROOS IN SURGERY. Shown in 1910 in the operating room at the Scranton State Hospital, Dr. Elias Roos was one of the first Jewish surgeons in Scranton. He was the first physician in the state of Pennsylvania to own an X-ray machine and was the first person to own an automobile in Scranton (a Stanley steamer). (Courtesy of Elinor Ratner.)

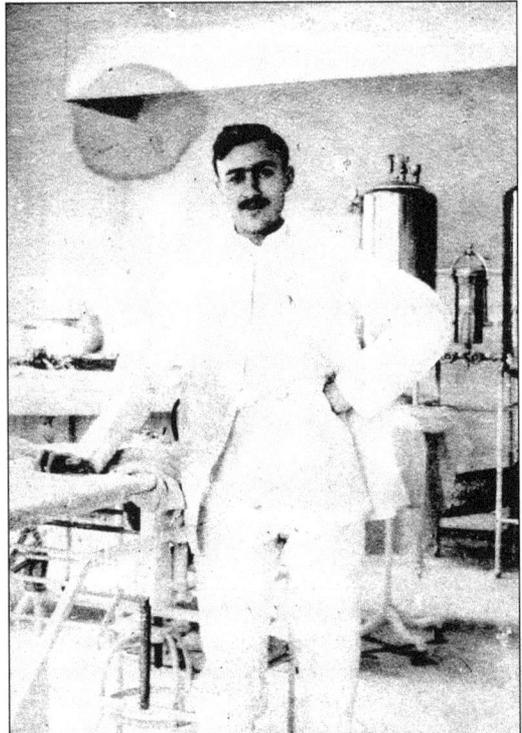

DR. HARRY GOODFRIEND. Dr. Harry Goodfriend came to Scranton in the early 20th century to work with Dr. Elias Roos. He later became Roos's son-in-law when he married Bea Roos. (Courtesy of Elinor Ratner.)

85

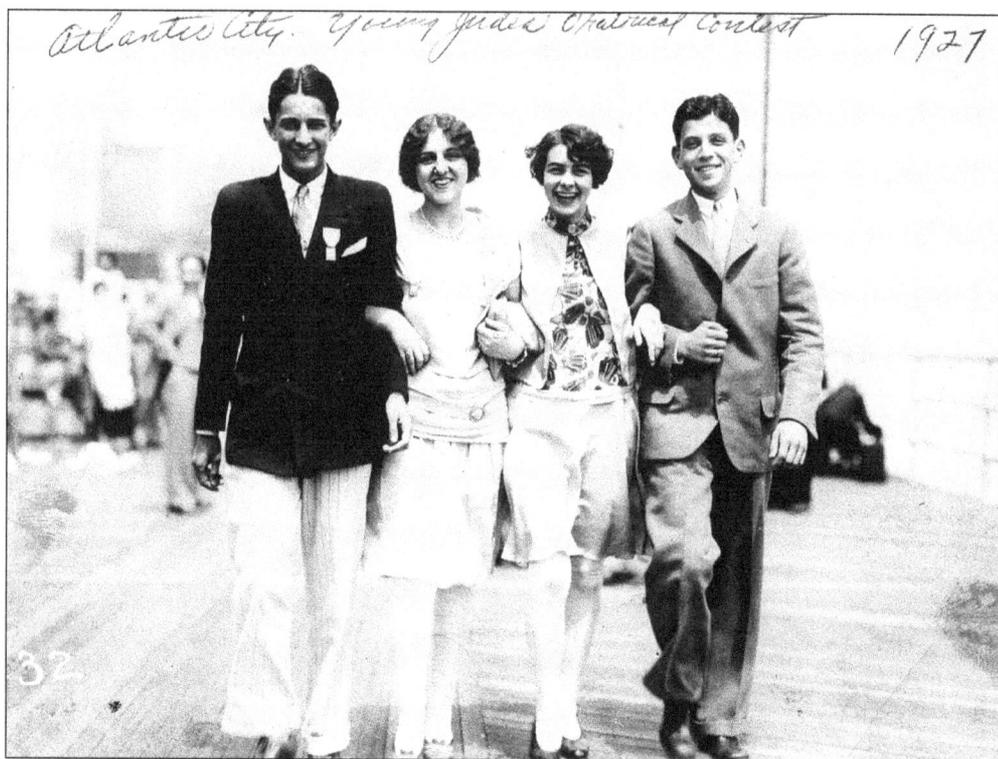

A YOUNG ORATORS COMPETITION. In 1927, Gerry Weisberger (Shair), third from the left, went to Atlantic City to compete in the Young Judea Oratorical Contest. She remained active in local theater throughout her life. (Courtesy of Sondra Shair.)

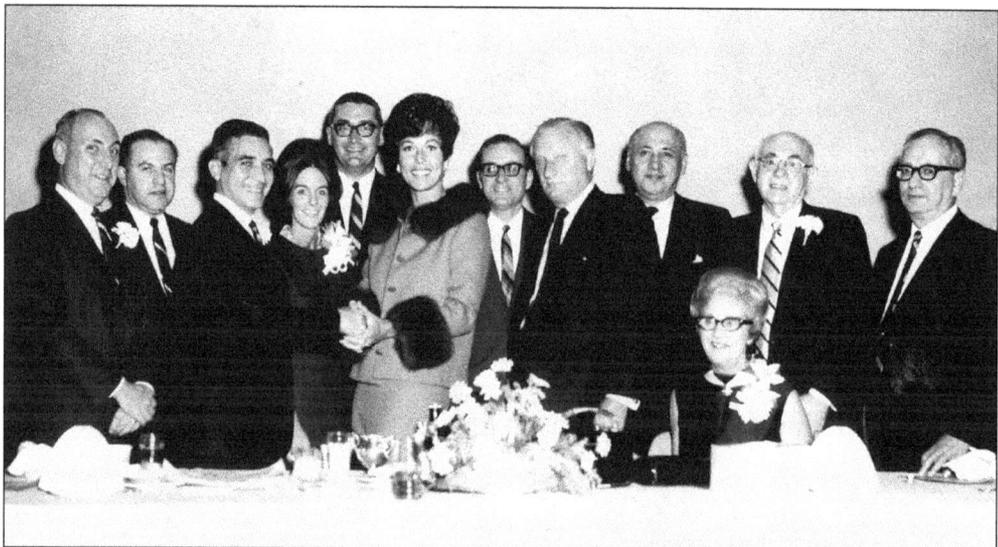

MISS AMERICA VISITING SCRANTON. In 1968, the United Jewish Appeal sponsored a reception for Bess Myerson, the only Jewish woman to be crowned Miss America. Pictured from left to right are Paul Alamar, Joe Dubin, Joe Hodin, Dorie Goodman, Bob Nolan, Bess Myerson, Lewis Ziman, Leo Swartz, Julius Weinberger, Mae Gelb, Morris Gelb, and George Joel. (Courtesy of the Gelb family.)

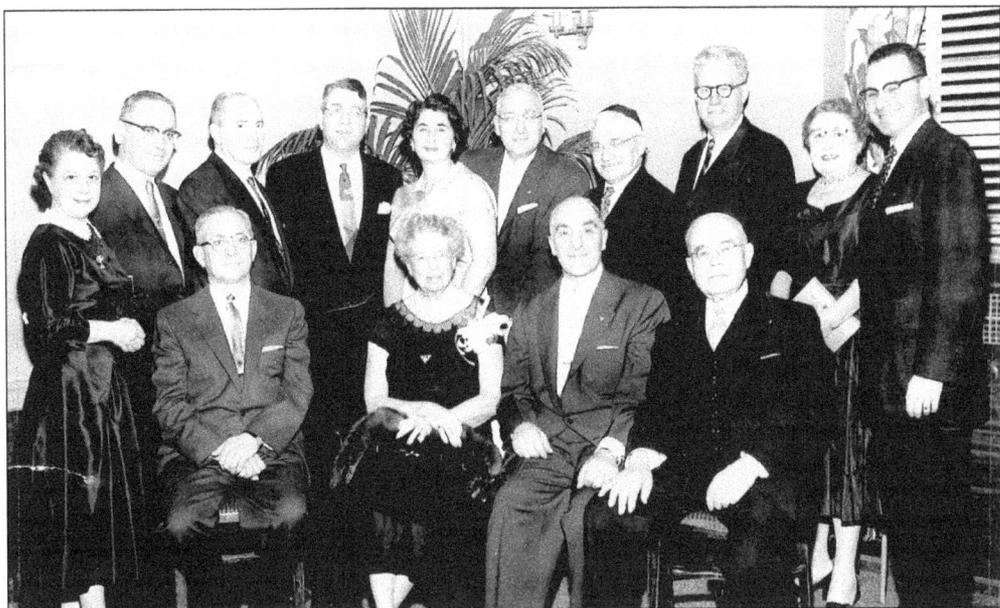

ELEANOR ROOSEVELT VISITING SCRANTON. In the early 1950s, former First Lady Eleanor Roosevelt came to Scranton. Pictured from left to right are the following: (first row) Irving Harris, Eleanor Roosevelt, M. L. Hodin, and A. B. Cohen; (second row) Rebecca Lear, Joe Harris, Cantor William Horn, Rabbi Simon Shoop, Mary Ellowitz, unidentified, Rabbi Henry Guterman, Mayor James Hanlon, Mrs. Hanlon, and Rabbi Erwin L. Herman. (Courtesy of the Hodin family.)

ELIE WIESEL AS A GELB LECTURE SERIES SPEAKER. During the 1980s, Elie Wiesel visited the University of Scranton to speak in the Gelb Lecture Series, presented through the university's Judaic Studies Program. From left to right are Elie Wiesel, Sondra Myers, Morris Gelb, Fr. J. A. Panuska (president of the University of Scranton), and Mae Gelb. (Courtesy of the Gelb family.)

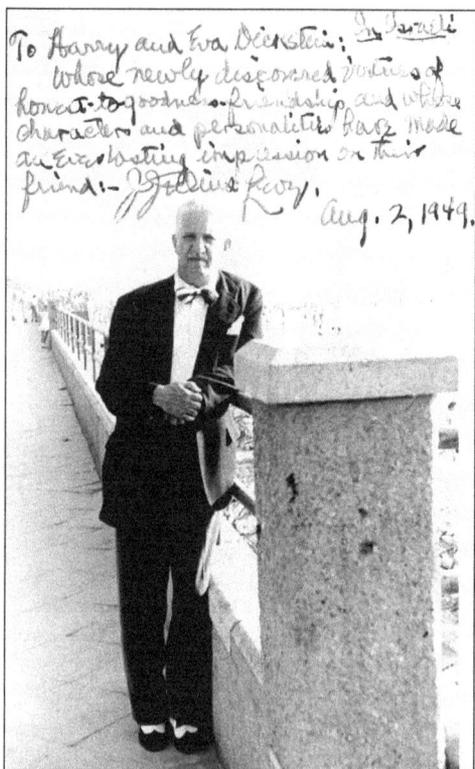

J. Julius Levy. J. Julius Levy was a well-respected lawyer in Scranton. On a visit to Israel in 1949, he inscribed this photograph to his good friend Harry Dickstein. (Courtesy of Shirley Hollenberg.)

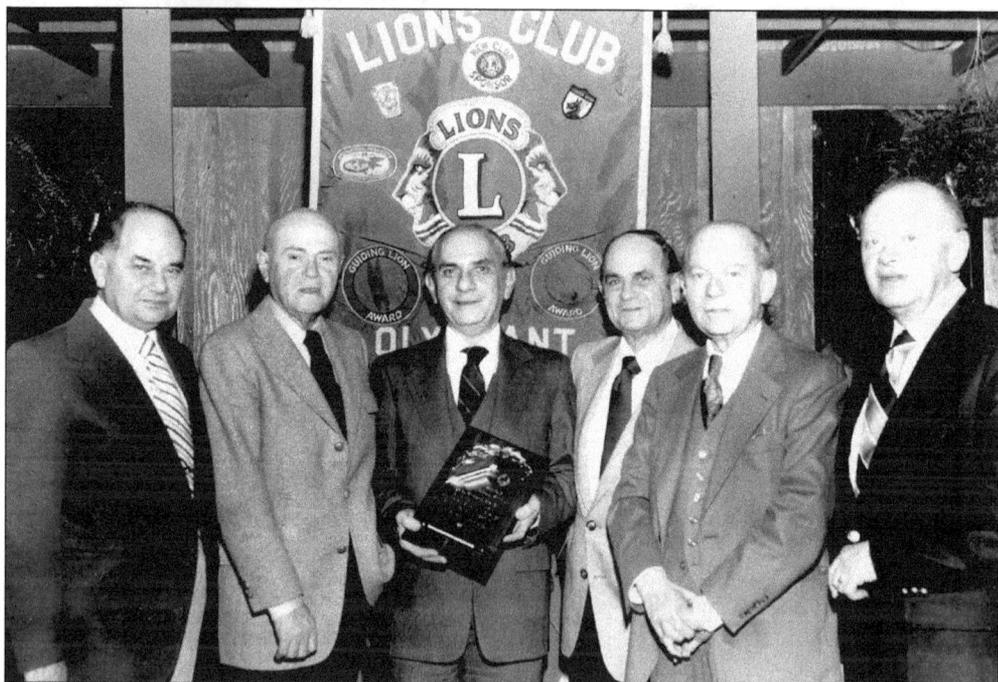

The Lions Club Honoring the Pinkus Brothers. The Pinkus brothers stand together as they are honored by the Lions Club in the 1960s. The brothers are, from left to right, Myron, Joseph, Harold ("Jad"), Irving, Jack, and Herman. (Courtesy of Helen Pinkus.)

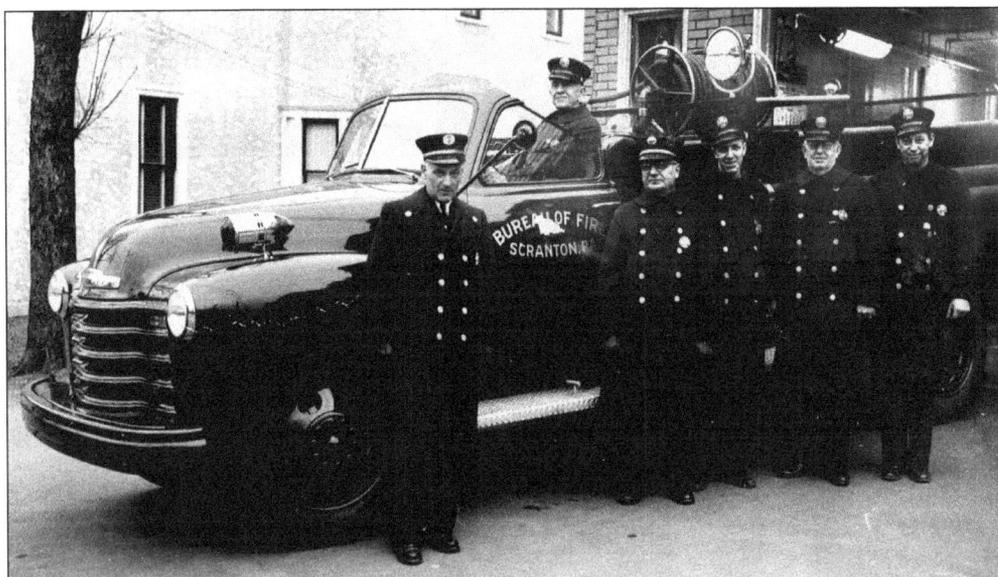

EDWARD WEISS AND THE SCRANTON FIRE DEPARTMENT. Edward Weiss held a number of positions within the Scranton Fire Department, including district chief. He was the only Jew ever to attain officer's rank within the department during the years in which he served. Weiss is seen standing at the front of the fire truck in this 1949 photograph. He retired from the department in 1969. (Courtesy of Carol Rubel.)

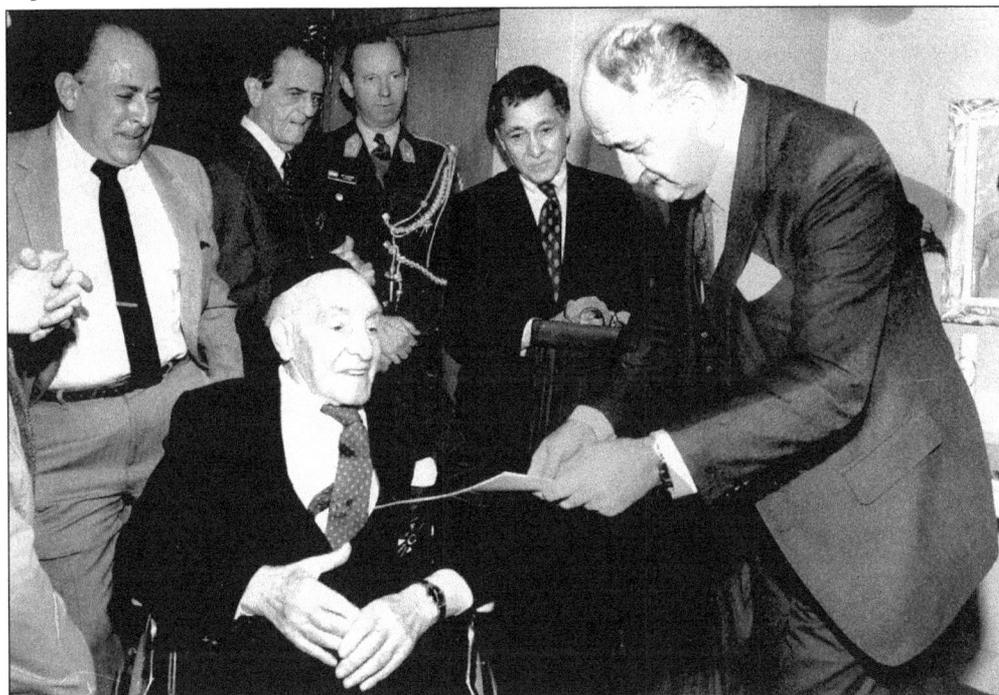

M. L. HODIN RECEIVING AN AUSTRIAN MILITARY MEDAL. In 1991 M. L. Hodin, age 98, received a long-overdue Military Service Cross of Honor from the Austrian ambassador to the United States. In 1918, before he immigrated to the United States, Hodin served in the Austrian military. (Courtesy of the Hodin family.)

THE PARKER FAMILY. Young Jerry Parker (far left) grew up to be a city councilman. He is pictured with unidentified family members in this photograph from the 1920s. (Courtesy of Natalie Solfanelli.)

LACKAWANNA COUNTY COMMISSIONERS. This group includes three men who held positions in Lackawanna County government during the 1960s. From left to right are Bob Pettinato (commissioner), Charlie Luger (commissioner), Jerry Parker (city councilman), Joe Hodin, and unidentified. (Courtesy of Joe Hodin.)

AUGUST WEINBERGER CAMPAIGN MATERIALS. In 1939 Weinberger was the Republican candidate for school director of Old Forge. (Courtesy of Nancy Weinberger.)

DAVID MILLER CAMPAIGN MATERIALS. David Miller was elected to represent the 10th Congressional District as a delegate to the Republican National Convention.

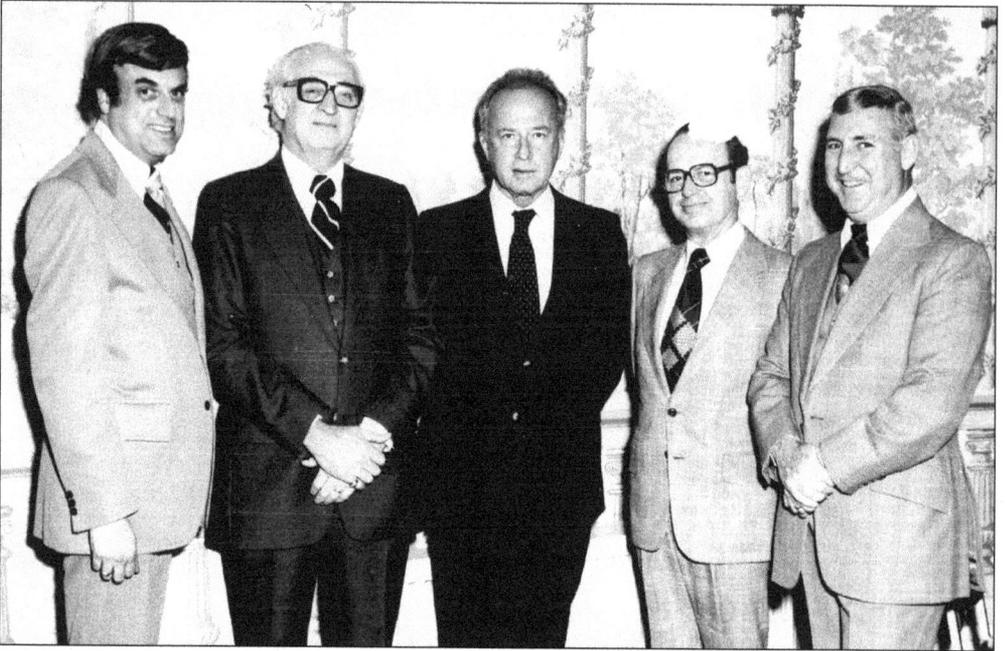

YITZHAK RABIN VISITING SCRANTON. This 1967 photograph shows, from left to right, Seymour Brotman, Alvin Nathan, Yitzhak Rabin, Ignatz Deutsch, and Paul Alamar at a United Jewish Appeal reception honoring Rabin. (Courtesy of Melba Nathan.)

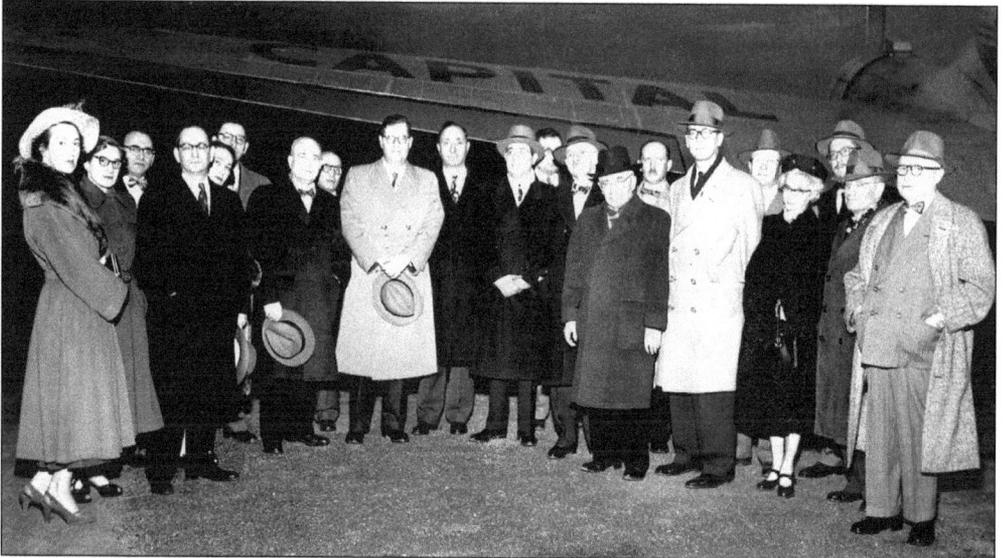

ABBA EBAN AT THE WILKES-BARRE/SCRANTON INTERNATIONAL AIRPORT. This 1951 reception committee greeted Abba Eban, Israel's ambassador to Washington, D.C., and permanent representative to the United Nations. Ambassador Eban later became Israel's deputy prime minister. From left to right are Rose Chenetz, Sandy Ziman, Sol Ziman, George Joel, unidentified woman, unidentified man, A. B. Cohen, unidentified man, Abba Eban, Harry Dickstein, Rabbi Simon Shoop, unidentified man, Harry Grossinger, Rabbi Henry Guterman, and Cal Ellowitz. The five men and one woman at the right end of the group are unidentified. (Courtesy of the Jewish Community Center.)

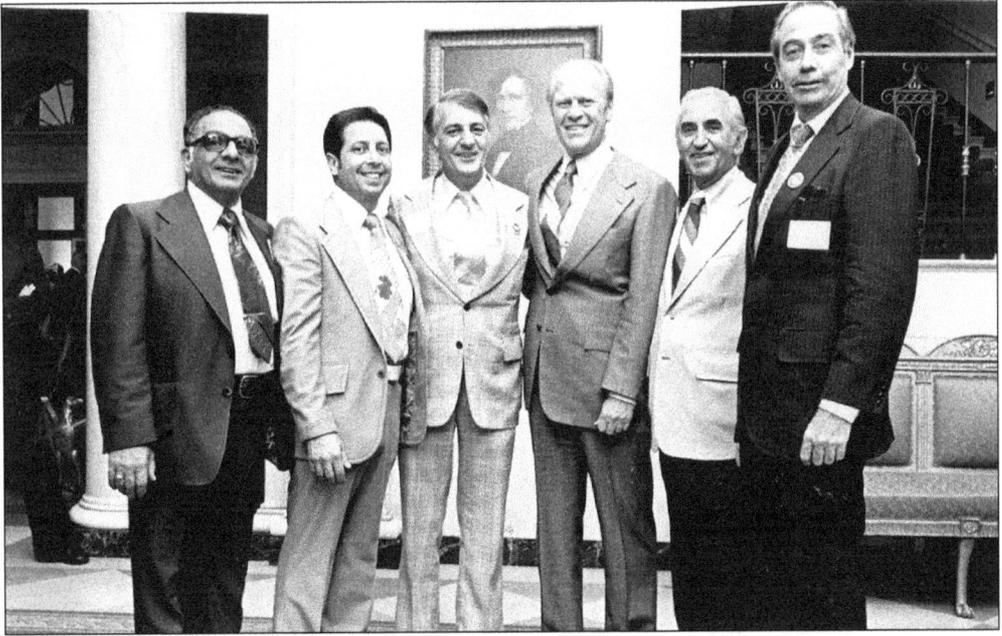

PRES. GERALD FORD AND GOV. WILLIAM SCRANTON WITH DELEGATES. Seen in this 1970s photograph are, from left to right, two unidentified delegates, Charles Morell (a Stroudsburg delegate), Pres. Gerald Ford, delegate David Miller, and Gov. William Scranton. (Courtesy of Helen Miller.)

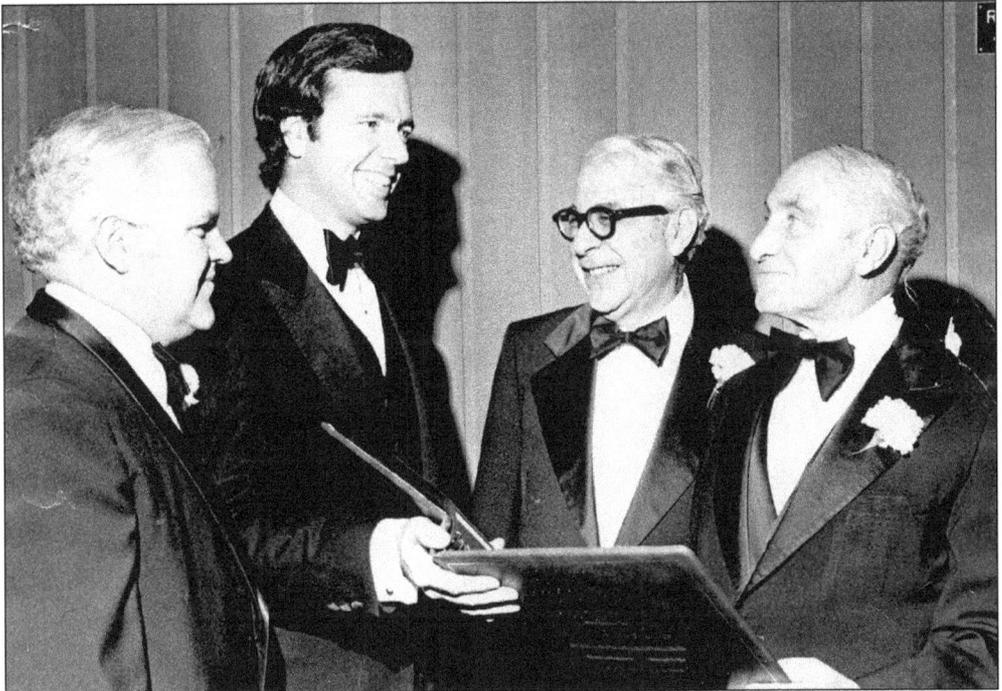

CONGRESSMAN JOSEPH MCDADE AND SEN. JOHN HEINZ. From left to right, Congressman Joseph McDade and Sen. John Heinz are shown at an awards ceremony with Rabbi Shoop and M. L. Hodin in the 1980s. (Courtesy of Lisa Starr.)

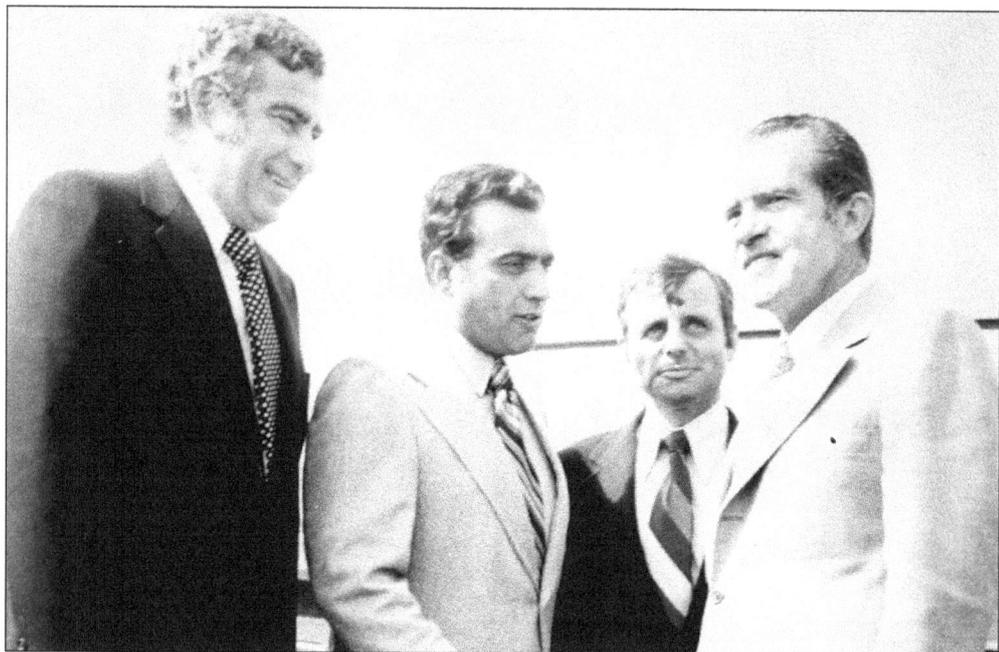

COMMISSIONER CHARLES LUGER WITH PRES. RICHARD NIXON. Charles Luger (far left), a longtime county commissioner and community activist, had occasion to meet several presidents, including Richard Nixon (far right). The other two men are unidentified. (Courtesy of Lisa Starr.)

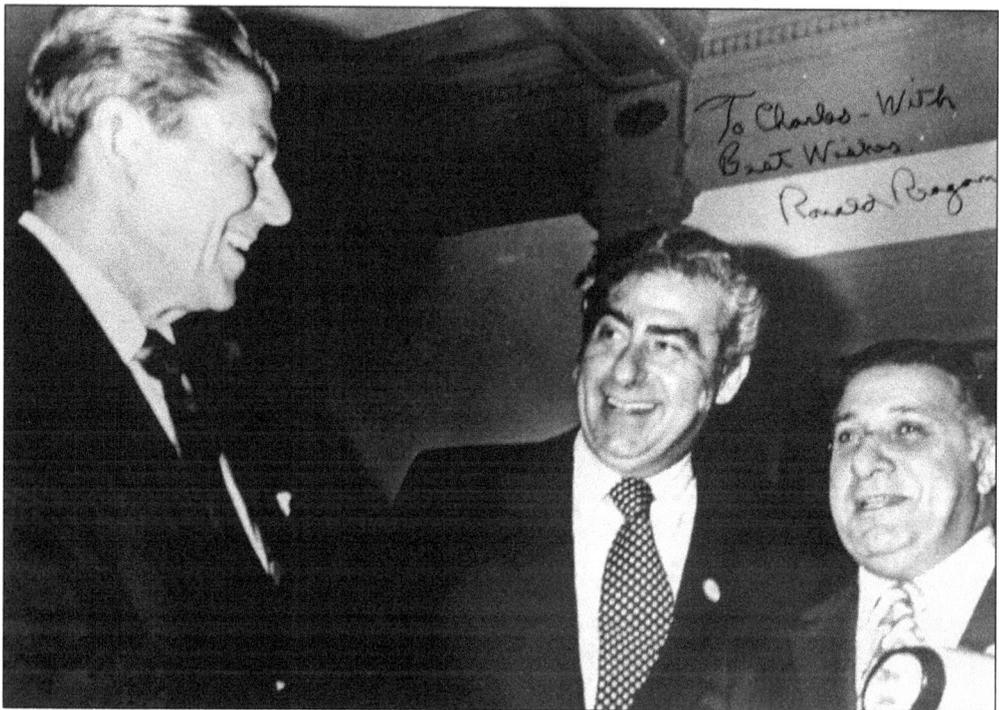

COMMISSIONER CHARLES LUGER WITH PRES. RONALD REAGAN. Here Commissioner Luger (center) is pictured with President Reagan (left) and Mayor Frank Rizzo of Philadelphia. (Courtesy of Lisa Starr.)

94

Five

MILITARY SERVICE

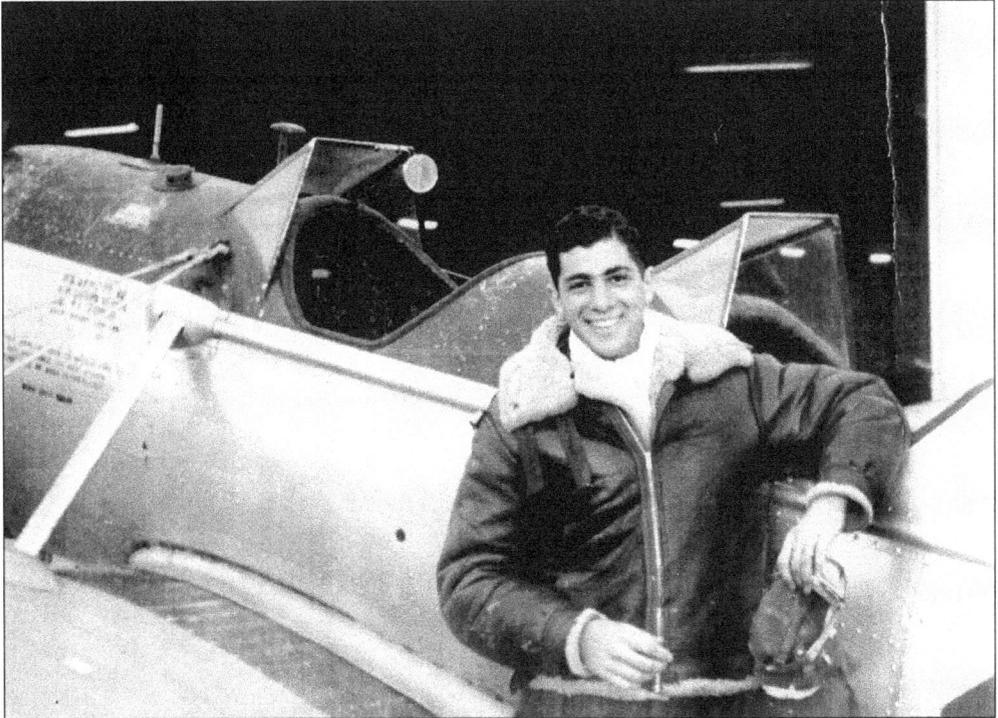

LT. MARVIN "PETE" PEARL WITH HIS B-17. During World War II, Lt. Marvin "Pete" Pearl flew 35 combat missions in a B-17. He earned an Air Medal with Five Oak Leaf Clusters. (Courtesy of Beverly Meil.)

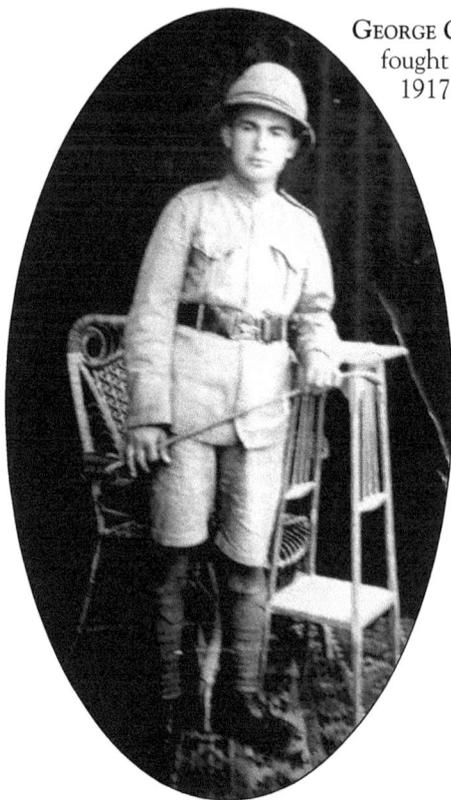

GEORGE GREEN IN JEWISH LEGION UNIFORM. George Green fought for the Jewish Legion and served in Palestine in 1917. (Courtesy of Harriet Rosenstein.)

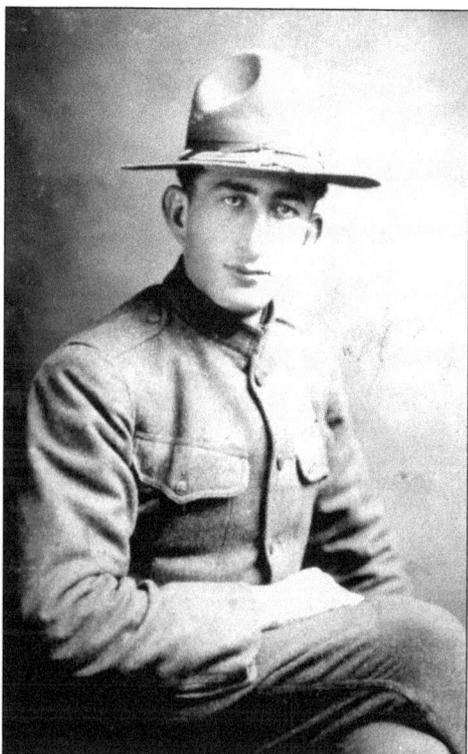

NATHAN "TONY" WEINBERGER IN HIS WORLD WAR I UNIFORM. Nathan Weinberger, husband of Sarah Weinberger, is shown in uniform in 1918. (Courtesy of Nancy Weinberger.)

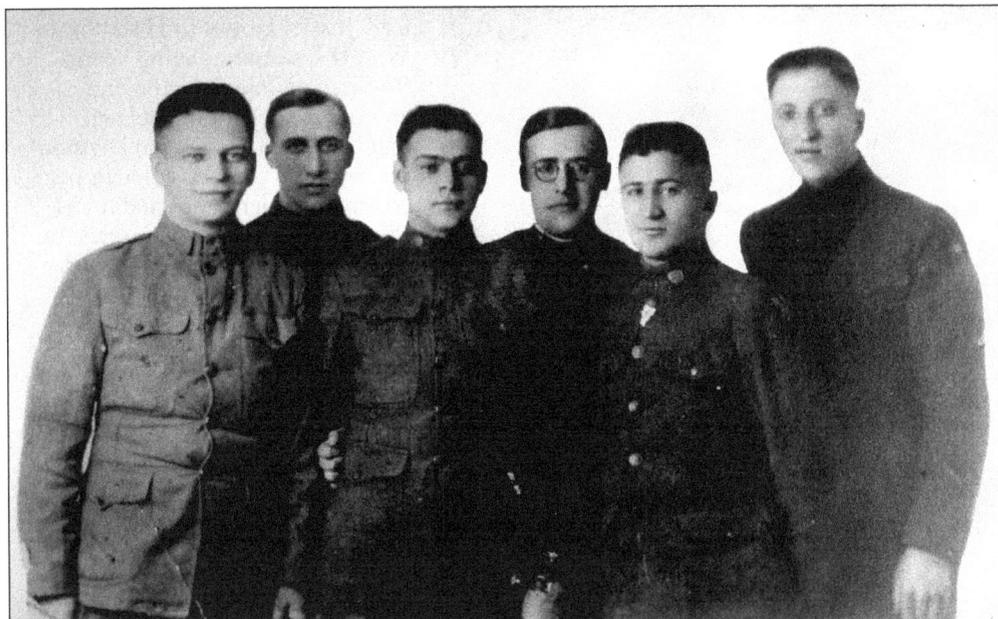

JEWISH SOLDIERS FROM SCRANTON SERVING IN WORLD WAR I. Seen in Paris in 1918 are, from left to right, Harry Spiegel, Samuel Suravitz, Jack Samsalig, Sandy Weisberger, Morris Waldman, and Meyer Bullman. Sandy Weisberger died in Paris in 1919. After completing his military service, Weisberger had remained in Paris to help the Jewish Welfare Board distribute matzohs during Passover. He was killed in a fall down an elevator shaft. The Jewish War Veterans post in Scranton was named after him and Leon Kaplan. (Courtesy of Joe Hodin.)

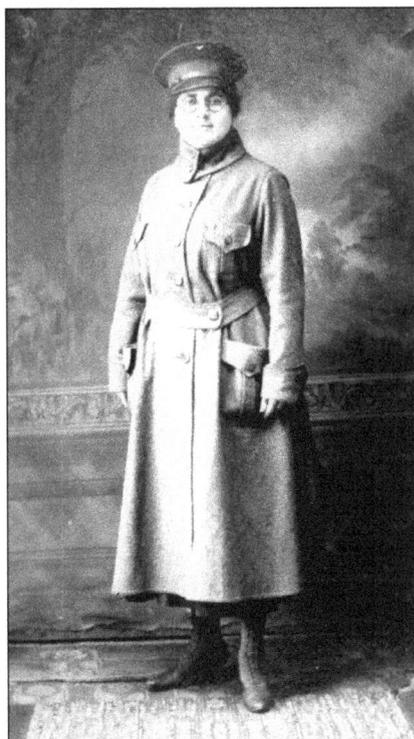

SARAH WEINBERGER IN HER WORLD WAR I UNIFORM. Sarah Weinberger, wife of Nathan Weinberger, is pictured in uniform in 1918. (Courtesy of Nancy Weinberger.)

CPL. JOSEPH HODIN IN HIS WORLD WAR II UNIFORM. During World War II, Cpl. Joseph Hodin and another member of the field artillery unit of the 7th Army's 3rd Division captured two German colonels near Nuremberg, Germany. Hodin was wounded in action on two separate occasions and was decorated with a Silver Star and two Purple Hearts. (Courtesy of the Hodin family.)

MAJ. MILTON J. GOLDSTEIN, M.D., IN HIS WORLD WAR II UNIFORM. Milton J. Goldstein, a prominent Scranton physician, served his country during World War II as a major in the U.S. Army. (Courtesy of Margie Rosenberg.)

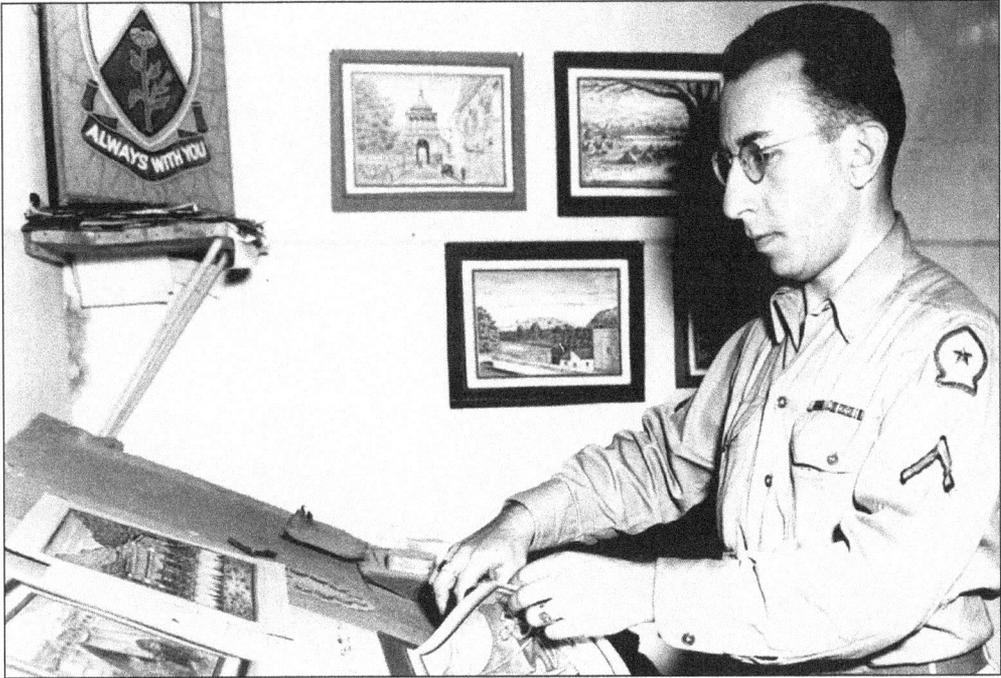

LESTER COHEN PREPARING FOR AN ART EXHIBITION. While serving with the U.S. Medical Corps from 1941 to 1945, artist Lester Cohen produced a series of vibrant watercolors documenting his experiences abroad in World War II. These works were exhibited at several venues upon his return to the United States in 1945. (Courtesy of Faye Spatt.)

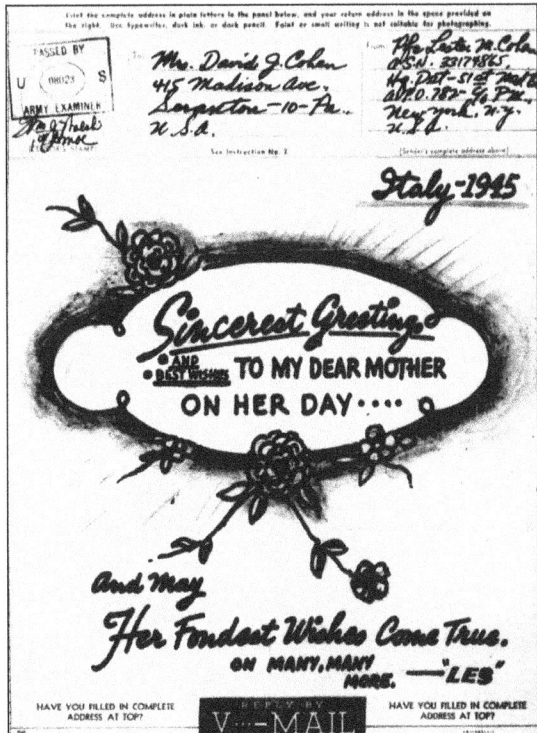

MOTHER'S DAY V-MAIL. An example of World War II "V-mail" is seen here. In 1945, Lester Cohen designed and sent this Mother's Day greeting to Fannie Schames Cohen. During the war, the U.S. military saved money and cargo space by creating a photographic system for conveying letters to and from servicemen and their folks back home. Messages were first written on "V-mail" forms, which were then photographed on microfilm. The small rolls of film (not the bulky letters themselves) were shipped overseas to postal centers, where the images of the letters were printed on photographic paper, and these were ultimately delivered to the addressees. (Courtesy of Faye Spatt.)

SHIRLEY HOLLENBERG AND LOUIS DINNER IN UNIFORM. After completing an accelerated study program at Cornell University, Shirley Hollenberg served in the U.S. Navy as a gunnery instructor during World War II. She is shown with her cousin Louis Dinner in Pensacola, Florida. (Courtesy of Shirley Hollenberg.)

CAPT. LOUIS PLOTKIN IN HIS WORLD WAR II UNIFORM. From 1942 to 1946, Capt. Louis Plotkin served in the U.S. Air Force as a communications officer. (Courtesy of the Plotkin family.)

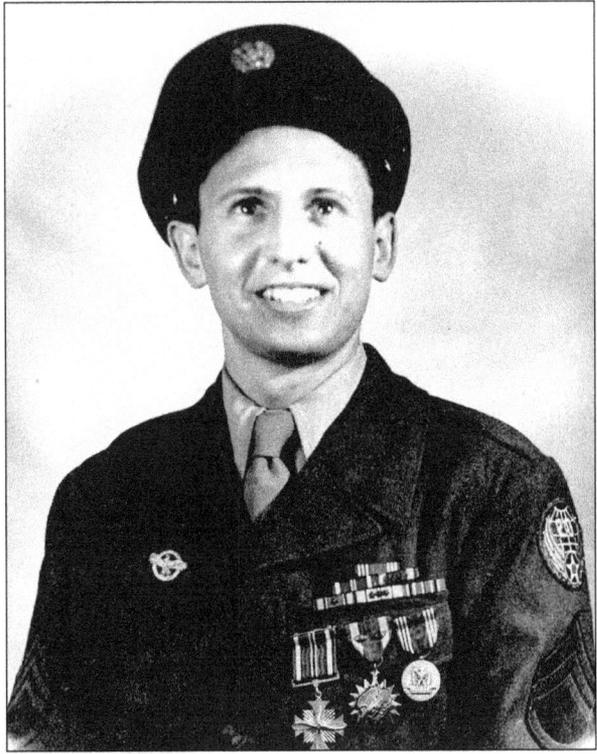

JEROME KARNOFF IN HIS WORLD WAR II UNIFORM. Jerome Karnoff, pictured here in 1943, was awarded the Distinguished Flying Cross for taking aerial photographs that identified a Japanese airplane-manufacturing plant during World War II. (Courtesy of Michael Karnoff.)

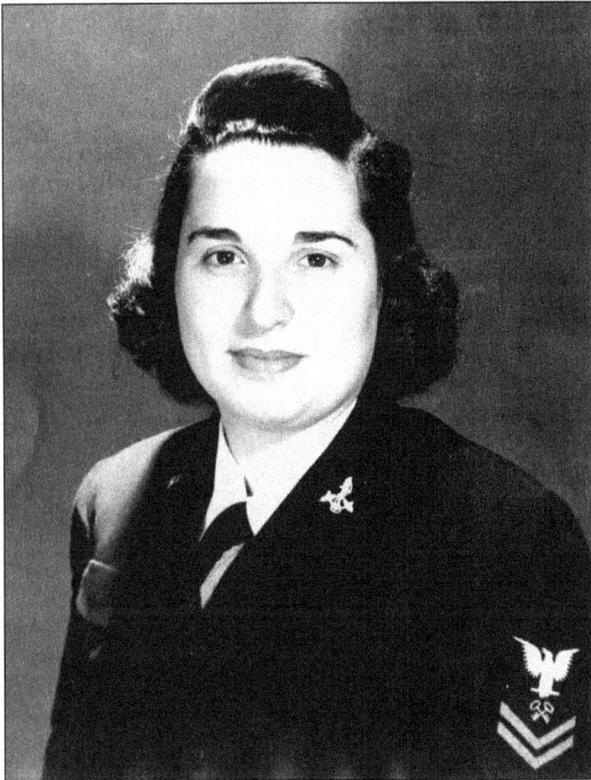

ANITA SIEGEL PLOTKIN IN HER WORLD WAR II UNIFORM. From 1942 to 1945, Anita Siegel Plotkin served in the U.S. Navy as a storekeeper first class. (Courtesy of the Plotkin family.)

101

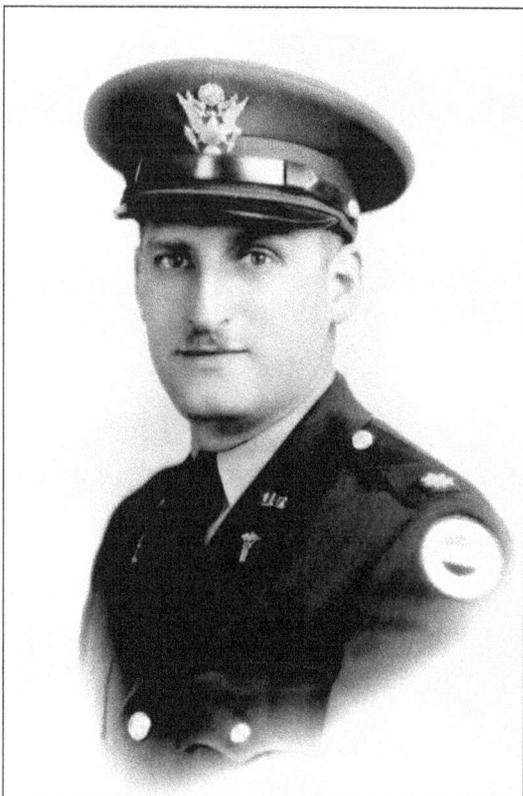

DR. BERNARD SMILEY. Dr. Bernard Smiley, a dentist, served as a major in the U.S. Army during World War II. (Courtesy of Mrs. Bernard Smiley.)

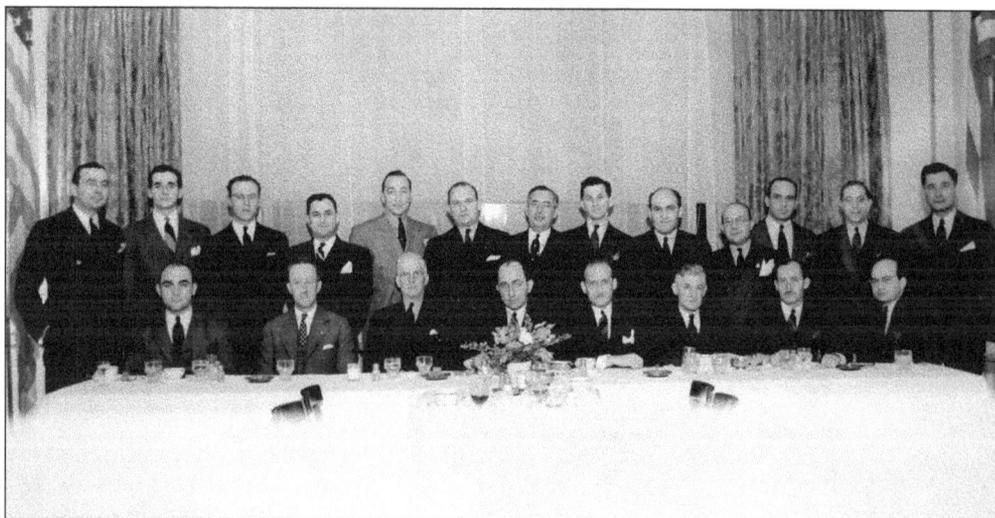

A BANQUET FOR DR. BERNARD SMILEY. During the 1940s, the YMHA Strivers' Club held a send-off banquet for Dr. Bernard Smiley and Dr. Jack Newman as they entered the military during World War II. (Courtesy of Mrs. Bernard Smiley.)

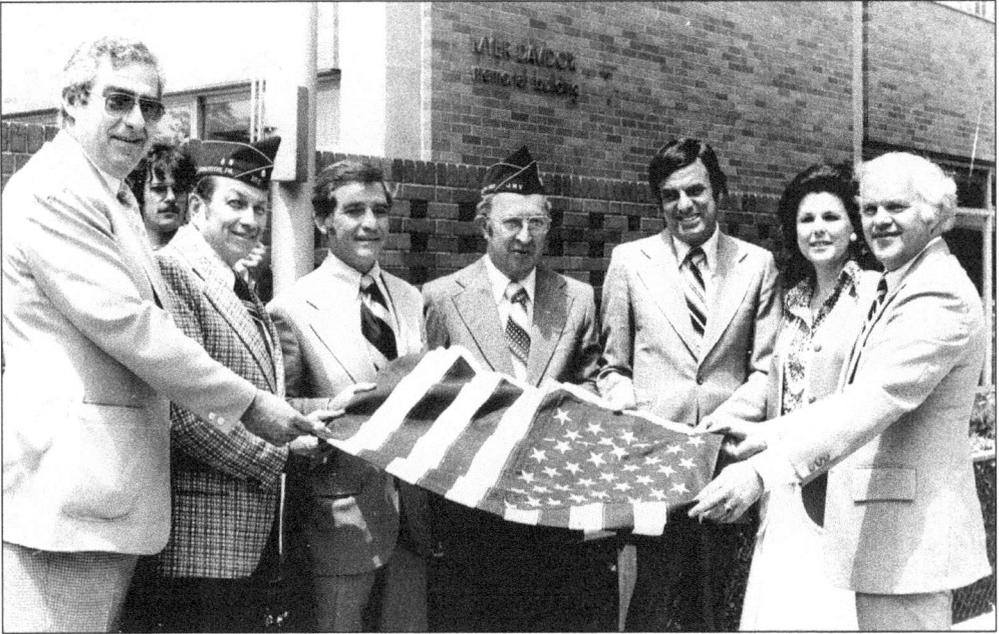

PRESENTATION OF A FLAG TO JEWISH WAR VETERANS. In the 1970s, Congressman Joseph McDade (far right) and his wife presented a flag from the Capitol to the Jewish War Veterans for the Jewish Community Center flagpole. (Courtesy of Jewish War Veterans.)

A BREAKFAST HONORING MICHAEL AND SAM WEISBERGER. In 1981, the Weisberger brothers—Michael (seated second from left) and Sam (seated third from left)—were honored for their military service. (Courtesy of Beth Shalom Synagogue.)

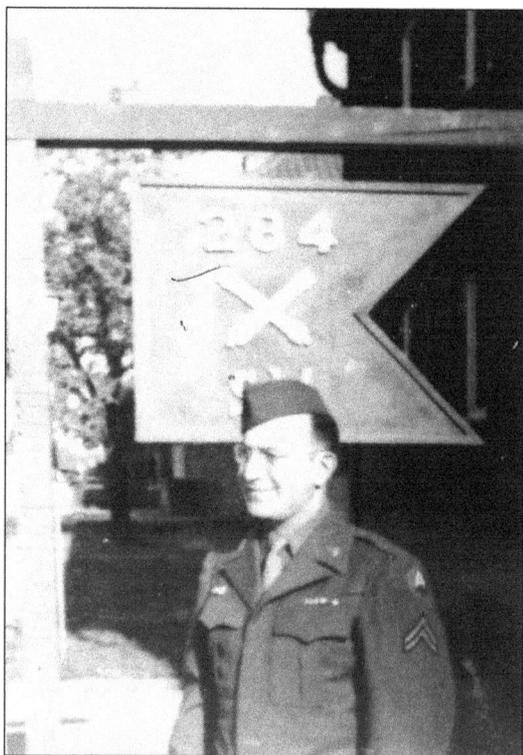

ABE PLOTKIN AT DACHAU. In 1944–1945, Abe Plotkin was involved in the Allied liberation of the Ohrdruf concentration camp. He is shown at Dachau in 1945. Plotkin was also instrumental in efforts to relocate displaced persons following the war, and he became active in Holocaust education programs upon returning to the United States. (Courtesy of Abe Plotkin.)

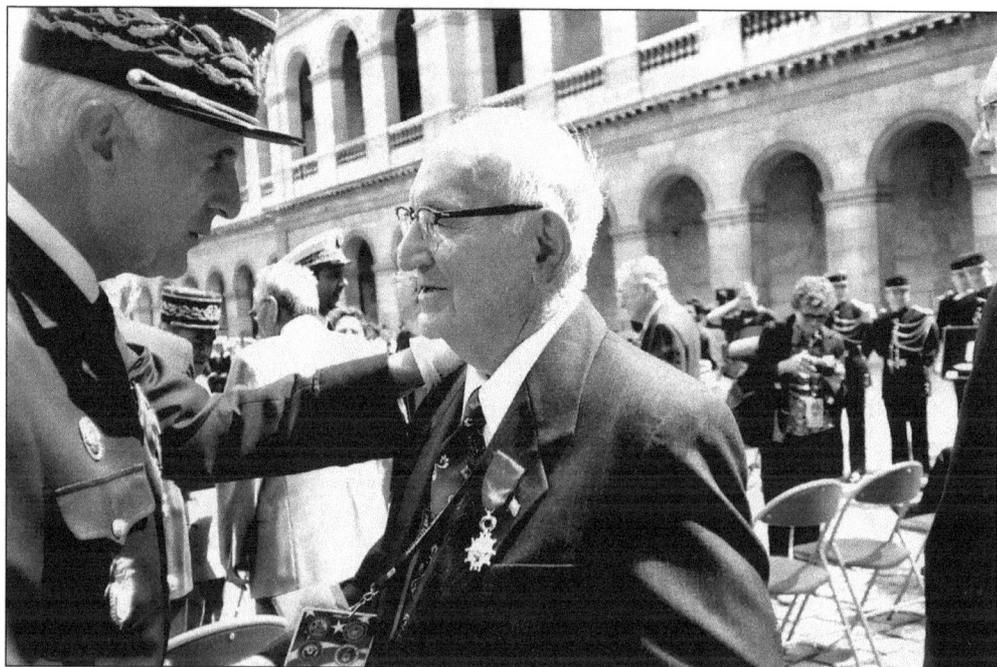

ABE PLOTKIN RECEIVING THE FRENCH MEDAL OF HONOR. In 1981 Abe Plotkin was honored by the U.S. Holocaust Memorial Council for valiant service during the Allied forces' 1944–1945 liberation of Nazi concentration camps. His efforts were further recognized in 2004, when he was awarded the French Medal of Honor. (Courtesy of Abe Plotkin.)

Six

FAMILY AND FRIENDS

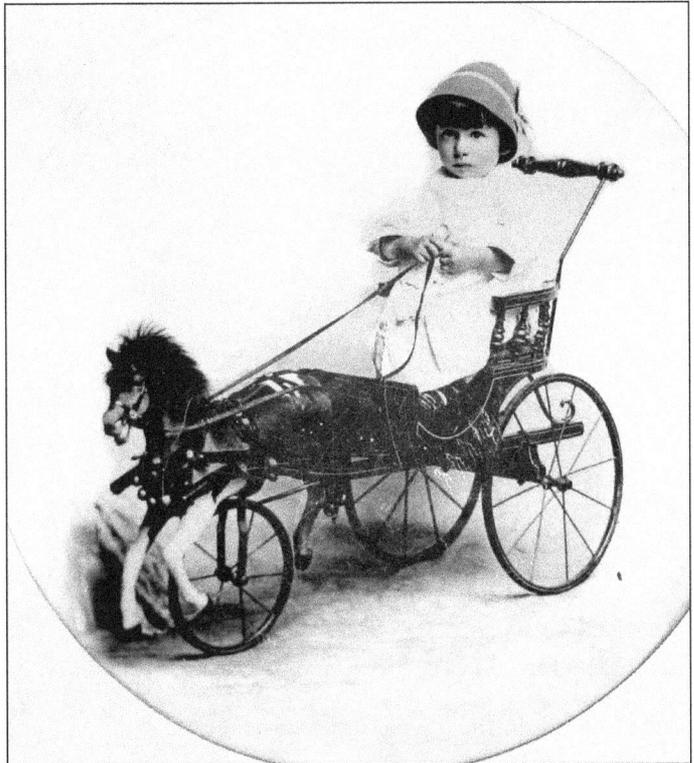

LESTER COHEN IN A PONY CART. Lester Cohen, pictured in the early 1900s with one of his favorite toys, was the son of David and Fannie Schames Cohen. He grew up to become a graphic artist and served in the military during World War II.

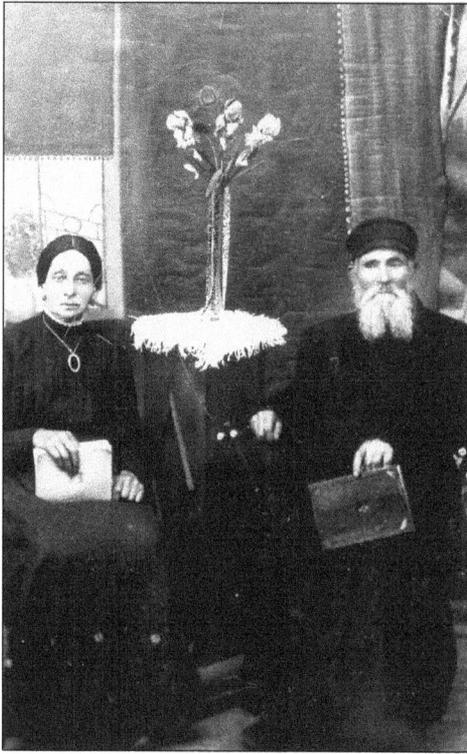

SHMUEL AND BASHA (KAMIEN) GELUDA. The Geludas, shown in Poland in the 1890s, were the ancestors of an early Scranton family who adopted the name Gilder upon coming to the United States. (Courtesy of Nancy Weinberger.)

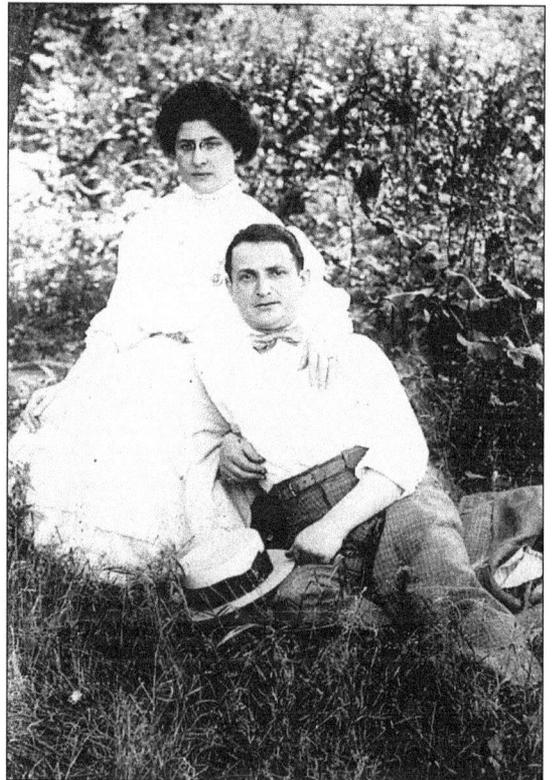

HENRY AND LENA LEVINE. Henry and Lena Levine spent their honeymoon in the Catskills in 1907. (Courtesy of Rachel Weisberger.)

GUS AND LENA WEINBERGER. Gus and Lena Weinberger, seen here as a young couple in the late 19th century, went on to run a hardware store in Old Forge. (Courtesy of Nancy Weinberger.)

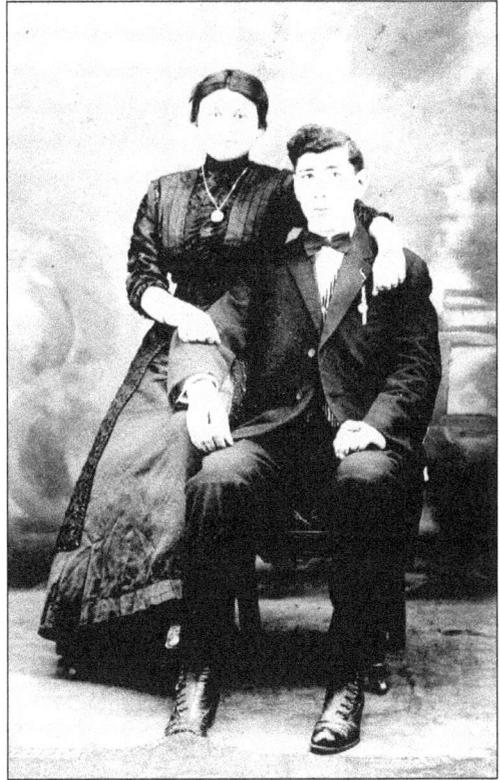

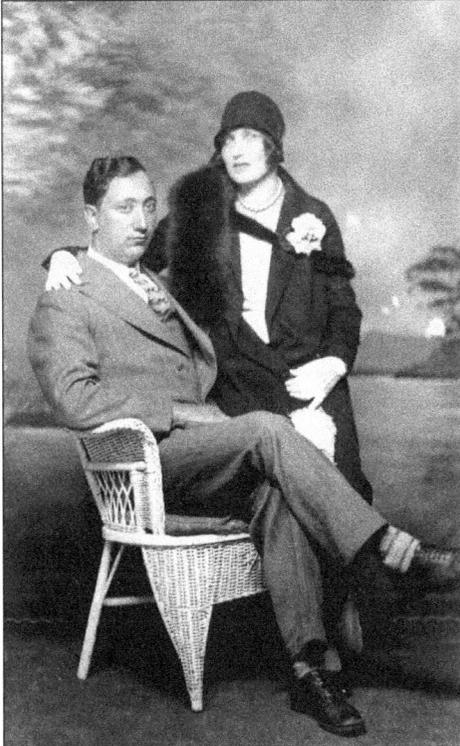

HARRY AND EVA DICKSTEIN. The Dicksteins were active in Scranton business as well as community service. (Courtesy of the Dickstein family.)

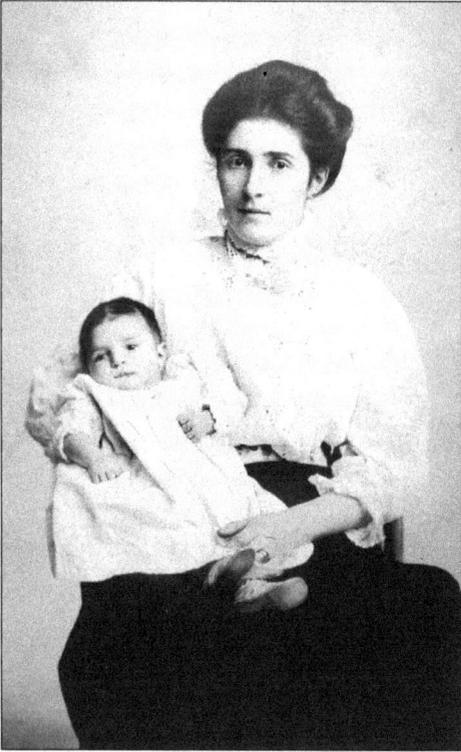

RACHAEL RABINOWITZ COHEN WITH SON ISADORE. This Scranton mother and son are pictured in 1907. (Courtesy of Helen Pinkus.)

SOPHIE EISNER HARRIS AND SON HARRY. Harry Harris was the valedictorian of the Scranton High School class of 1919. (Courtesy of the Harris family.)

MOLLY KESSLER AND DAUGHTER LUCILLE.
This Scranton mother and daughter are
pictured in 1917. (Courtesy of Lucille
Kessler Plotkin.)

RITA WISSOKER LEBOWITZ. Rita Wissoker
Lebowitz is shown in 1925. (Courtesy of the
Gruber family.)

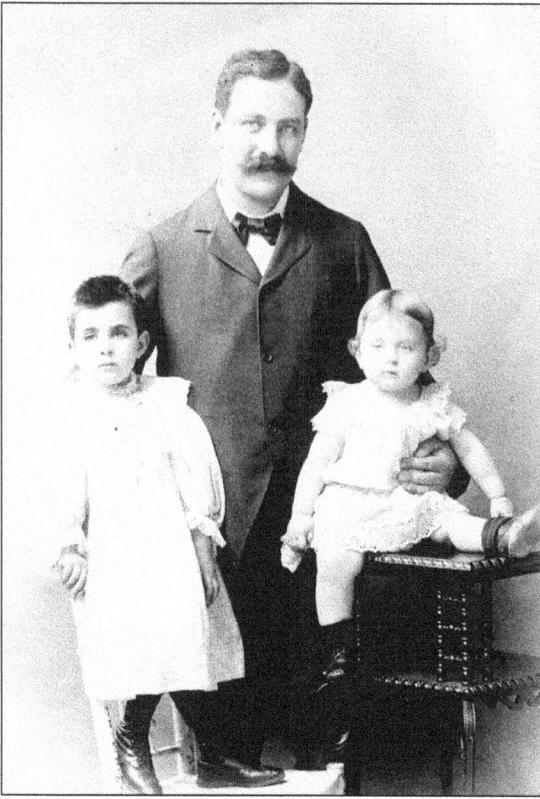

DR. ROOS AND DAUGHTERS. Dr. Elias Roos appears in this photograph with his daughters Bernice (left) and Henrietta. (Courtesy of Elinor Ratner.)

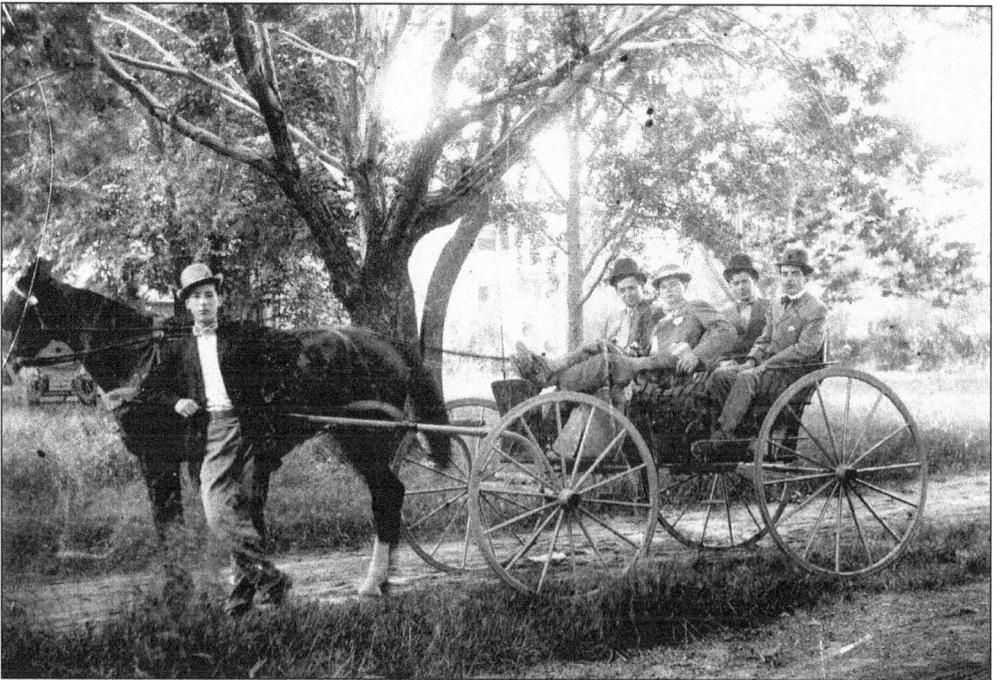

GUS WEINBERGER AND FRIENDS. During the late 19th century, Gus Weinberger (standing) and friends pose for a photograph with their horse and wagon. (Courtesy of Nancy Weinberger.)

FANNIE ROOS. Fannie Roos was the wife of Joseph Roos, who owned a butcher shop. (Courtesy of Elinor Ratner.)

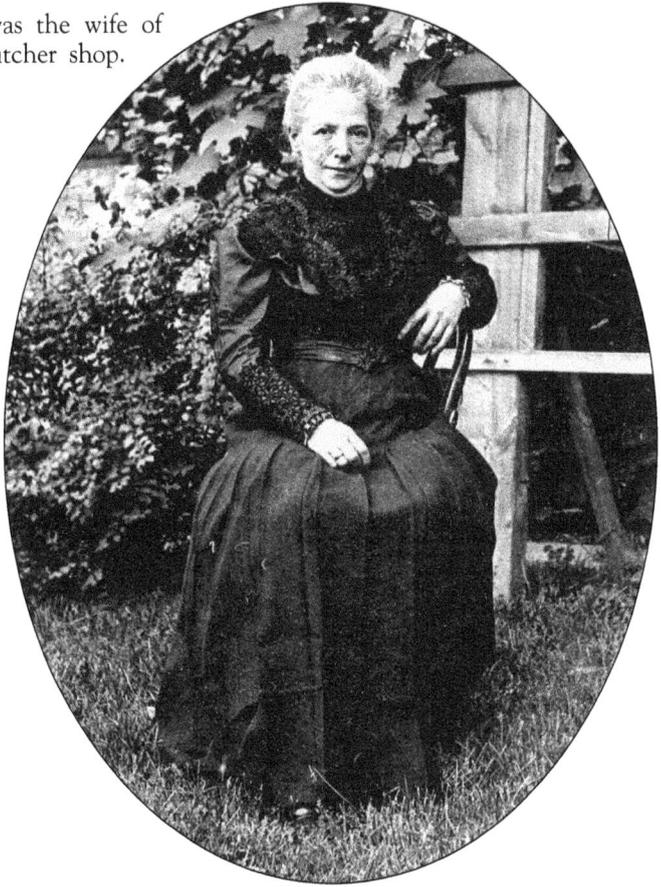

FRANCES WERTHEIMER. Frances Wertheimer of Philadelphia is one of the women seen in this photograph from 1889. She became the wife of Dr. Elias Roos. (Courtesy of Elinor Ratner.)

NATE STONE. Nate Stone, who worked for the post office in Scranton, is shown in his uniform in the 1890s. (Courtesy of the Gruber family.)

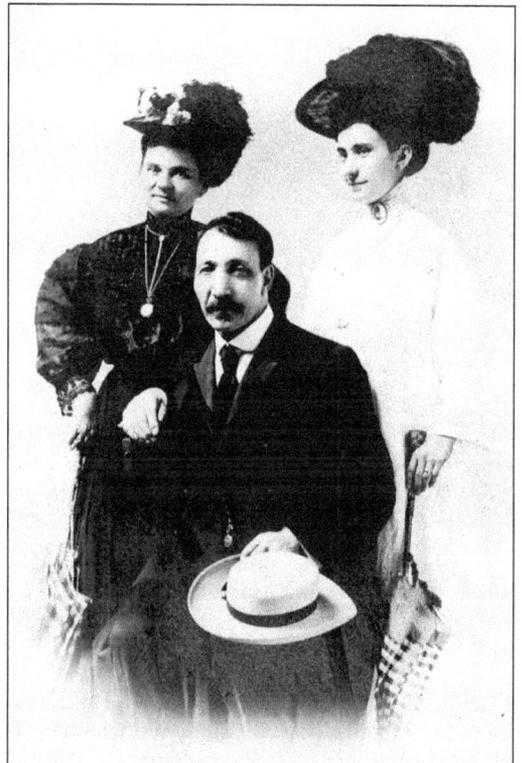

THE SCHAMES FAMILY. This *c.* 1900 photograph depicts Leopold and Charlotte Baertz Schames (on left) with their daughter Fannie. (Courtesy of Faye Spatt.)

ABE STONE. Abe Stone, brother to Nate Stone and Anna Stone Gruber, is pictured in the 1890s. (Courtesy of the Gruber family.)

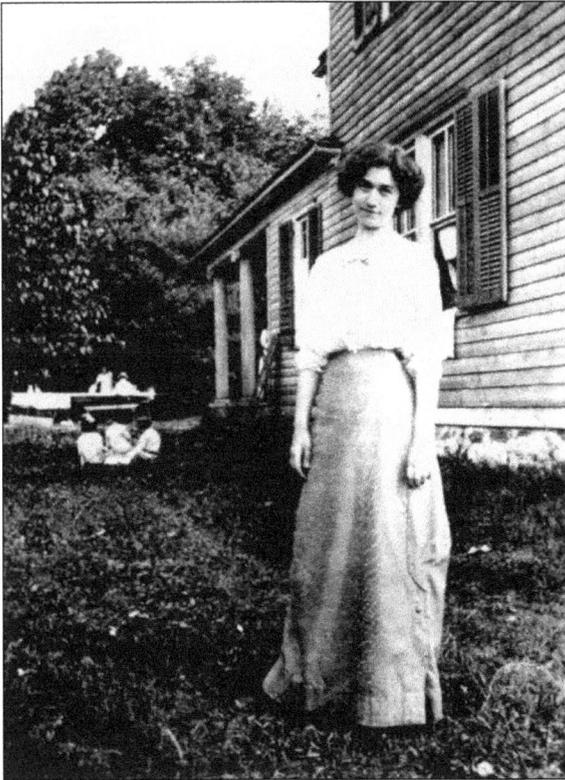

ANNA STONE GRUBER. Anna Stone Gruber, sister to Nate and Abe Stone, poses at Harvey's Lake. (Courtesy of the Gruber family.)

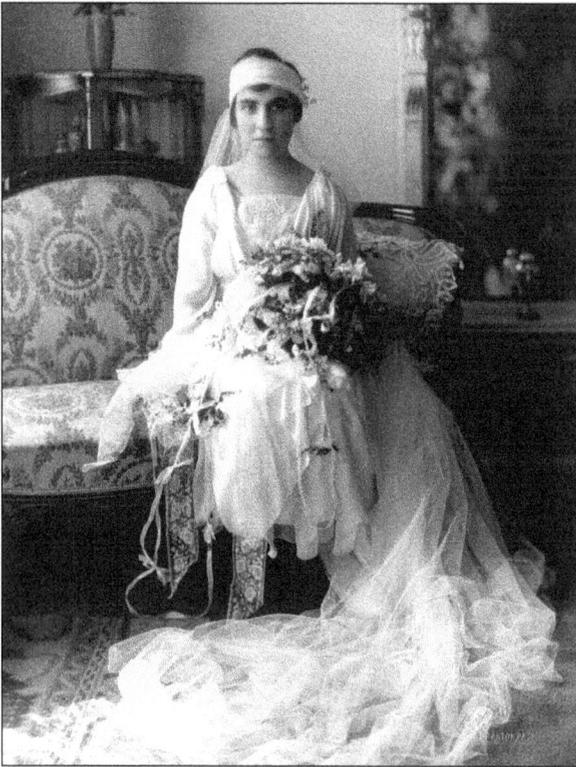

BERNICE ROOS GOODFRIEND.
Bernice Roos married Dr. Harry
Goodfriend in 1918. (Courtesy of
Elinor Ratner.)

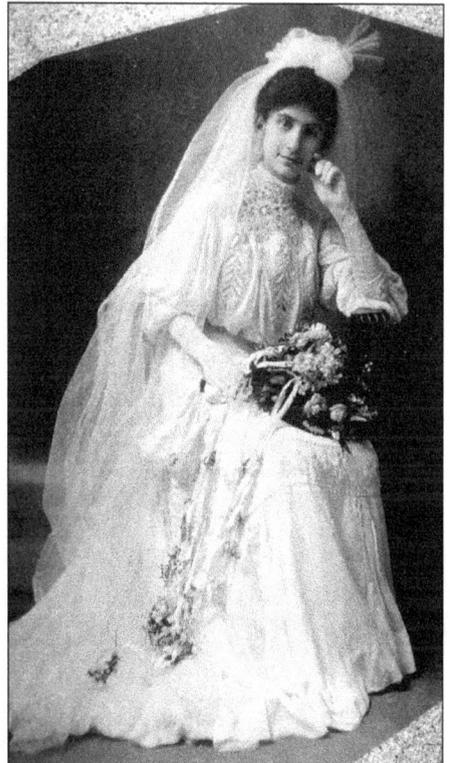

**FANNIE SCHAMES COHEN, BRIDE OF DAVID
COHEN.** In 1904, the Cohens were married by
Rabbi Lewis at the Linden Street Shul. David
Cohen started life in Scranton as a peddler,
literally carrying his wares on his back. He
later opened a men's store in North Scranton.
(Courtesy of Faye Spatt.)

114

HENRIETTA ROOS GEISBERG.
Henrietta Roos Geisberg is shown in
her bridal gown at the Hotel Casey
in 1917. (Courtesy of Elinor Ratner.)

LILLIAN HALPRIN GROSS. Lillian
Halprin Gross wore this bridal gown in
1938. (Courtesy of the Gross family.)

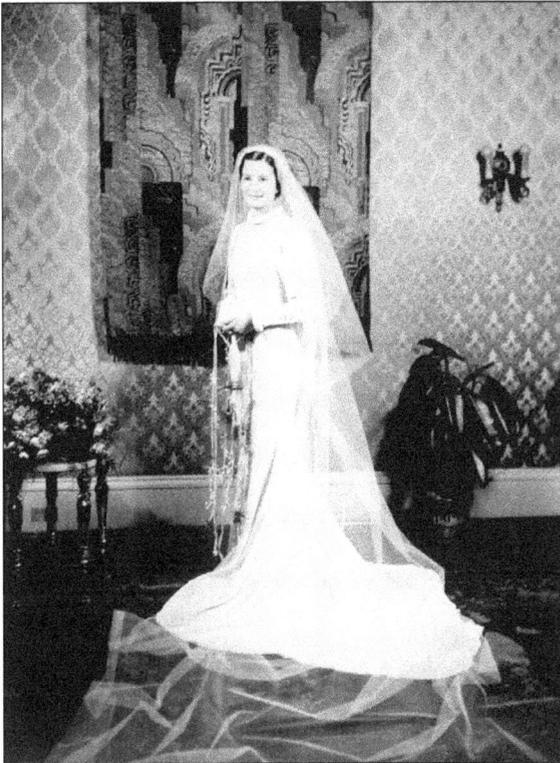

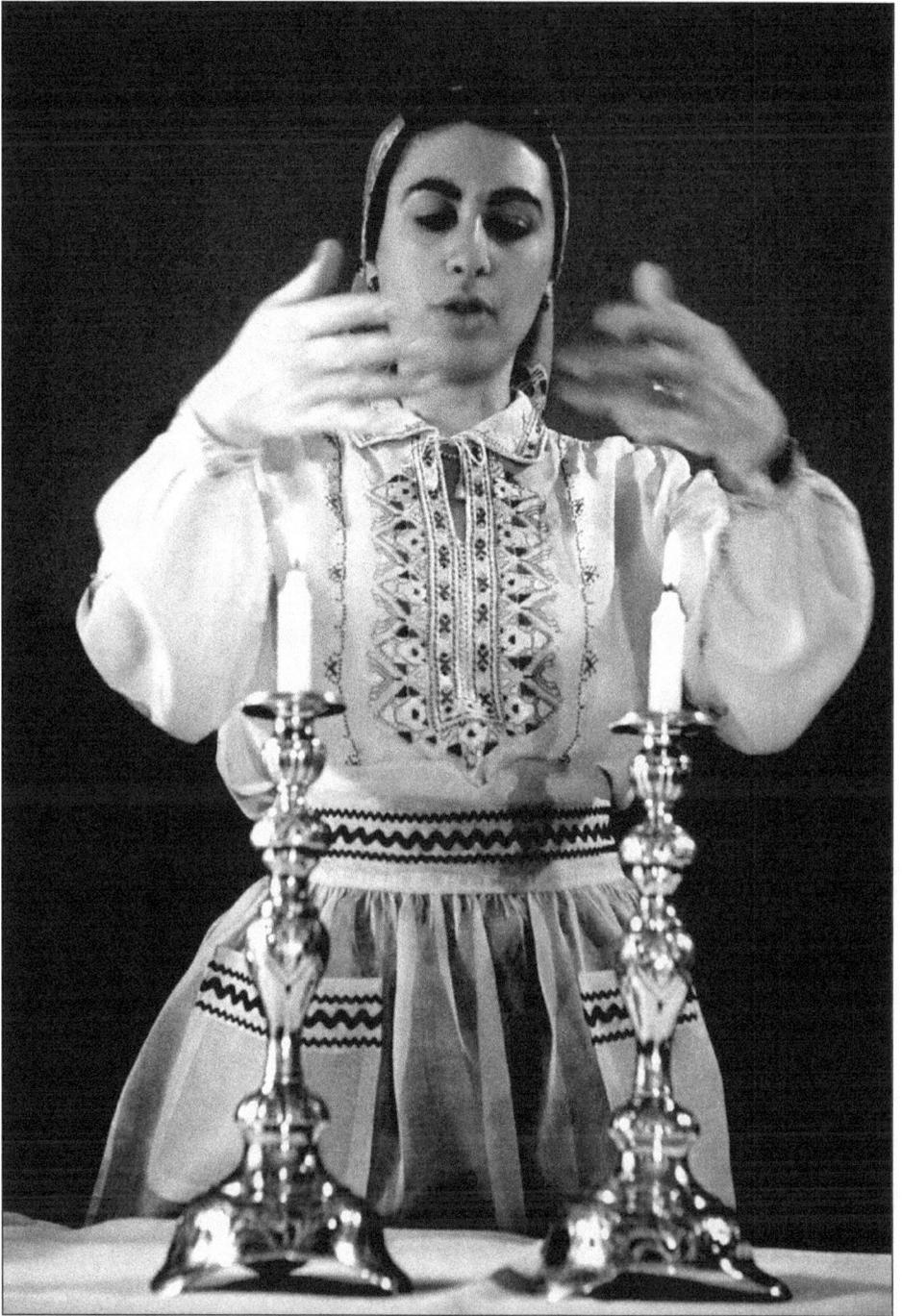

TOBI FINK BLESSING THE SHABBAS CANDLES. In 1955, *Life* magazine did a major series of articles on the great religions of the world. For its feature on Judaism, the magazine produced a photo story that documented the life of an Orthodox family. The Fink family of Scranton were chosen to be the subjects for the article. This image by Cornell Capa was used as a cover photograph for *Life* magazine on June 13, 1955 (vol. 38, no. 24). (Reprinted with permission from Magnum Photos.)

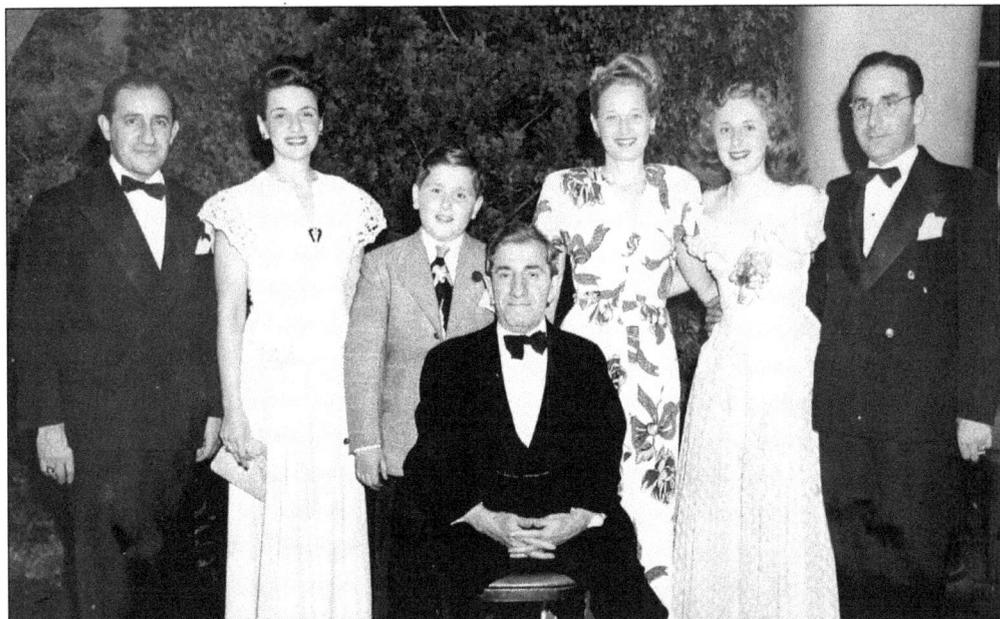

THE GOODMAN FAMILY. This 1940s bar mitzvah photograph shows, from left to right, David Rose, Ruth Rose, Nelson Goodman, M. L. Goodman (seated), Else Goodman, Barbara Goodman, and Herman Goodman. (Courtesy of Barbara Goodman Ehrenpreis.)

THE HARRIS FAMILY. Posing in the 1960s are, from left to right, George Harris, Esther Levy, Joe Harris, Harry Harris, Irving Harris, Ruth Meyers, and Arthur Harris. (Courtesy of the Harris family.)

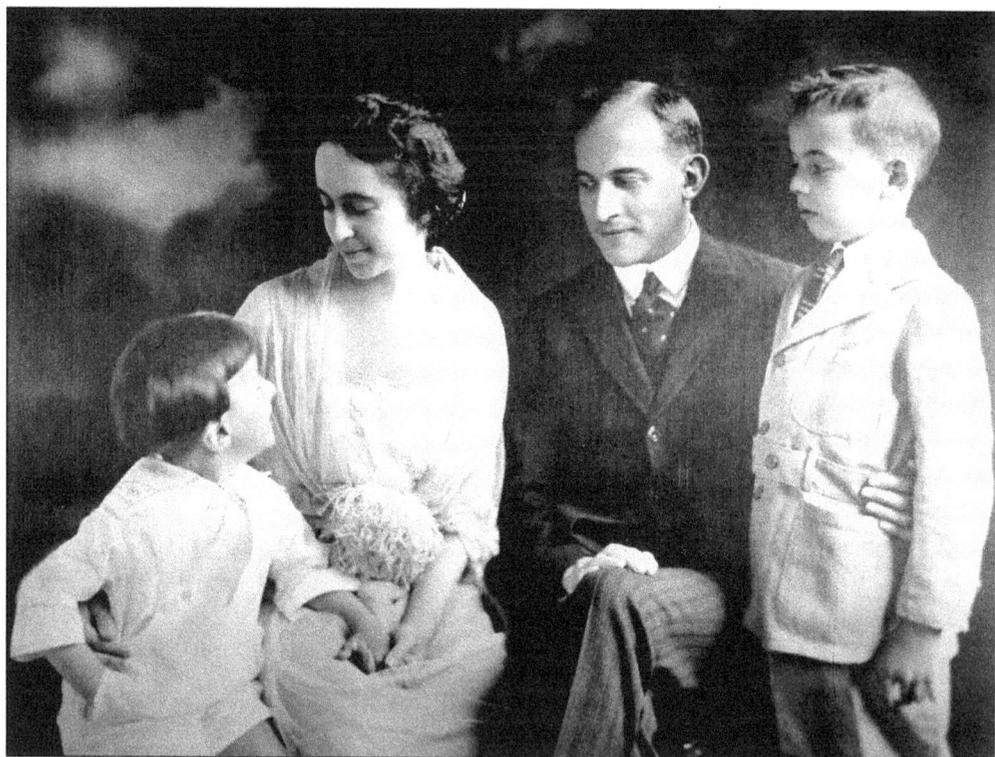

THE OPPENHEIM FAMILY. The Oppenheim family owned and operated Scranton Dry Goods, a legendary department store that flourished in Scranton during the early 20th century. I. E. Oppenheim, owner of the store, was known not only for his impeccable business sense but also for his philanthropy to a wide range of civic, community, and religious causes. He and his wife, Constance, sat for a family portrait with their sons, Richard (left) and Ellis, in 1922. (Courtesy of the Oppenheim family.)

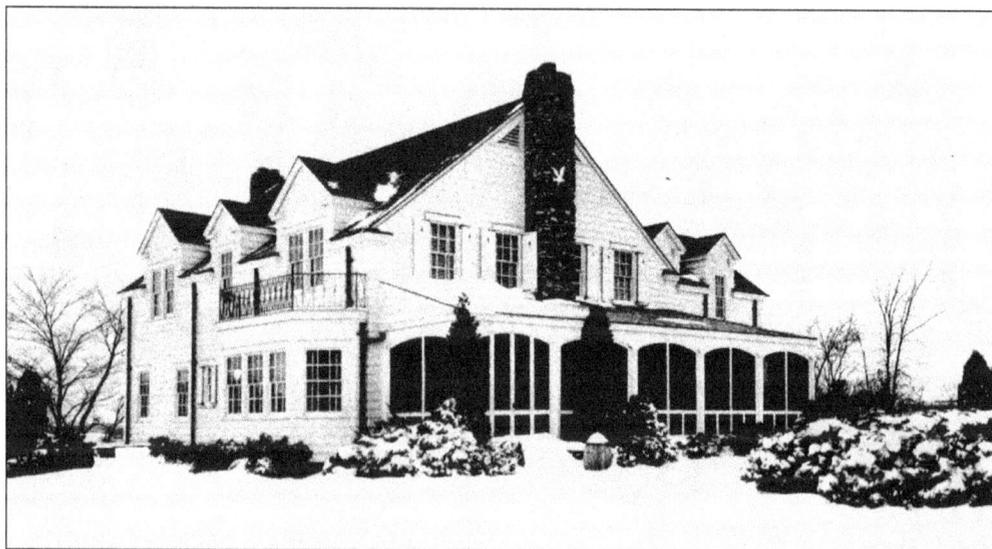

THE OPPENHEIM RESIDENCE. The Oppenheim family home in La Plume is shown in a 1920s photograph. (Courtesy of the Oppenheim family.)

ELINOR GOODFRIEND (RATNER). This photograph of Elinor Goodfriend (Ratner) was taken while she was a student at Wellesley in 1940. (Courtesy of Elinor Ratner.)

THE GELB FAMILY. The Gelb family was active in Scranton business and philanthropy. Seen here in 1950 are, from left to right, Beverly, Mae, Sondra, and Morris. (Courtesy of the Gelb family.)

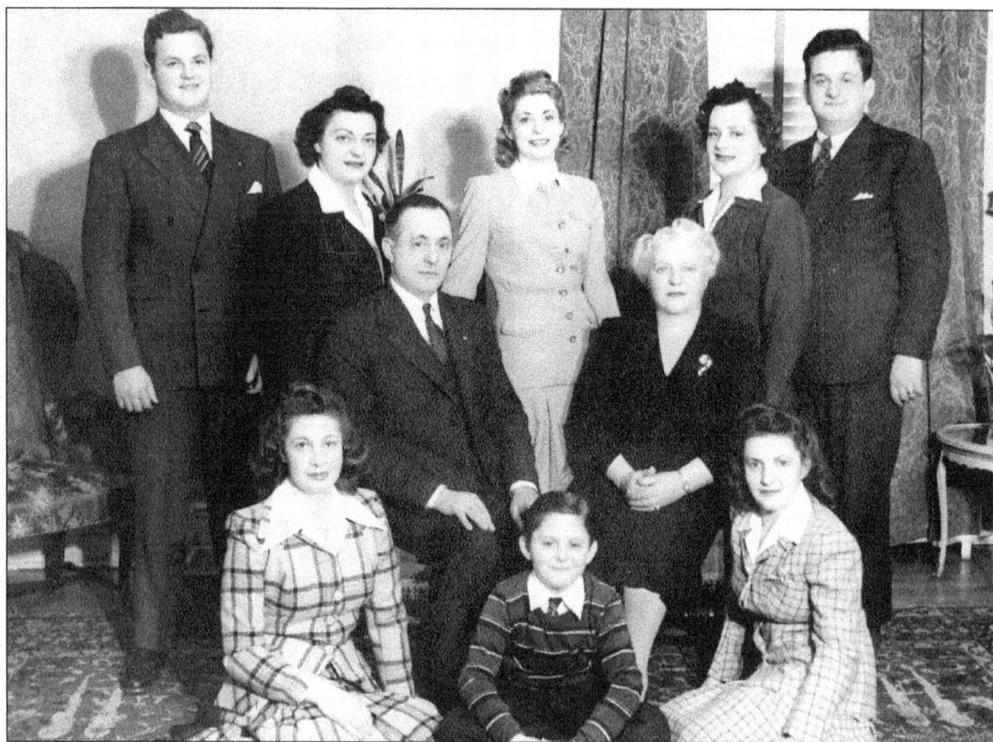

THE BERNSTEIN FAMILY. Pictured in 1945, these Bernstein family members are, from left to right, as follows: (first row) Theresa, Richard, and Esther Bernstein; (second row, seated) Isaac Edward Bernstein and Sarah Lefsetz Bernstein; (third row) Abram ("Bud"), Molly, Helen, Jeannette, and Maynard Bernstein. (Courtesy of Helen Miller.)

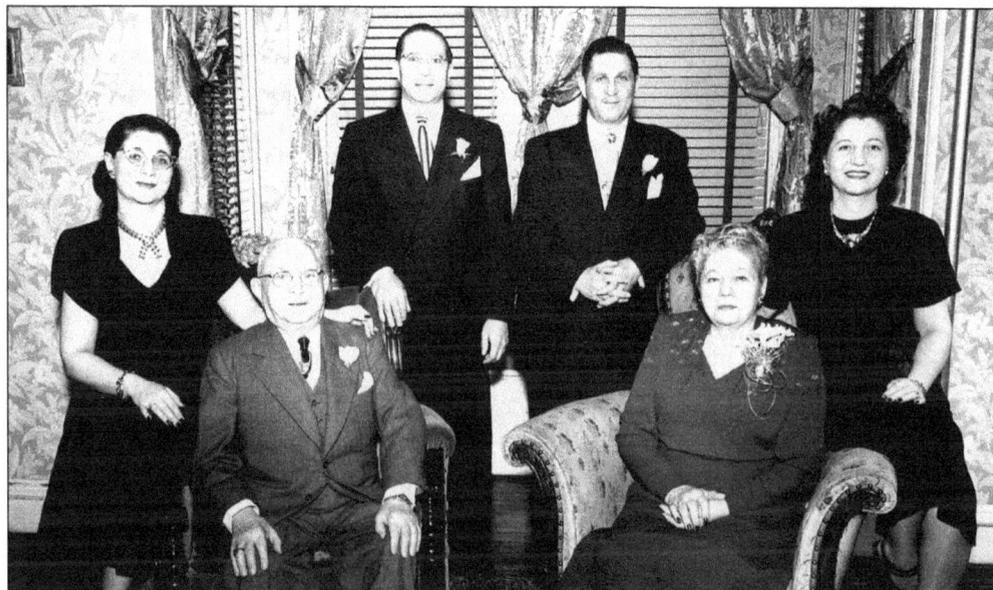

THE LOWENSTEIN FAMILY. In this 1920s photograph, Max and Rebecca Lowenstein (seated) pose with their children. From left to right are Florence, Theodore, Ben, and Dorothy. (Courtesy of Goldye Weinberger.)

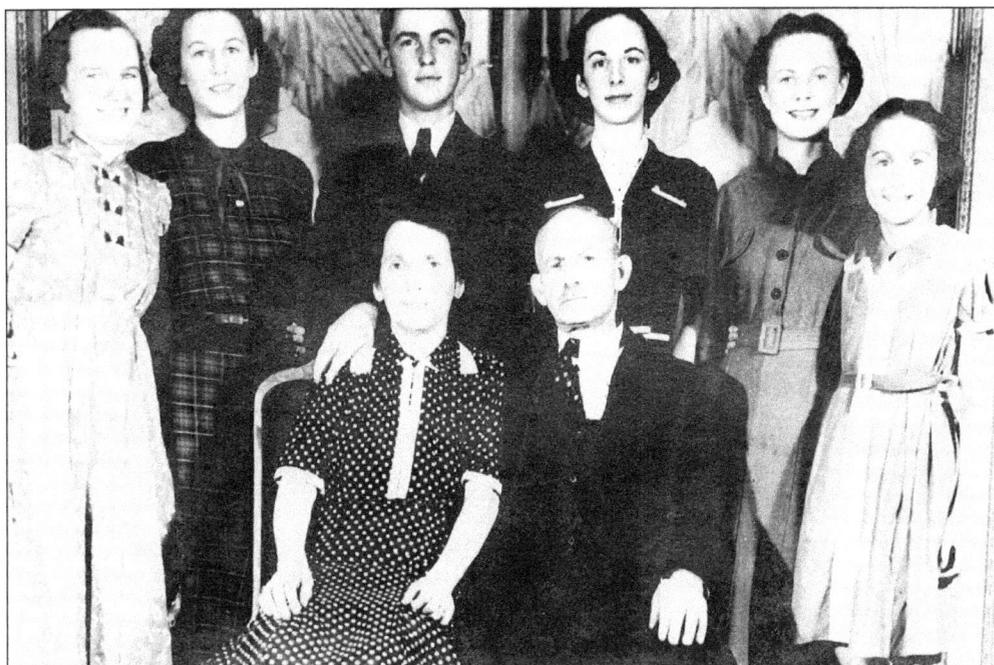

THE GILDAR FAMILY. Morris and Ida Gildar (seated) pose for a portrait in the 1930s with their children. Standing from left to right are Bernice, Sylvia, Harold, Annette, Rosalyn, and Lillian Gildar. (Courtesy of Nancy Weinberger.)

THE ROOS FAMILY. The Roos family gathers for a group portrait in the mid-20th century. (Courtesy of Elinor Ratner.)

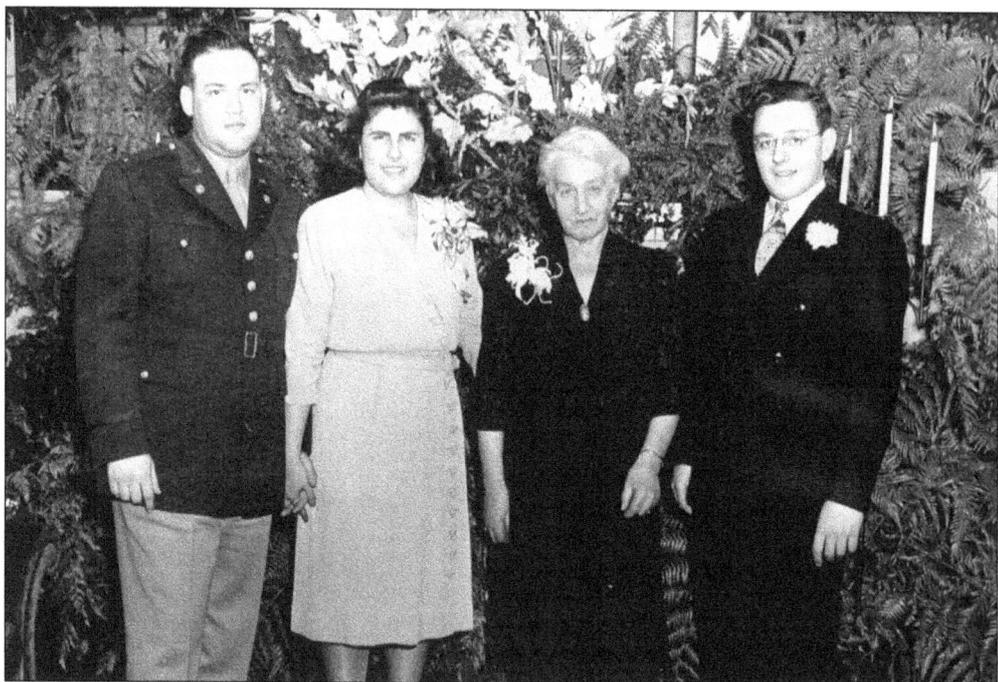

THE WEDDING OF ELINOR AND ROBERT RATNER. Robert and Elinor Ratner (two on left) are shown at their wedding with Edith Roos and Richard Geisberg. (Courtesy of Elinor Ratner.)

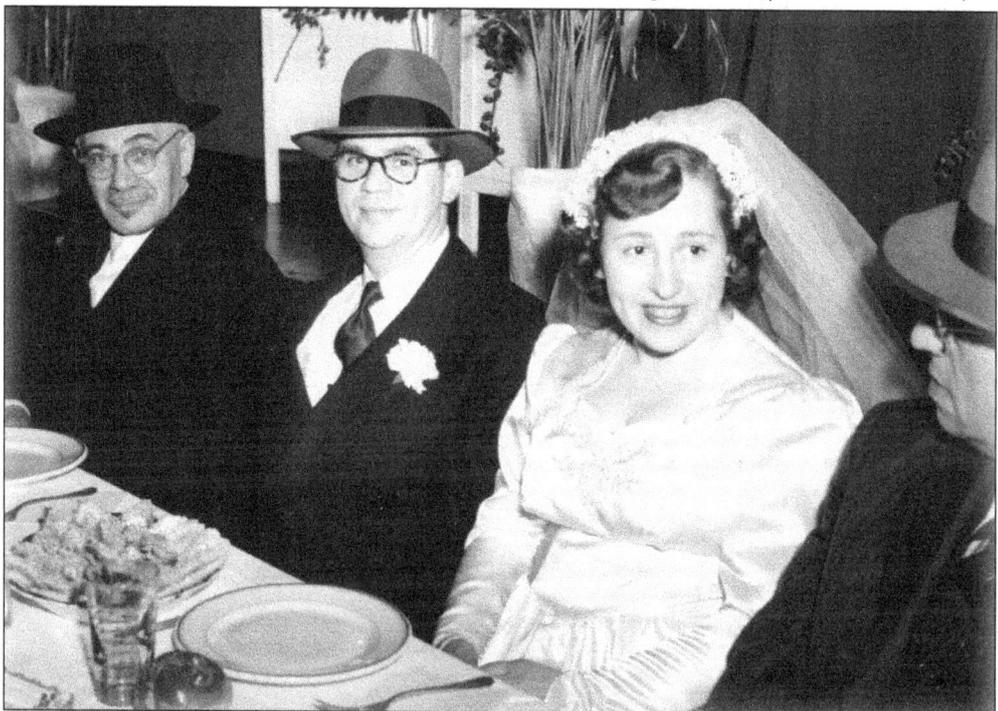

THE WEDDING OF RUTH AND SOLOMON FIRESTONE. The Firestones (at center) were married at Ohav Zedek in 1949. The two men sitting with the Firestones are not identified. (Courtesy of Alan Firestone.)

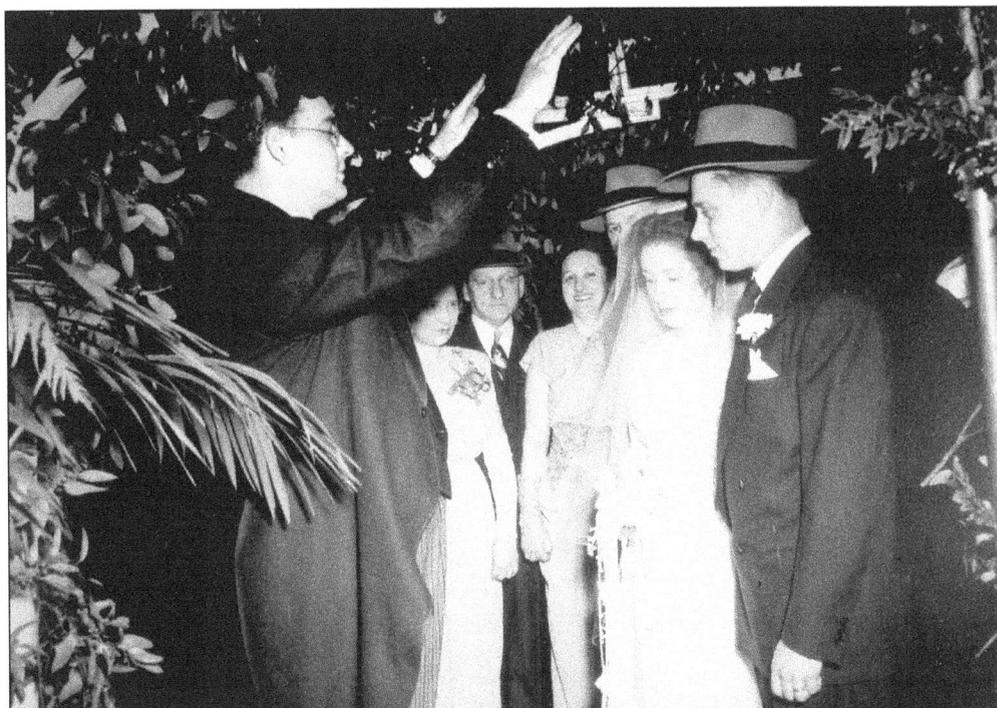

THE WEDDING OF SHIRLEY AND ALBERT KANE. The Kanes (right foreground) were married at Temple Israel in 1947 in a ceremony officiated by Rabbi Arthur Buch (far left) and Cantor William Horn (not pictured). Along with her flowers, Mrs. Kane held a small prayer book that was a gift from her parents. (Courtesy of Shirley and Albert Kane.)

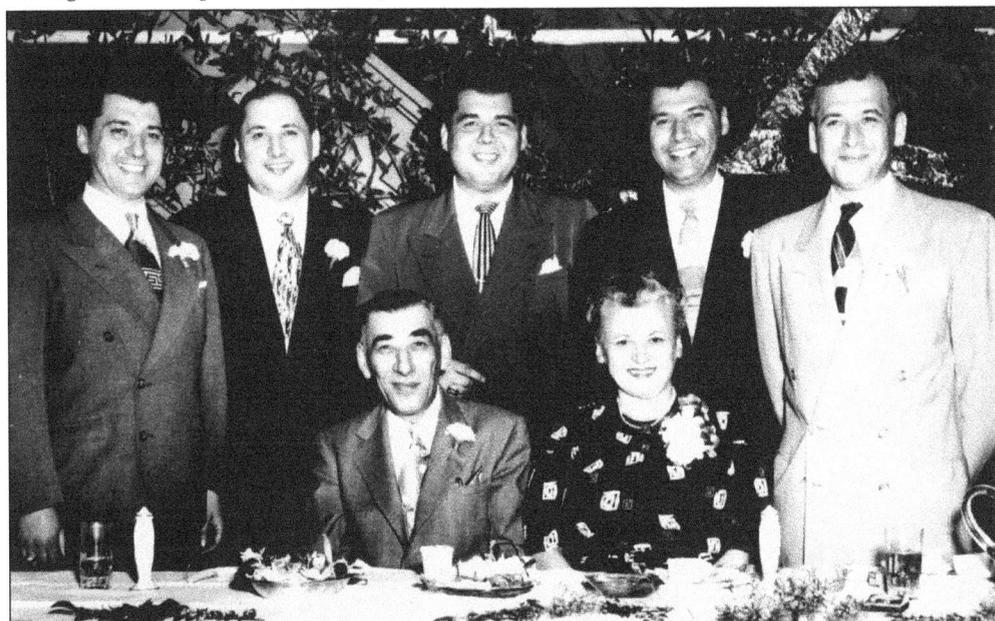

A WEINBERGER ANNIVERSARY PARTY. Gus and Lena Weinberger (seated) celebrate their 50th wedding anniversary with their sons in 1948. Standing from left to right are Harold, Louis, Murray, Gilbert, and Julius Weinberger. (Courtesy of Nancy Weinberger.)

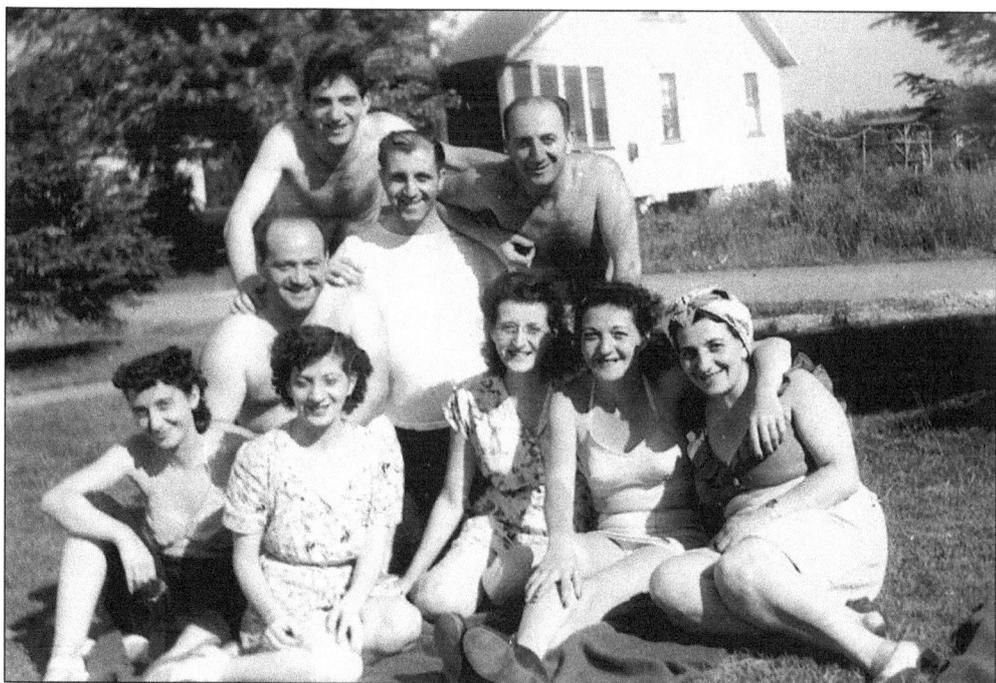

A Plotkin Picnic. Lou Plotkin (kneeling at center) and Anita Plotkin (far left) relax with family and friends at Chapman's Lake during the 1950s. (Courtesy of the Plotkin family.)

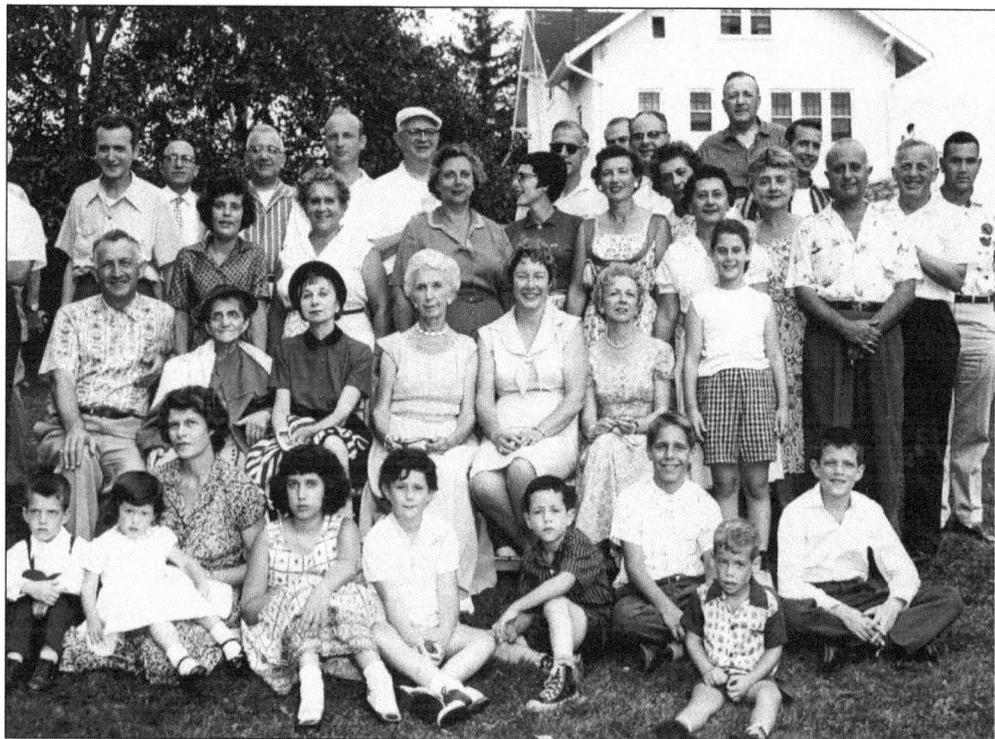

An Eisner and Harris Family Party. Members of the Eisner and Harris families enjoy a summer gathering in 1955. (Courtesy of Sara Eisner.)

CAMP KAWANEE. Members of the Goodfriend family are pictured in the 1920s at Camp Kawanee, a popular camp for Scranton youth. (Courtesy of Elinor Ratner.)

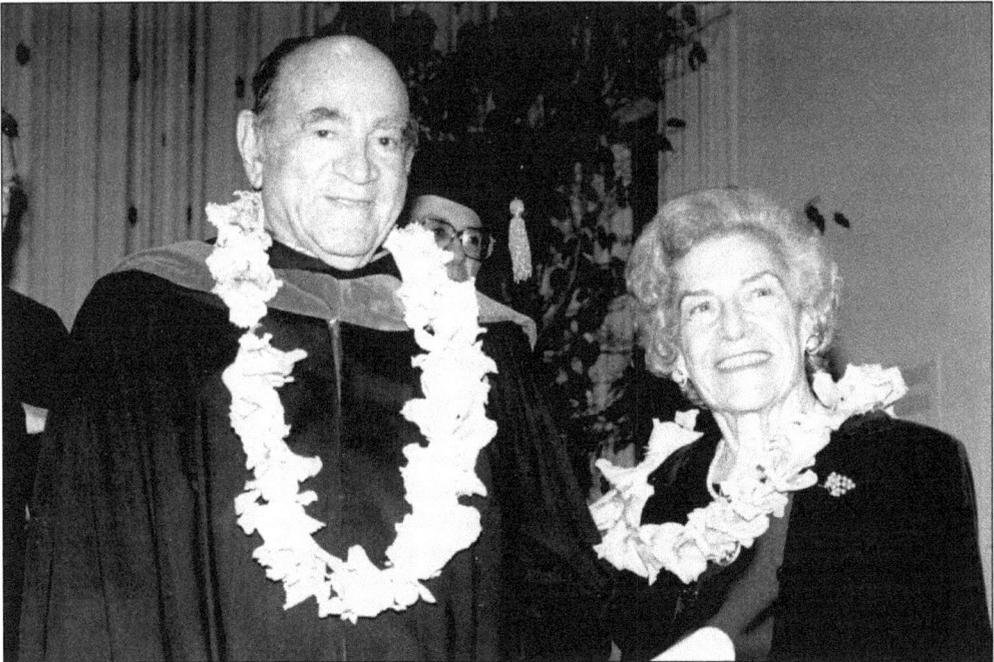

HARRY AND JEANNETTE WEINBERG. In 1987, Harry Weinberg was presented with an honorary degree by Fr. J. A. Panuska, president of the University of Scranton, in recognition of Weinberg's business achievements and generosity to charitable causes. (Courtesy of the University of Scranton.)

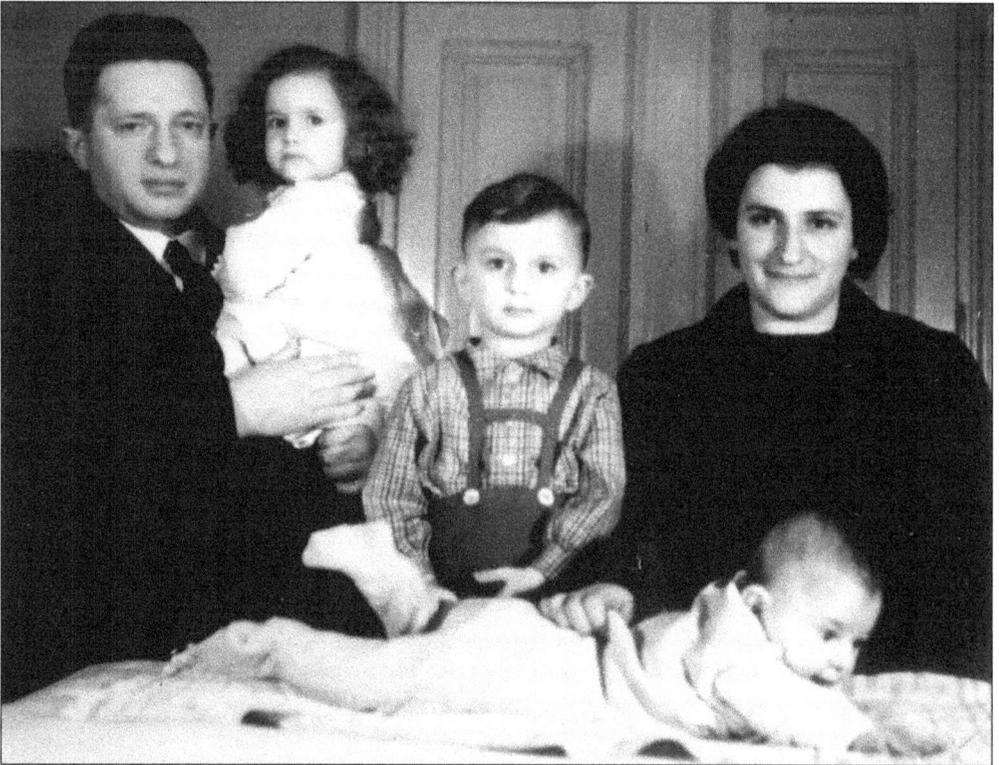

THEKLA DODOLES AND THE KINDERTRANSPORT. Mr. and Mrs. Joseph Dodoles of Leipzig, Germany, were photographed in 1937 with their young sons and daughter Thekla. In 1939, during World War II, Thekla and her brothers were put on the Kindertransport to London. Later, Thekla's loving foster parents refused to return her. After futile legal appeals, Thekla's uncle Rabbi Arthur Joelson took her from the foster parents without permission. Rabbi Joelson was arrested and charged with "child stealing"—a crime punishable by hanging—but he was ultimately exonerated. (Courtesy of Thekla Dodoles Horowitz.)

THEKLA DODOLES REUNITED WITH HER FAMILY. In 1947, all four Dodoles children were reunited with their parents and arrived in the United States, as shown in this newspaper clipping. Thekla Dodoles Horowitz lived for most of her married life in Scranton. (Courtesy of Thekla Dodoles Horowitz.)

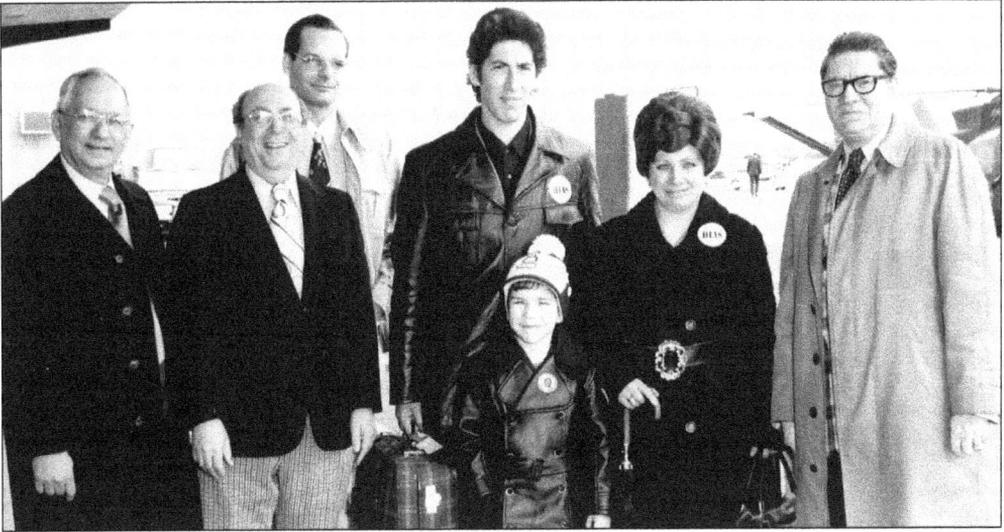

A Russian Resettlement Family at the Airport. This family, immigrating to Scranton as part of the Russian Resettlement Program, was met at the Wilkes-Barre/Scranton International Airport by members of the Jewish Family Service. The present-day Jewish Family Service was originally called the Jewish Federation of Scranton and was organized in 1915. The primary function of this organization was to coordinate the relief activities of all of the service organizations in the Jewish community. In 1976, the name was changed from the Jewish Federation to the Jewish Family Service of Lackawanna County. In 1988, with the advent of Glasnost in the former Soviet Union, Russian Jews were finally allowed to emigrate. The Jewish Family Service was the agency that was responsible for the resettlement of newly arriving Russian Jews. (Courtesy of Jewish Family Service.)

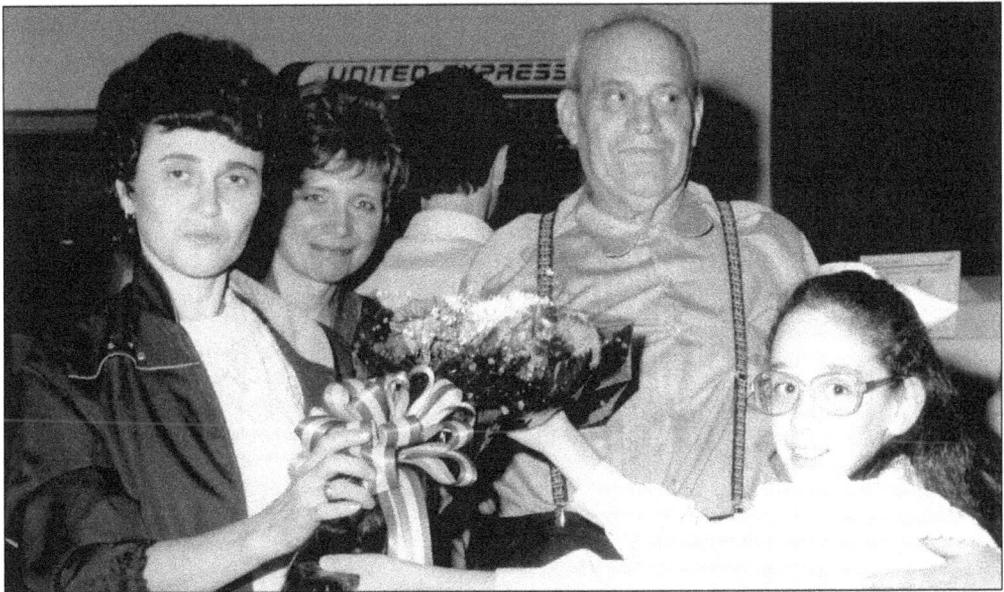

A Russian Resettlement Family Arriving in Scranton. When Russian resettlement families arrived in Scranton, they were met at the airport and greeted with flowers and often shabbas candles. They were then given keys to apartments that had been fully furnished, with the beds made and refrigerators stocked with kosher food. (Courtesy of Jewish Family Service.)

127

ACKNOWLEDGMENTS

During the spring and summer of 2004, the exhibition entitled Jews of Scranton: 1840–2000, held at the Hope Horn Gallery of the University of Scranton, chronicled the rich history of the Jewish community in the Lackawanna Valley. The exhibition was part of a national commemoration of the 350th anniversary of the Jews settling in the New World, and featured objects and materials borrowed from private individuals and local organizations. This volume now becomes the permanent documentation and perpetuation of that exhibition.

As we celebrate the connections that link the Jewish community to the city of Scranton at large, we gratefully acknowledge the co-sponsorship during the exhibition of the Gelb Foundation, the Jewish Community Center of Scranton, and the Jewish Federation of Northeastern Pennsylvania, as well as the Weinberg Judaic Studies Institute and Friends of the Harry and Jeannette Weinberg Memorial Library at the University of Scranton. We are also indebted to many individuals who contributed their insights and skills to the project, including Mark Silverberg, director of the Jewish Federation of Northeastern Pennsylvania; Ed Basan, director of the Jewish Community Center; Sondra Myers, the Gelb Foundation; Rabbi David Geffen, formerly of Temple Israel; Marc Shapiro, Ph.D, director of the Weinberg Judaic Studies Institute, the University of Scranton; Fr. Richard Rousseau, University of Scranton Press; Gerald Zaboski, Stan Zygmunt, and Lynn Sfanos, University of Scranton Public Relations and Publications; and Evan and Alan Firestone, Stephanie Douglass, Yolana Stern, Paula Wasser, Ann Goldberg, Sara Eisner, Irwin Kalisher, and Jack Hiddlestone. Most importantly, we thank the Jewish families of the Lackawanna Valley. It is a pleasure and a privilege to tell their stories. Without their enthusiasm and participation, this project would not have been possible.

www.ingramcontent.com/pod-product-compliance
Lightning Source LLC
Chambersburg PA
CBHW050640110426
42813CB00007B/1872